跨界与融合

"南京创造"

国际校际设计联展作品集

CROSS-DISCIPLINARY AND INTEGRATION
Portfolio of "**Nanjing Innovation**" International
Universities' Design Exhibition

"南京创造" 国际校际设计联展组委会　编

中国建筑工业出版社

IDL

24h 01h 02h 03h 04h 05h 06h 07h 08h 09h 10h 11h

GMT

IDL

13h 14h 15h 16h 17h 18h 19h 20h 21h 22h 23h 24h

主编：
南京理工大学设计艺术与传媒学院
"南京创造"国际校际设计联展组委会

总策划：
段齐骏

组委会成员（按姓名拼音排序）：
Andrew BECK　Ching Chiuan YEN　段齐骏　管倖生　黄　钦
姜　斌　姜　霖　Justus THEINERT　李荟萃　李亚军　梁　雯
乔　泱　Scott SHIM　Steve VISSER　孙守迁　Tin-Man LAU
Tom Nelson　王　辉　王　展　徐瑞华　徐　伟　徐耀东
张　利　张　锡　郑建启　周　明　Zurlo FRANCESCO

书籍整体设计：
王　辉

编排设计（按姓名拼音排序）：
费佳皓　洪流斌　季婵媛　罗　丹
吕志伟　孙春燕　张雨涵　张郅政

前　言

食物、居所和衣服：这是我们经常说的人类生活必需品。随着社会日趋精致复杂，我们又在这个单子上加上了工具和机器（因为它们能够使我们生产其他的三项）。但是，人类有比食物、居所和衣服更多的基本的需求。

即使许多设计机构的法人利益不允许这种设计，至少，我们应该鼓励学生去做一些这样的事情。因为在把一个新的工作领域呈现给同学们的同时，我们可能也就为思考设计问题提供了一种新的可能的模式。我们可以帮助他们产生一种真正需要的社会和道德责任。

——［美］维克多·帕帕奈克《为真实的世界设计》

当今社会，设计教育的职能不再局限于传授设计技能、引导学生以用户的部分需求为基础展开设计思维，其更大的亦是更难体现的价值应为：对学生社会责任意识的培养。

"'南京创造'2013国际校际设计作品联展"，作为第四届国际创新与设计教育论坛的一项主要的也是特色的学术交流活动，将展示来自世界各地高校设计专业师生的设计作品。而秉承上述观念，本届展会的工作目标在于：①促进中外文化的交流与融合，促进设计创新；②为国内外各大院校的师生提供展示设计创意的舞台；③通过作品的交流，实现设计教育思想的交流，进而促进设计教育的共同发展。

相伴于"国际创新设计与教育论坛"，作品联展已经举办了3届。旨在赋予"创造"这一人类发展的永恒主题以南京这座历史文化名城的特殊意味，2011年，设计作品联展正式以"南京创造"命名；2013年度的这次作品联展继续冠以"南京创造"之名，意在打造一个对文化传承、设计交流和设计教育发展有卓越影响力的设计联展品牌。

《跨界与融合——"南京创造"国际校际设计联展作品集》共收录作品120余件，包括产品设计、信息与视觉传达设计、环境设计等不同类别。参展作品来自于英国考文垂大学、美国普渡大学、美国俄亥俄州立大学、美国奥本大学、意大利米兰理工大学、德国达姆施塔特应用科学大学、新加坡国立大学，以及中国台湾云林科技大学、清华大学、武汉理工大学、浙江大学和南京理工大学等12所境内外知名院校。所有参展作品体现出了各校的设计教育特色，其视角、内容、形式乃至于创新思想异彩纷呈，恰好符合本次作品联展的目的。

值此作品集付梓之际，我们谨对各支持、参与院校的相关老师和同学表示衷心的感谢，没有你们提供的优秀作品，便无法有效达成设计与教育思想的交流与碰撞；也对负责作品整理、作品集与作品展版面设计制作的老师和同学们，道一声"辛苦"，没有你们耐心、细致的工作和默默无闻的奉献精神，就不会有成功的作品集和作品展。

由于作品征集完毕至作品集成稿的时间有限，我们的工作可能还存在着一定的问题，为此，我们向各参展单位、参赛者和读者致歉；同时我们希望能得到各有关单位和同行的支持与帮助，将今后的工作做得更好。

"南京创造"国际校际设计联展组委会

2013年7月25日于中国南京

Preface

Food, shelter, and clothing: that is the way we have always described mankind's basic needs; with increasing sophistication we have added: tools and machines. But man has more basic needs than food, shelter, and clothing.

Even if the corporate greed of many design offices makes this kind of design impossible, students should at least be encouraged to work in this manner. For in showing students new areas of engagement, we may set up alternative patterns of thinking about design problems. We may help them to develop the kind of social and moral responsibility that is needed in design.

Victor Papanek, Design for the Real World

Nowadays the functions of design education are no longer limited to passing on the bare knowledge of design and guiding students through design thinking based on the fundamental requirements of users. The fateful value of design education, which is hard to be realized, is the cultivation of the students' consciousness of social responsibility.

"Nanjing Innovation" International Universities' Design Exhibition, as the main part and the most distinctive academic exchange activity of the 4th International Innovational Design & Education Forum, will display design works of teachers and students majoring in design from universities and colleges all over the world. In accordance of the above-mentioned education concept, this exhibition aims at:

· promoting design innovation and the exchanges and integration of various cultures;

· providing teachers and students from universities and colleges all over the world with a platform for displaying creativity;

· and realizing the interchange of ideas of innovational education through exchanging design works, thereby promoting the common development of design education.

For the purpose of polishing Innovation, one of the timeless themes of human development by adding the temperament of Nanjing, a city filled with the historical and cultural heritages, the exhibition of designs has been held for three times, along with International Innovational Design & Education Forum. In 2011, the exhibition was officially named as "Nanjing Innovation" and that in 2013 the Exhibition continues to use this name shows the effort for building a remarkable brand of design exhibition for cultural transmission, design communication and development of design education.

Cross-disciplinary and Integration—Portfolio of "Nanjing Innovation" International Universities' Design Exhibition embodies more than 120 design works, covering products design, information and visual communication design, and environmental design, etc.. Participating universities include Coventry University(GBR), Purdue University(USA), the Ohio State University (USA), Auburn University (USA), Politecnico di Milano (ITA), Hochschule Darmstadt University of Applied Sciences (GER), National University of Singapore (SIN), Yunlin University of Science and Technology(TW, CHN), Tsinghua University (CHN), Wuhan University of Science and Technology (CHN), Zhejiang University (CHN) and Nanjing University of Science and Technology (CHN). Entries from these 12 esteemed universities show the differed characteristics of design education, with the splendour of various angles, objects, forms and innovational thoughts, which correspond to the purpose of this exhibition of design works.

At the time that the portfolio is finished and submitted for publication, we sincerely express our gratitude to teachers and students of the participating universities, for the design works provided by you further the collision and exchange of design and education ideas. Meantime, we gratefully acknowledge the contributions of every teachers and students involved in the collection of design works and the layout design of the portfolio and the exhibition. Without your patience, carefulness and dedication, neither such successful exhibition would be held nor would the portfolio be perfect.

As time for the completion of portfolio is limited, it is inavoidable that there should be error in the portfolio, for which we apology to participants and readers. We hope to perform a better job in future with the helping hands from relevant units and all our fellow colleagues.

Organizing Committee of "Nanjing Innovation" International Universities' Design Exhibition

July 25th, 2013 in Nanjing, China

目录

　　　　前言

001　[美国]普渡大学

029　[英国]考文垂大学

057　[德国]达姆施塔特应用科学大学

077　[美国]奥本大学

087　[新加坡]新加坡国立大学

105　[美国]俄亥俄州立大学

123　[意大利]米兰理工大学

141　台湾云林科技大学

163　清华大学

189　浙江大学

211　武汉理工大学

233　南京理工大学

PURDUE
UNIVERSITY

Purdue University
[美国] 普渡大学

GMT

IDL

13h　14h　15h　16h　17h　18h　19h　20h　21h　22h　23h　24h

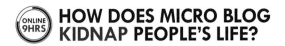

HOW DOES MICRO BLOG KIDNAP PEOPLE'S LIFE?

56% OF SURFING TIME IS SPENT ON SOCIAL MEDIA

LOGGING IN FREQUENCY

SEVERAL TIMES PER DAY 50.5%
2-3 TIMES PER DAY 22.6%
1-2 TIMES PER WEEK 14.5%
1-3 TIMES PER MONTH 6.9%
RARELY USE 5.5%

56%

With the development of social networks, social media provide enormous conveniences and sufficiency for people getting the latest information. As they becoming an increasingly essential part of life, they impact people's living patterns as well. Here are some details of the number of people using micro blog:
Registered accounts 100,000,000;
New accounts created per day 200,000;
New tweets published per day 800,000;
Mobile users 450,000;
Since social media is kidnapping people's daytime with overloaded information in return, can we get our normal life back?

20% IN 24HRS IS SPENT ON SOCIAL MEDIA

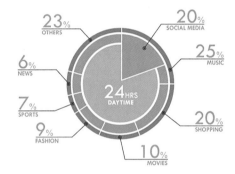

23% OTHERS
20% SOCIAL MEDIA
25% MUSIC
6% NEWS
24HRS DAYTIME
20% SHOPPING
7% SPORTS
9% FASHION
10% MOVIES

9HRS IN 24HRS ARE SPENT ON MICRO BLOG INTENSIVELY

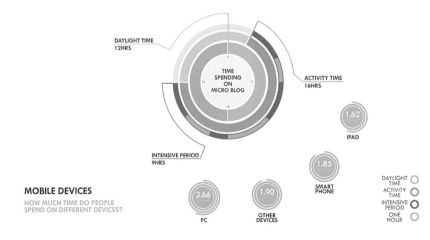

DAYLIGHT TIME 12HRS

TIME SPENDING ON MICRO BLOG

ACTIVITY TIME 16HRS

INTENSIVE PERIOD 9HRS

1.62 IPAD

1.85 SMART PHONE

MOBILE DEVICES
HOW MUCH TIME DO PEOPLE SPEND ON DIFFERENT DEVICES?

2.66 PC

1.90 OTHER DEVICES

DAYLIGHT TIME
ACTIVITY TIME
INTENSIVE PERIOD
ONE HOUR

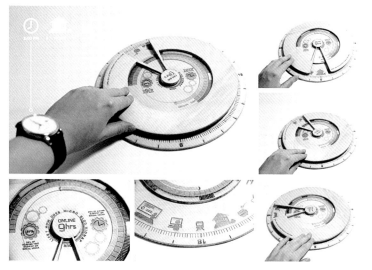

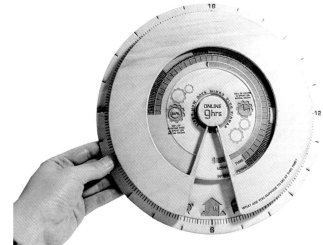

Based on the timeline standard, this infographic project is to show the impact of micro blog among people's life, since social media becoming an increasingly essential part of modern living pattern.

The poster includes the information from the main background of social media and micro blog, what are people looking for during their online time, how much time do people spend on micro blog in 24 hours to what kinds of mobile devices do people use to log in their accounts, showing the details gradually. The 3D application is illustrated with both the comparison between the normal activities at each specific hour and online time. People can also do self-diagnosis of "What are you supposed to do at this time?" with rotating the top plate, which is more interactive.

Weiran Lei

"How does Micro Blog Kidnap People's Life?"

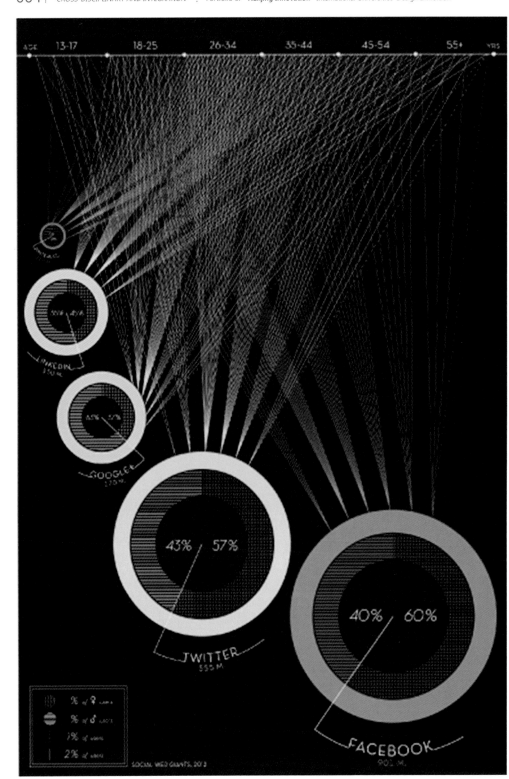

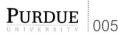

"Social Web Giants, 2013"

Emily M. Cox

While conceptualizing this design, I was inspired to represent data abstractly through the use of simple lines and geometric shapes. To achieve this, I chose to represent each social media giant with a distinctly colored circle. Lines of corresponding colors radiate from each circle, representing the percentage of site users in each age demographic. Colored lines are grouped according to which age demographic and website they belong. This grouping makes the information easier to attain when viewed at a close distance and also creates an aesthetically pleasing web-like effect when viewed further away. I strived to create a beautiful, clean and modern design with striking colors and simple shapes that would inspire the viewer to take a closer look.

Because the original design is a large printed poster, I chose to create a more interactive and hand-held way to display the same information. To do so, I focused on isolating each social media website on a separate sheet of transparency film. My final solution is a hand-held print booklet in which each social media site lays over the other to re-create the original poster design. By placing each site's elements on a separate page, the viewer can flip through and analyze the data in detail. I believe this grouping/separation allows the viewer more of an opportunity to interact with the design while fully absorbing its numerical data and design intricacies.

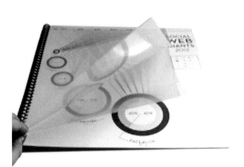

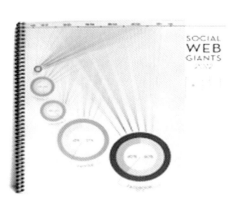

WHAT MEASURES YOUR LIFE?

Eating disorders have the **highest mortality rate** of any mental illness

Only 30%~40% of those with an eating disorder ever fully recover

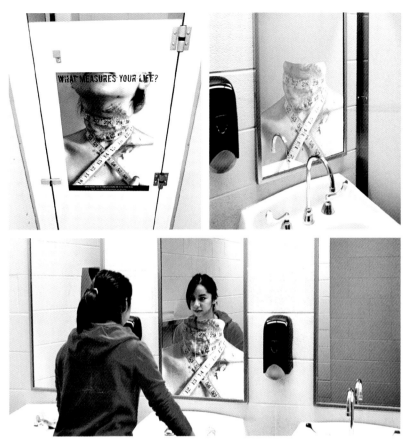

Eating disorders have the highest mortality rate of any mental illness. I wanted this poster to focus on how fatal eating disorders can be and how they can slowly suffocate those who suffer from it. We, as a society, are very focused on the size and shape of the human body. We force these standards on young women and men alike and demand that they reach an unattainable level of perfection. Many young men and women are so pressured by these demands that they often develop eating disorders. Most of those with an eating disorder will never fully recover. This social issue is widely ignored or unnoticed by the general public. I wanted to bring awareness to the issue and how dangerous it can be.

Sarah-Jean Murray

What Measures Your Life?

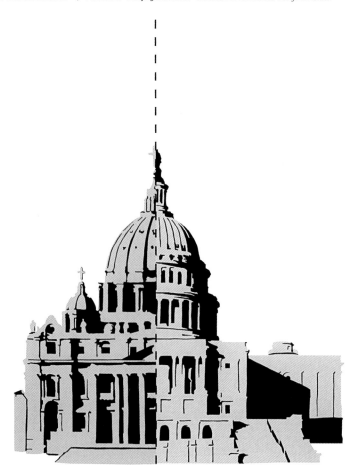

SEPARATE HERE

"Separate Here"

Alex Hanson

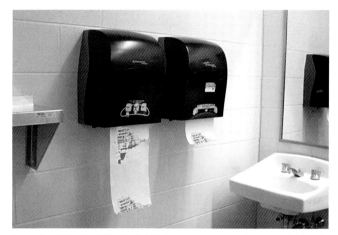

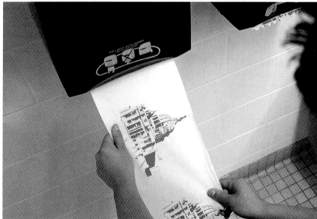

The poster "Separate Here" is a visual representation of support for the issue on church and state. Whether someone is in favor or not of the issue, the two are commonly seen together, hence the combination of St. Peter's Basilica as church and the United States Capitol Building as state. The use of color and style creates the subtle distinction between the buildings.

In accompaniment with the 24″x36″ poster, disposable paper towel rolls would be produced and placed in public restrooms to increase awareness of the issue. Tearing the paper towels is the equivalent of subtly "separating" the two from one another.

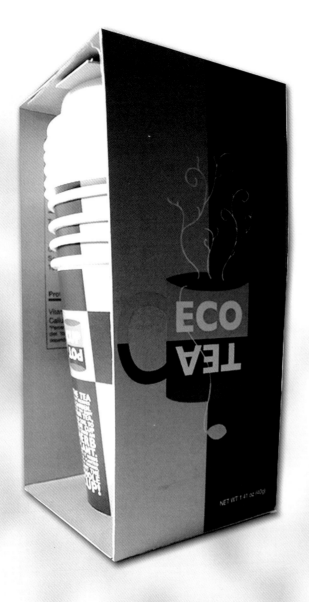

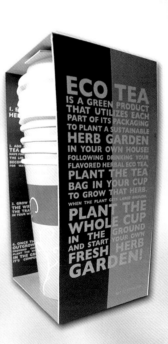

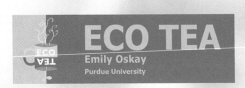

ECO TEA

Emily Oskay
Purdue University

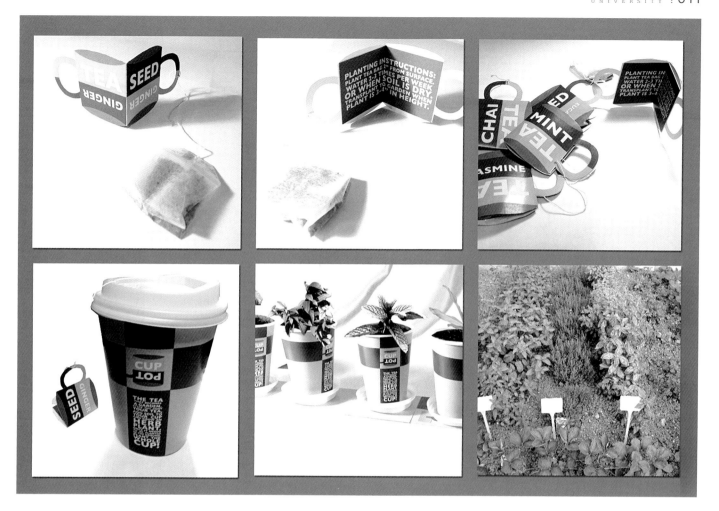

"Eco Tea" is a package design project based on sustainability. The product "Eco Tea" is a completely sustainable tea brand that, upon consumption, uses each part of its packaging and tea to create a sustainable herb garden. The outside wrapper of the tea becomes a tray for the window sill to avoid a mess, the to-go cup for the tea the pot, the cup lid becomes the tray for water overflow, the stir-sticks become the labels for the different plants, and the tea bag itself contains the seed for the herb garden. After the plant becomes too large for its cup, the whole container can be planted into the ground as each piece is compostable. The market for this product was ages 20+.

Emily Oskay

Eco Tea

INFORMATION OVERLOAD ON WEIBO

Weibo hits 100 million posts per day. As an average Weibo user who follows about 100 people, Weibo is just like an iceberg for you

YOU SEE: **300** POSTS PER DAY

YOU DON'T SEE: **100,000,000** POSTS PER DAY

22%
News

17%
Recreation

12%
Sports

12%
Auto

8%
Blog

6%
Feminie

WEIBO HAS **300,000,000** USERS

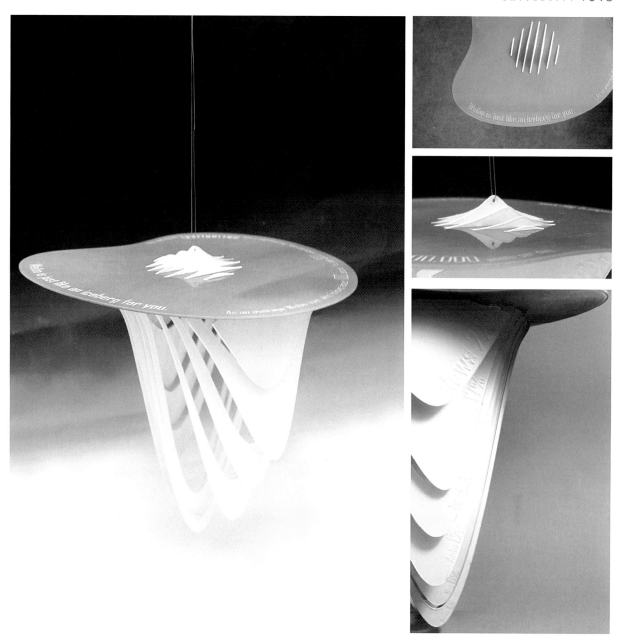

Weibo, a Chinese microblogging service, hits 100 million posts per day. However, as an average active weibo user with about 100 followers, he or she only gets 300 posts per day. 300 posts vs 100,000,000 posts, this is a huge contrast showing we are living in an information overloaded age.

To display such a phenomenon in Weibo, the designer use the iceberg concept to show that information we get is only the tip of the iceberg. A 3D iceberg is used to stand for information. It is made from laser cut acrylic sheets.

Anqi Wang

Iceberg

Pebble
Stone Chair

Anqi Wang

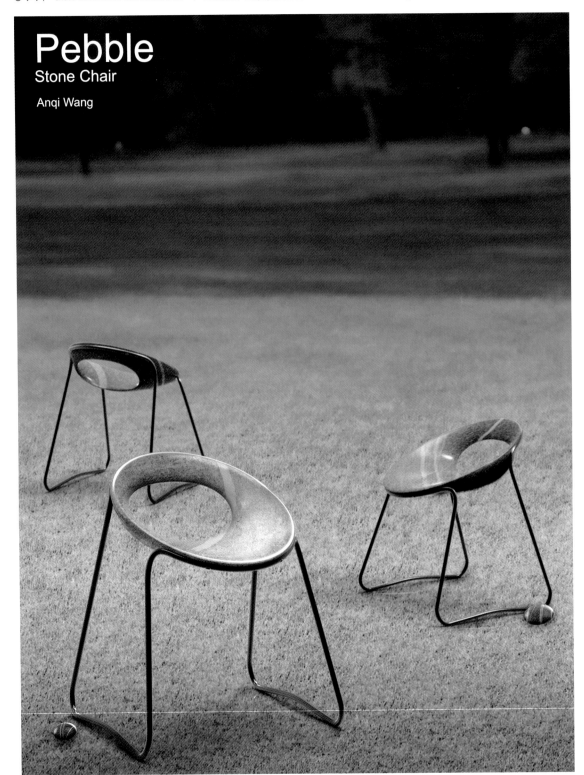

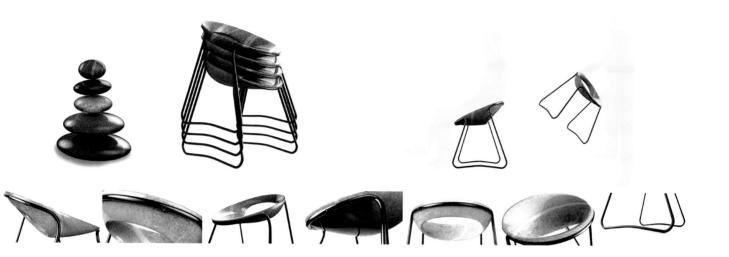

Pebble is a stackable outdoor chair designed for Battery Park. It combines elegant shape and useful functionality with a beauty of natural materials. The seat is made by stone. It's flat, smooth and rounded. Each seat has its unique texture which makes the chair iconic. The bended legs are stable and friendly to the grass-lawn surface. Sit on Pebbles and enjoy a sunny day in Battery Park!

be any rocker chair

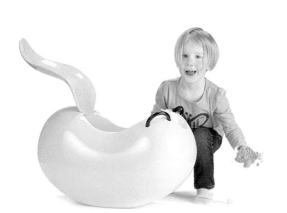

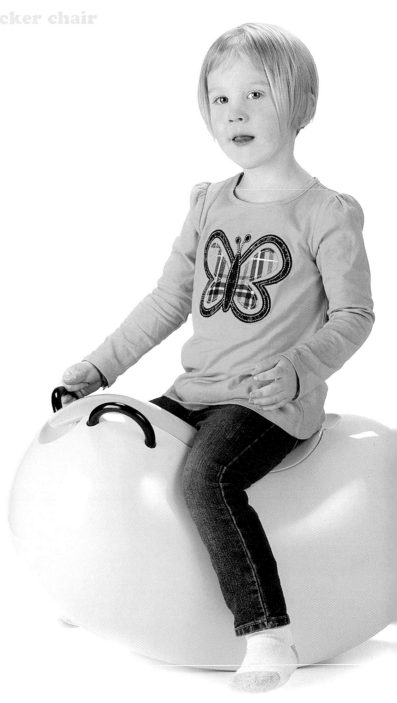

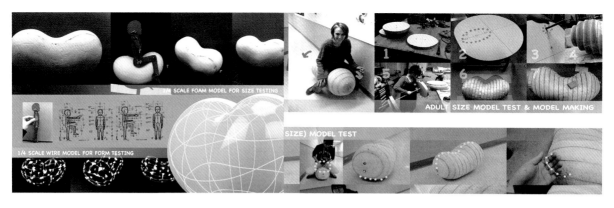

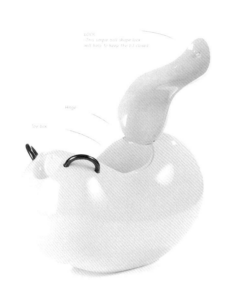

Beany Rocker Chair is a combination of rocker chair and toy box. It is a piece of furniture for fun and space saving. This simple bean shape plastic has a seat positioned on the top. The seat part has a lid which allows children to open and put their toys inside. The "mouth" of the bean is an open space for hands to open the lid. The hollow shape on the back part create the two rails for rocking. Two handles (eyes of the bean) on the top part makes it easy to hold, the bright colors combination and organic shape make it easy to love.

Junyao (Zoey) Feng

Beany Rocker Chair

Caterpillar Dump Truck

T.J. Eads, Patrick Fiori, Sally Bluemke,
Yue Dai, Elizabeth Barrett

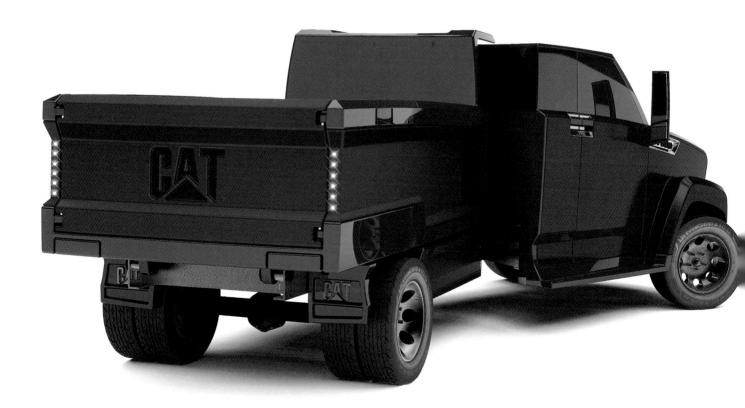

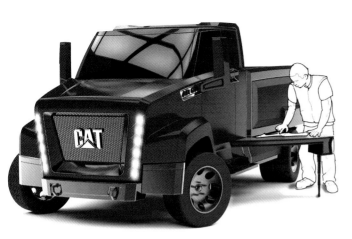

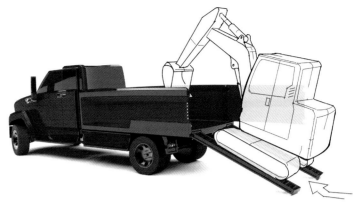

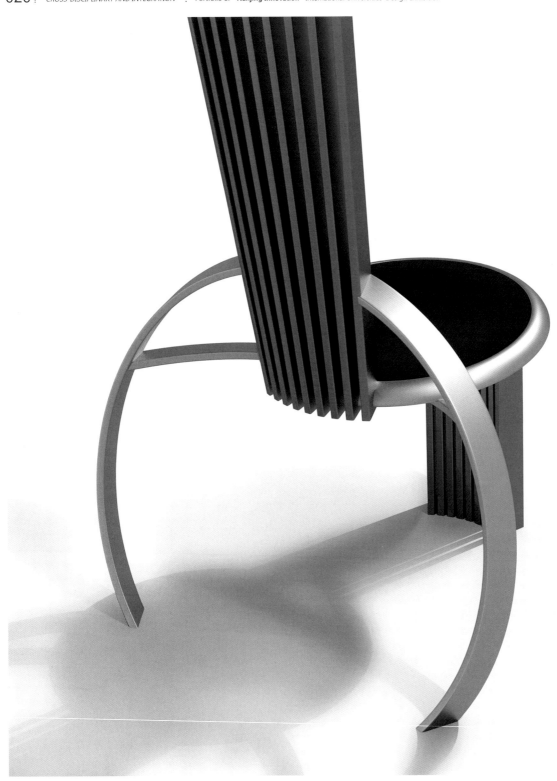

Exclamation Stacking Chair

Steve Visser

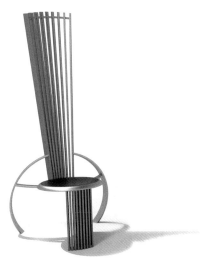

Design

The Exclamation Stacking Chair has a tall tapered back chair that is especially narrow to accent its height. The array of slats that make up the seatback and front legs of the chair accentuate the verticality of the exclamation chair. The Exclamation Chair is 57″ tall or a few inches taller than a seated adult, yet the back averages only 10″ wide, creating a dramatic profile. The seat back forms the vertical line of an exclamation mark. The seat itself is circular casting a round shadow on the ground completing the exclamation point.

Manufacturing

The Exclamation chair is made of recycled materials. The vertical slats for the back and front legs are made of recycled extruded aluminum. The blue color is an anodizing finish on the slats. The back legs and seat rim are made of recycled cast aluminum. The cast aluminum provides strength and added weight for stability. Finally, the seat pan is made of rubber sheet made of recycled tires and roofing materials. The rubber sheet is cut into final form with a computer controlled water jet cutter.

Becky

Ross Brinkmann

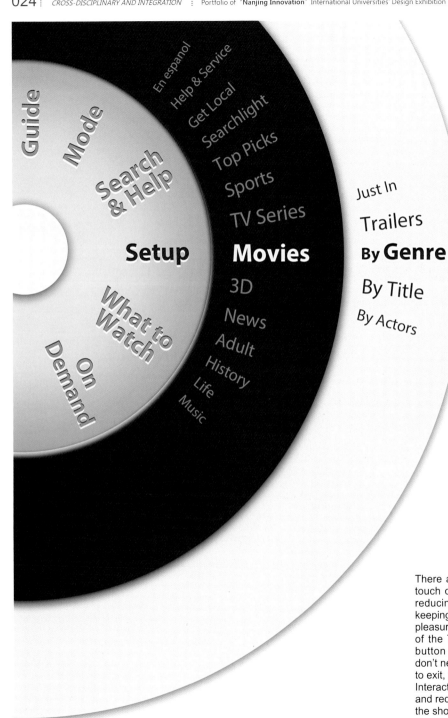

Guide
Mode
Search & Help
What to Watch
On Demand

En espanol
Help & Service
Get Local
Searchlight
Top Picks
Sports
TV Series
3D
News
Adult
History
Life
Music

Setup
Movies

Just In
Trailers
By Genre
By Title
By Actors

Action
Adventure
Comedy
Crime
Fantasy
Horror
Love
Science Fiction
Thriller

There are so many buttons that you will never touch on your remote control.LEAF-O aims at reducing the buttons to the minimal while still keeping a great usability, and giving you the true pleasure while watching TV. The radial structure of the TV interface corresponds to the wheel button on the remote control.TV lovers now don't need to look up for buttons when you want to exit, mute, or change chanels any longer. The Interaction of this system is functionaly intuitive and requires minimal effort to master. Just enjoy the show!

LEAF-O
Tv and Remote Control System

Yinghuan Peng, Zewen Liang

(1) Press the **central key** to pop out the main directory wheel interface.

. .

 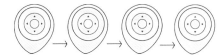

(2a) Spin the **outside wheel** to choose one category (e.g. Guide)
(2b) Press the **central key** to confirm , and the whole interface will fan out
(2c) Spin the **outside wheel** again to see different programs in a timeline
(2d) Use the **inside wheel** to jump from different channels

. .

 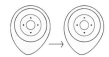

(3a) Double press the **central key** to exit to the previous layer
(3b) Double press the **central key** again to totally clear the menu

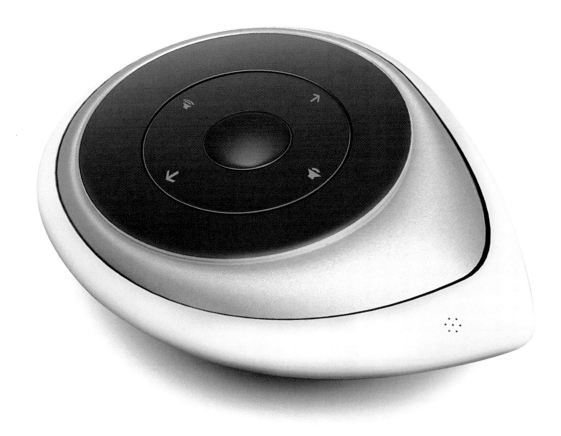

APEX
Backpacking Stove

Jimmy Page

Legs adjust for level
ground anywhere

Benefits

APEX is a backpacking stove that helps address current problems that users have while in the wilderness. Not only to meet the users needs but to create an enjoyable experience. APEX is extremely versatile, durable and is able to adapt to any terrain when needed. This allows the user to have a hassle free and safe cooking experience.

Compact for easy storage

Pot Design

Double walled for insulation and protection from heat

Weather Resistance

Dove tail protects flame from cross winds and weather

Gas Lever

Lift up & down to increase or decrease gas flow

Flint Striker

Press to one side & release for strike

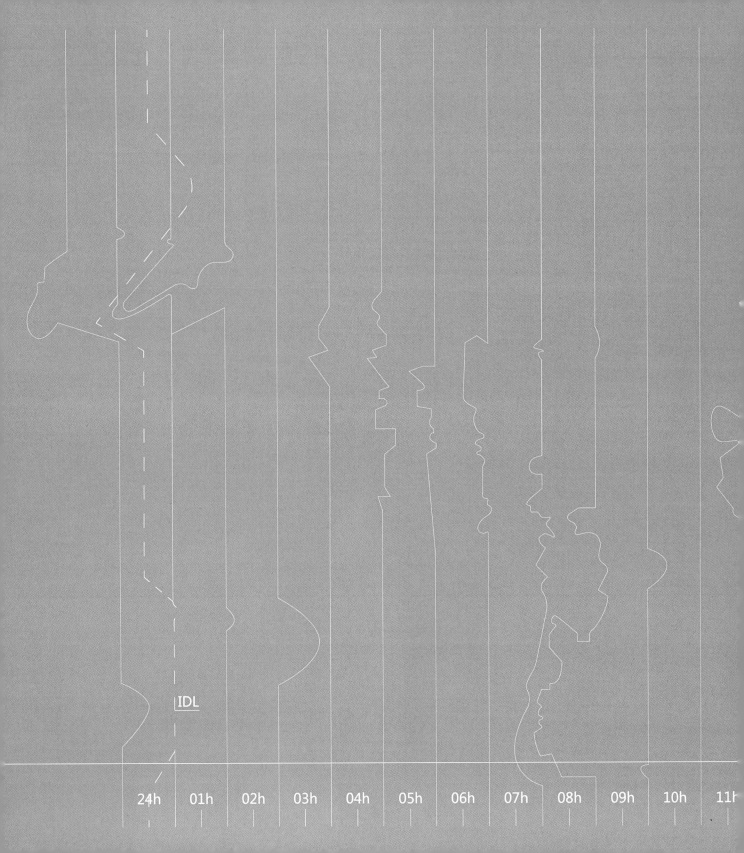

IDL

24h 01h 02h 03h 04h 05h 06h 07h 08h 09h 10h 11h

Coventry University
[英国] 考文垂大学

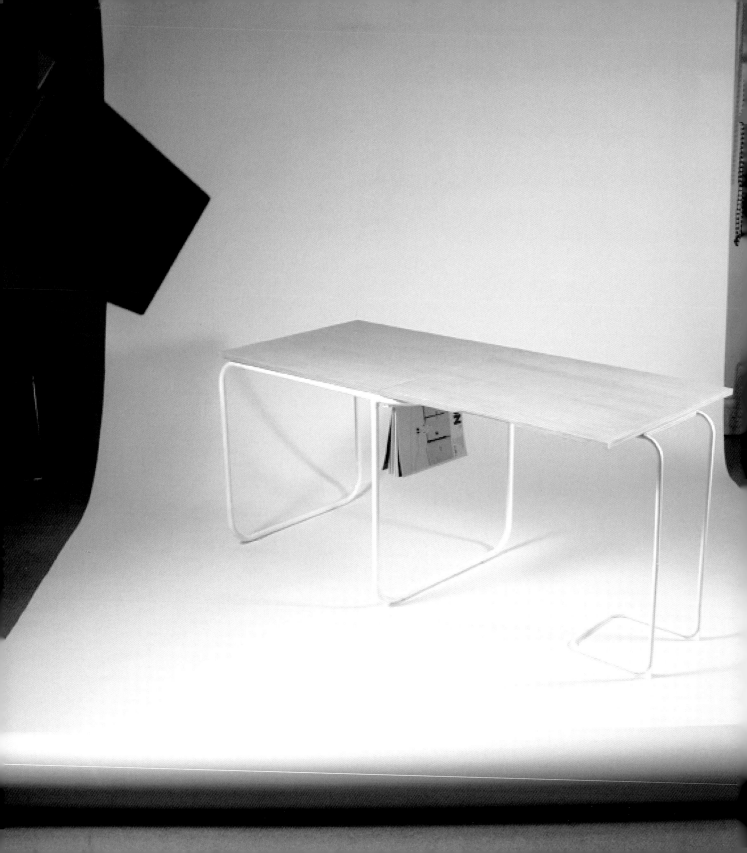

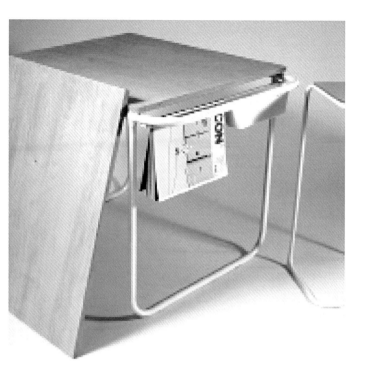

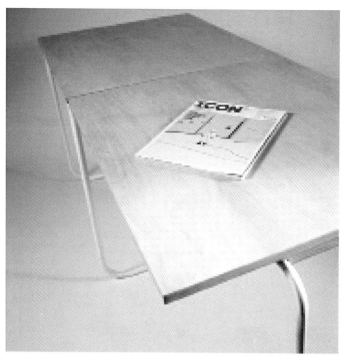

Larger single-purpose pieces of furniture are often unsuitable for smaller living spaces. This contemporary and compact dining table for two extends to sit up to five people whilst providing an occasional coffee table, side table and extra storage; optimising space and promoting flexible living, which is often problematic in smaller houses.

Aaron Clarkson
BSc (Hons.)
Coventry University

Furniture for the Smaller Home

Secura: System for Samsonite

Christina Perkins
MDes
Coventry University

The loss or theft of valuables while travelling is an extremely common and traumatic experience. Secura is an effective universal solution, combining a range of simple product deterrants to help safeguard key valuables: the bum-bag complete with covert magnetic interlocking zippers and inner magnetic clips works alongside a retractable electromagnetic padlock and wristband key.

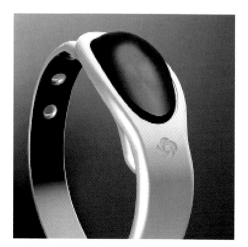

Variation: Sustainable Footwear

Dann Forrester
BA (Hons.)
Coventry University

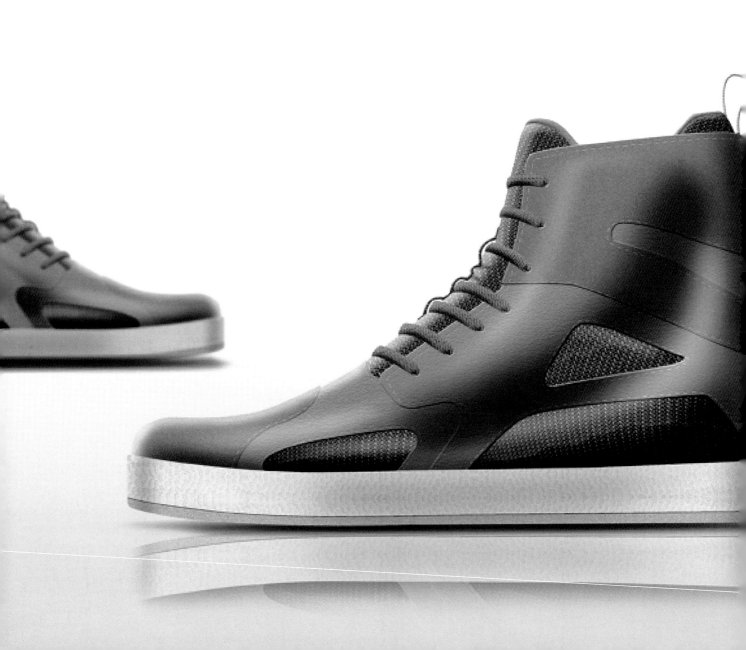

I believe it is possible for sustainable footwear to perform as well as a nonsustainable product. There are many alternative ecological materials that possess great qualities. This project aims to change the way in which users view eco-products; reacting to current trends in fashion and architecture in order to enhance aesthetic appeal.

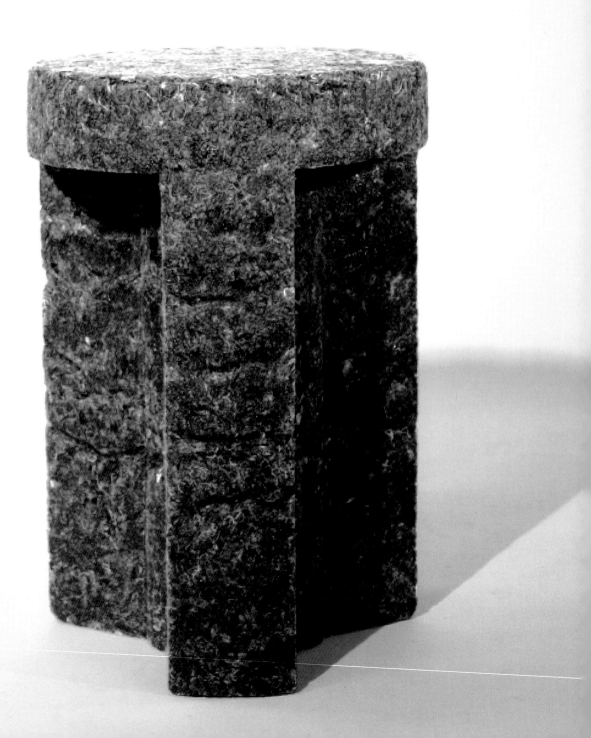

The UK throws away

6 million mattresses every year.

Rubbish Design **reuses and recovers** the material's value.

Rising landfill charges have increased the need for sustainable waste disposal methods. Vast quantities of reusable material are being disposed of with potential economic and environmental value overlooked. Rubbish Design explores how textile waste could be successfully utilised to create projects made from new composite materials.

David Riley MDes
Coventry University

Rubbish Design: Stool

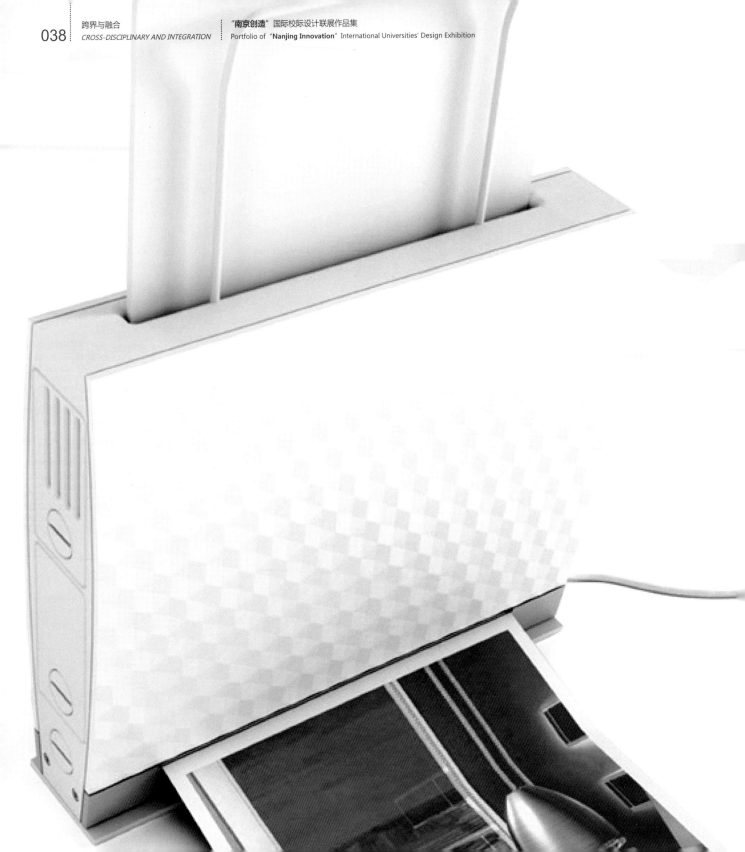

Increasing levels of legislation governing the collection, recovery and recycling of waste electrical products has been implemented in an attempt to alleviate the pressures upon precious finite resources.

This project explores the underlying social demands of electrical product ownership and means of increasing owner attachment to minimise premature disposal, using the home printer to demonstrate these design principles. Both the ink reservoirs and print heads are replaceable/upgrade-able.

Greg Chick MDes
Coventry University

Sustaining Product Relationships:Inkjet Printer

Biology to Design: Toaster for Bodum

Juste Pavasaryte
MDes
Coventry University

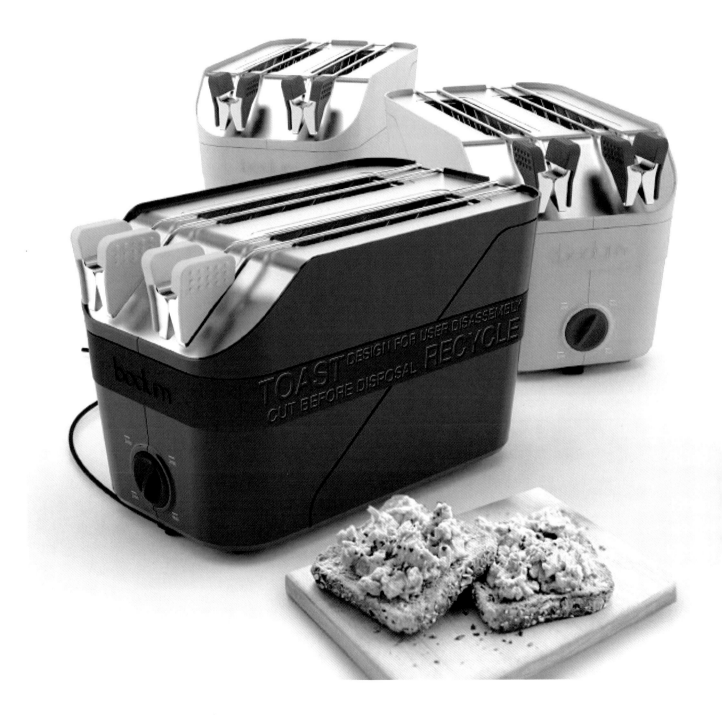

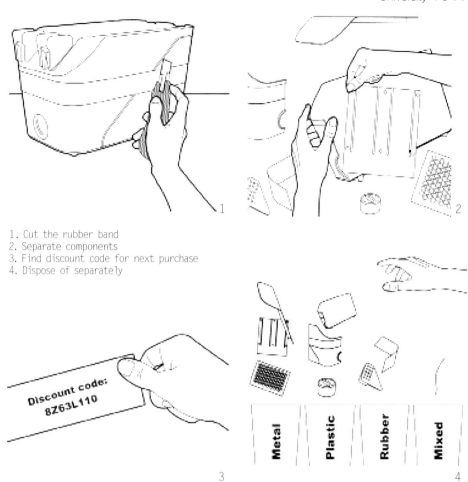

1. Cut the rubber band
2. Separate components
3. Find discount code for next purchase
4. Dispose of separately

Discount code:
8Z63L110

Metal Plastic Rubber Mixed

My research Biology to Design compared the life cycles of living organisms and products, analysed consumer patterns and provided creative approaches to sustainability inspired by nature. Component materials must be separable in order for a product to be truly recyclable. I have redesigned the toaster to illustrate how these features can be achieved in product design.

Hive: Footwear for New Balance

Madison Curzon
BA (Hons.)
Coventry University

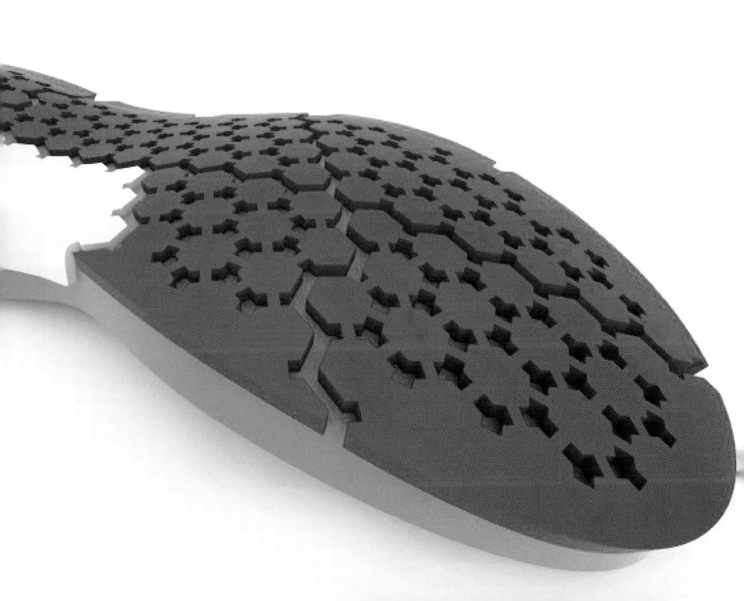

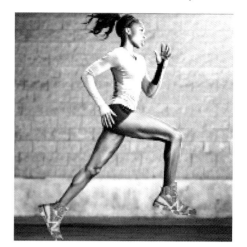

Fashionable yet functional footwear, designed to prevent ankle sprains in female netball and basketball players. The product is supportive and comfortable, offering compliance in the form of an adaptable high-top. The sole has been specifically engineered to offer impact protection as well as aiding a controlled landing for optimum stability.

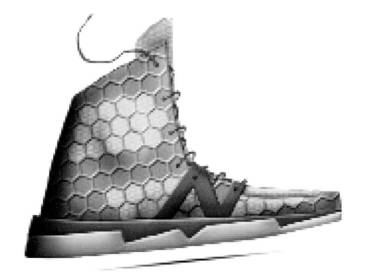

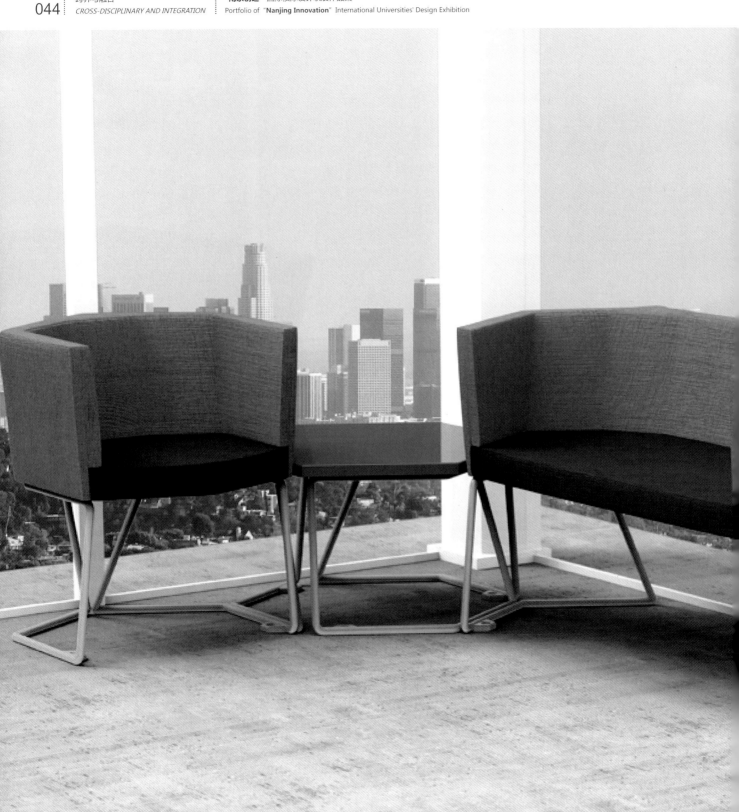

The current waiting experience at airports leaves much to be desired. Providing a socially comfortable area can make all the difference. I have designed a flexible seating system that decreases conflict between passengers, eases anxiety and encourages 100% passenger occupancy of seats.

Tom Jacobs MDes
Coventry University

T1: Hexagonal Seating System

New Automotive DNA

Alex Siamatas

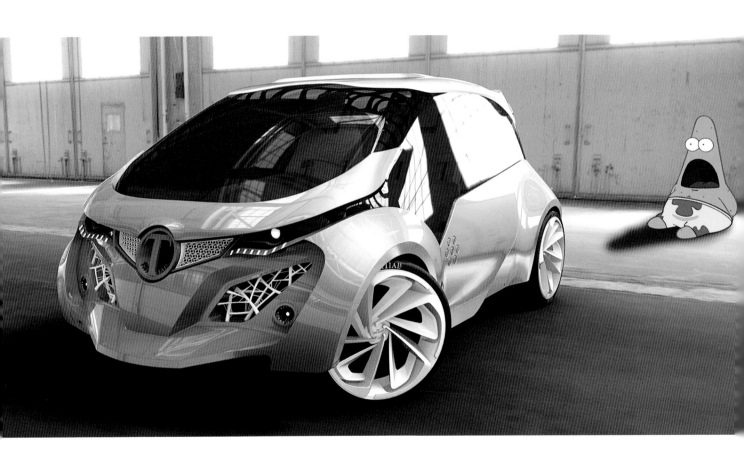

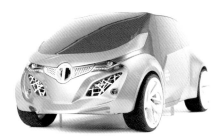

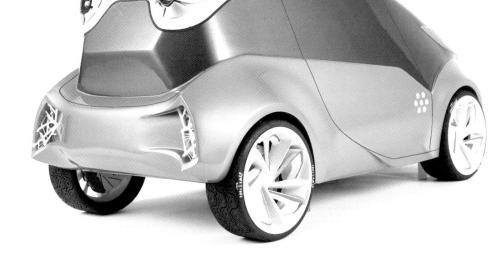

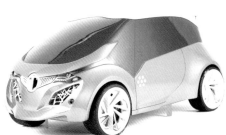

Nobody thinks of an iPhone as a miniature telephone box, equally nobody should believe an electric vehicle is a dull transportation device. Therefore, I designed a fun, intelligent vehicle that uses feedback from early adopters and raises the expectations for regular electric car drivers, through a new automotive DNA.

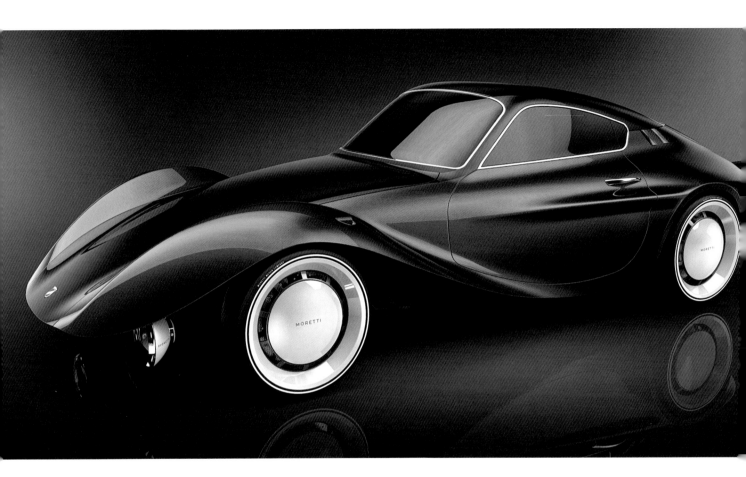

In no field more than in the design of automobiles is the Italian genius for sensual pleasure better manifested. Moretti EGS is the reinterpretation of 1954 Moretti 750 Grand Sport and is the result of a deep research into the human-machine relationship on a visceral level.

Emotions of Italy

Brian Males Moretti

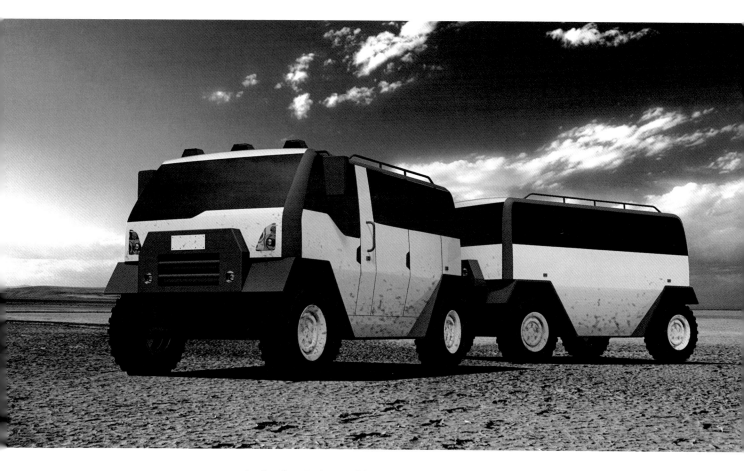

As the threat of natural hazards increase, there is greater demand for vehicles with superior reliability and efficiency. Gemini is a multi unit vehicle that can be deployed by aircraft, delivering various aid facilities depending on what is required. All terrain and amphibious capabilities allow it to access remote areas.

Chris Manuel

Emergency Aid Transportation Vehicles

Rural Delivery Vehicle

James Bedding

A compact delivery vehicle for rural communities, which can deliver a variety of goods including parcels and fresh produce. The vehicle uses automated technologies to move between destinations which are close to one another without its driver, aiding the driver in avoiding collisions and improving the efficiency of current systems.

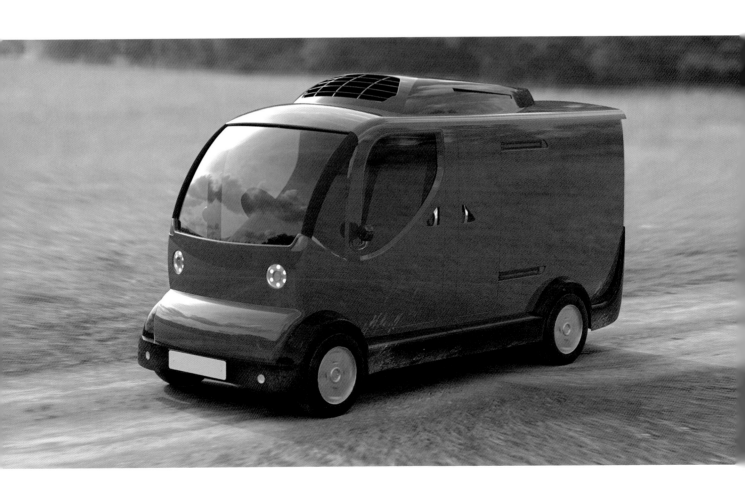

Emotionally Enriching Public Transport

Lewis Earl

The design of public transport traditionally focuses on efficiency, leading to a low uptake by discretionary customers. Rather than competing directly with the convenience and privacy-based emotional experiences of the car, this project seeks to redefine public transport as a mobile public space for emotionally and socially-enriching experiences.

450X Motor Yacht

Stefan Monro Rolls

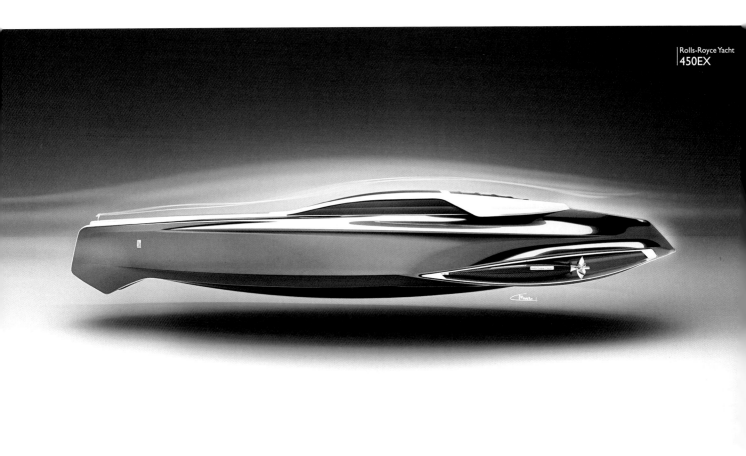

Rolls-Royce Yacht
450EX

The project aimed to address the issue of value within the luxury yacht market, it demonstrates the potential and appeal for automotive brands to exploit automotive styling and technologies in a contrasting industrial design sector. The design provides the exclusivity and appeal of a luxury yacht with the artistry, subtlety and technology of Rolls-Royce.

Reebok International
MODCON

Nick Abrams

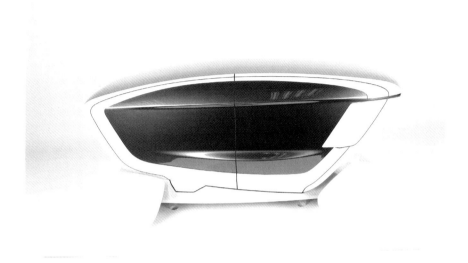

Transportation as a modern convenience. An investigative project looking at the future of publically shared urban vehicles. Redefining perceptions of the car, its usage system and it's role within the environment and society.

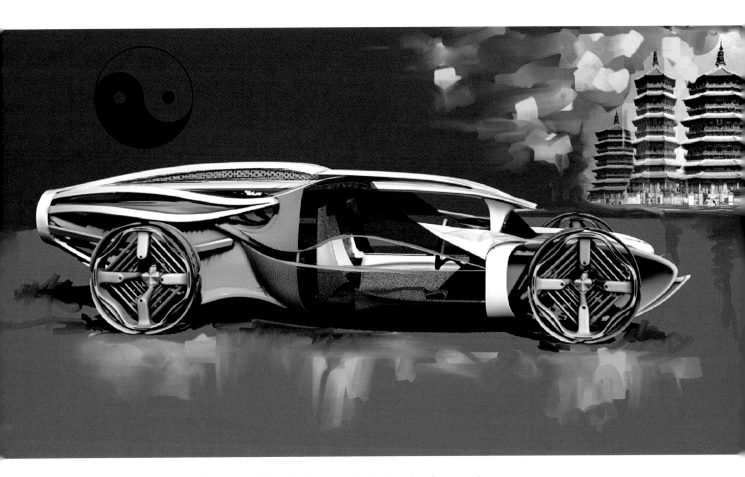

Supercars go too fast for the public roads and the only place to enjoy their real performance is on the track, so why do people still buy supercars and not track cars? The main reason is class, prestige and status. Looking at the recent history of supercars there has been a lack of design innovation and drama as they all seem to be the same with slightly newer bodies and up-to-date technologies.

New Direction for Supercars

Sepehr Amirseyedi

A culture exists in which both consumers and manufacturers have become accustomed to discarding products that still function. Although recycling has become commonplace within modern culture, the underlying issue is the needless replacement of still-functioning products especially motor vehicles. Investigating alternative ways of extending a product's lifespan may help resolve this issue.

Tom Broadbent

Car Interior for Emotional Attachment

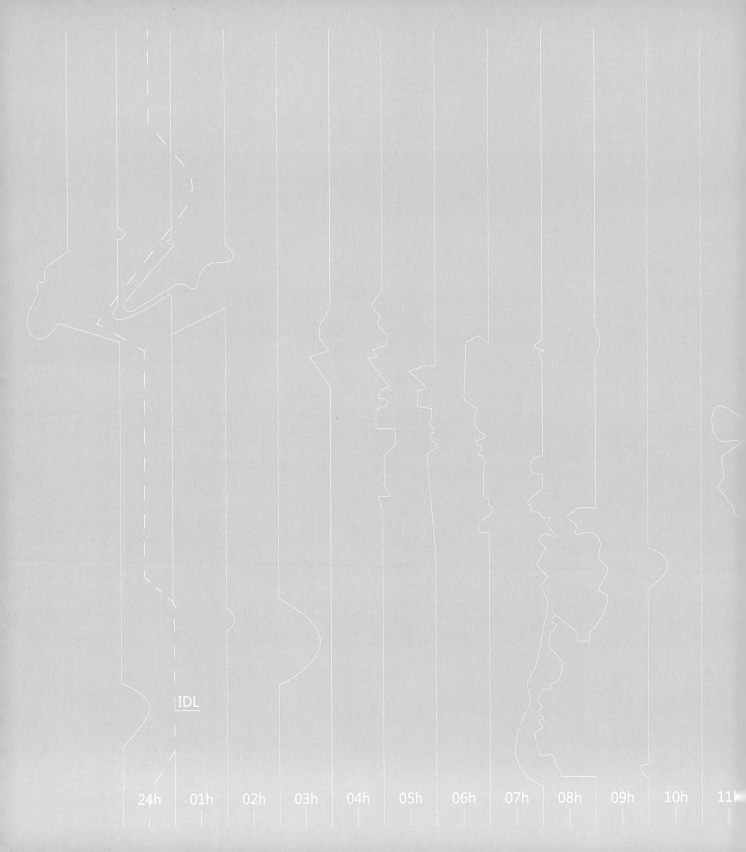

IDL

24h 01h 02h 03h 04h 05h 06h 07h 08h 09h 10h 11h

h_da
HOCHSCHULE DARMSTADT
UNIVERSITY OF APPLIED SCIENCES

Hochschule Darmstadt University of Applied Sciences

[德国] 达姆施塔特应用科学大学

GMT

IDL

Electric Vehicle Velcura

Dennis Redmonds

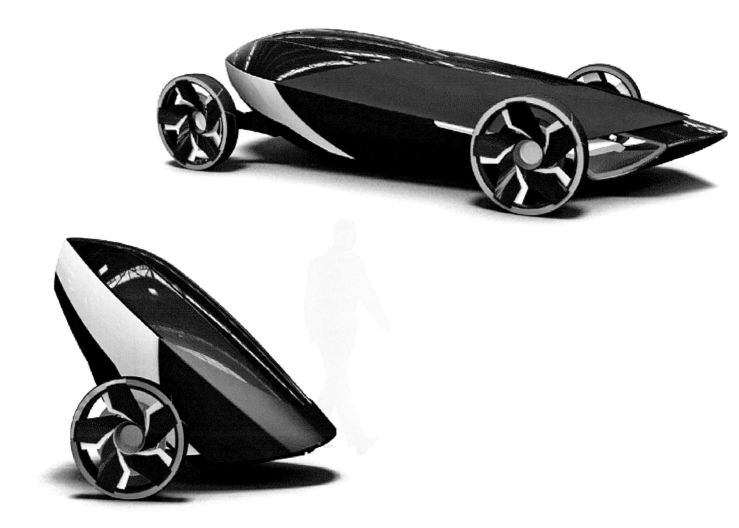

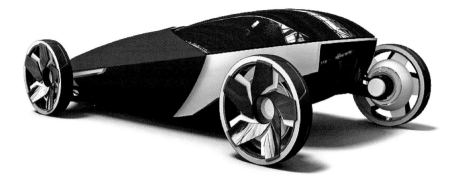

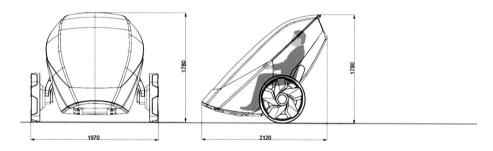

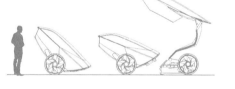

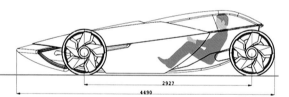

The vehicle consists of a Segway module (inner city), which has room for two passengers, and a front module (long distance capability) with a foldable solar panel which raises up while stationary,thereby creating the largest-possible solar surface area.The focus of this study is the issue of how to emotionalize the technological aspects of electromobility.

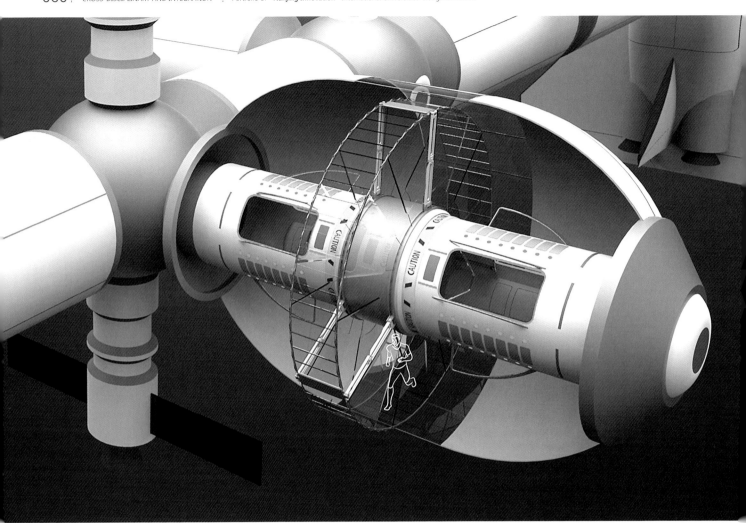

WiSS (Walking in Space System)

Sebastian Oettler

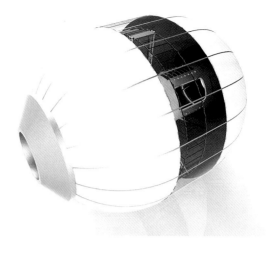

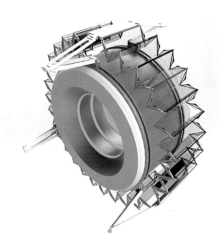

The WiSS is a modular wheel module.By utilizing the centrifugal force it creates a simulated gravity that eliminates the degeneration of muscles and skeletal apparatus in space. Current problems of astronauts on their return to earth are poor muscle strength, dizziness and balance disorders.For longer expeditions, it is important to have a training program. This task could be done by the WiSS.

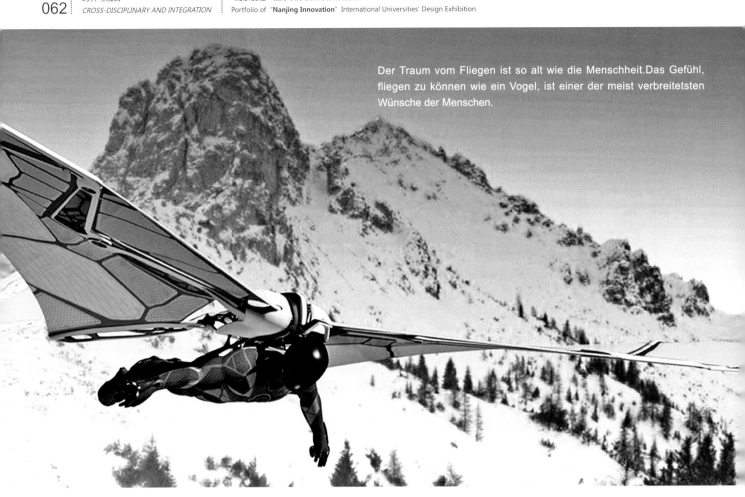

Der Traum vom Fliegen ist so alt wie die Menschheit.Das Gefühl, fliegen zu können wie ein Vogel, ist einer der meist verbreitetsten Wünsche der Menschen.

Exogen-Milan Aircraft

Johannes Rasche

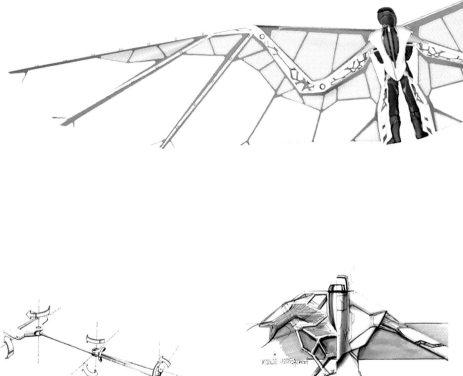

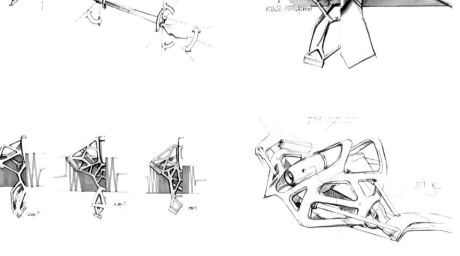

Milan is an ornithopter study (wing-flapping apparatus) that builds on a material feasibility study. The construction based on an exoskeleton cites the future possibilities and options that nanotubes technology has to offer. The systematic combination of lightweight design, modern materials, and an effective energy supply will enable one of mankind's oldest dreams: to fly like an eagle.

Emergency Airdrop

Adrienne Frizsch

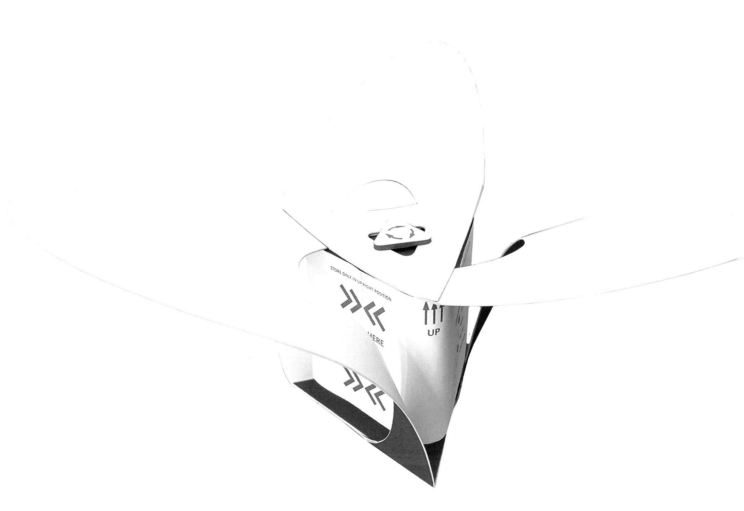

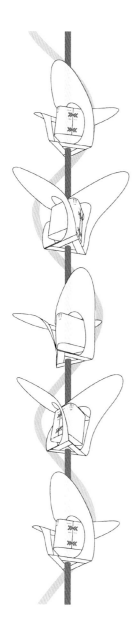

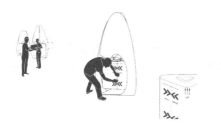

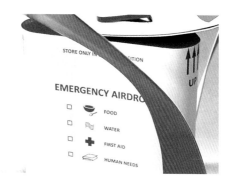

High loss rates are accepted and taken into account. The budget for expensive parachute systems is only available in the military.Fast direct help without restrictions is not assured. But how can people in need be provided and supplied quickly and inexpensively? Nature covers the inspiration. Many plant seeds use the ability of the passive flight to transport their important asset. Maple seeds, for instance, concentrate the biggest part of their mass in a compact core and only a slight wing allows the aesthetic rotational descent. The air resistance is utilized to the maximum and the rate of descent is minimal. This principle is the key to the development of the Emergency Airdrop.

Development

With contact to the German and American army and humanitarian aid organizations worldwide, I came to important background information regard to air-relief operations, workflow, costs, and the loss of goods. The simpler the system, the faster it can be operated by volunteers and reach people in need—another important principle and claim of the whole system and idea. Due to many case studies using the bionic and physical inspiration I realized that a three-winged system has the most stable flight. The twisting of the wings causes more lift and

slows down the flight. Attracted to the aspect of transformation I worked with numerous of models to find the perfect residual stress for the self-supporting winged-system. Just by loading and unloading the center, the wings tilt up and down. This transformation and the ability of the passive flight ensure a fast predictable relief operation and increase the assistance for people in disaster areas.

Function

Emergency Airdrop is an auto-rotating system for delivery all kinds of relief supplies to reach people in disaster areas. It provides a predictable cost-efficient relief based on a more efficient transport. Emergency Airdrop is composed of two elements, a cargo-container and a threewinged-system. When the container gets connected to the winged-system the wings tilt up, due to the force applied to the wings center. Emergency Airdrop is now ready for shipping. Inside the air freighter the triangular shape ensures optimal space utilization. As a result more than 33% additional goods can be carried in each plane. After release the wings spread out, use the drag and start to rotate immediately. The passive rotation flight and a double bottom cushion the impact of landing and provide for delivery fragile goods. With symbols and color scheme, distribution of goods is easier in the disaster area. The recyclable waxed carton, pattern and construction allow a cost-effective production.

Inspiration

In case of emergency, when rescue workers are not able to reach people in need via land or sea, boxes with humanitarian aid supplies are dropped from planes without parachutes because the flightoperation-costs are enormous.

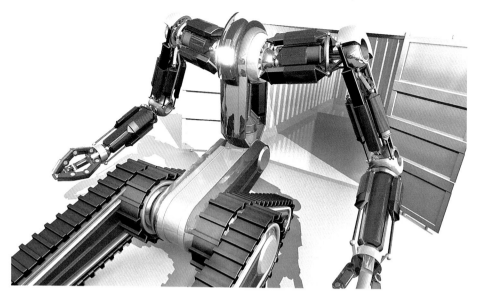

This device connects the human reason with the power of machines. The target was to achieve maximum intuitive handling by leaning the design to the human body. The human user prescribes through his motions the action which has to be performed—the device reacts analogical. Vice versa he gets feedback about information collected by the sensors. Due to this, the operator is able to interact with "super human" forces by telecomanding the machine even in highly dangerous environments.

Robert Toroczkay

Bergungsroboter 2030
A Human Controlled Machine

Identity of Embodiment

Christian Schrepfer

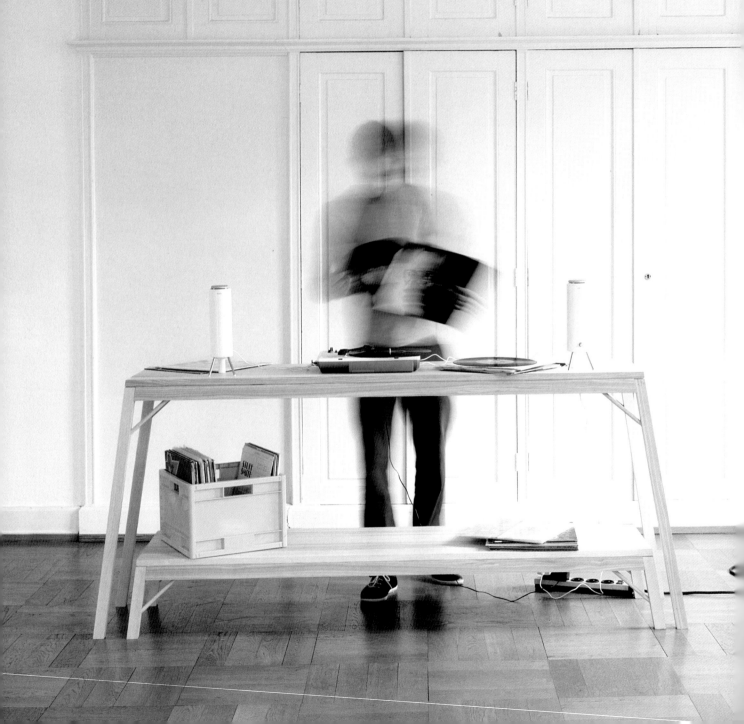

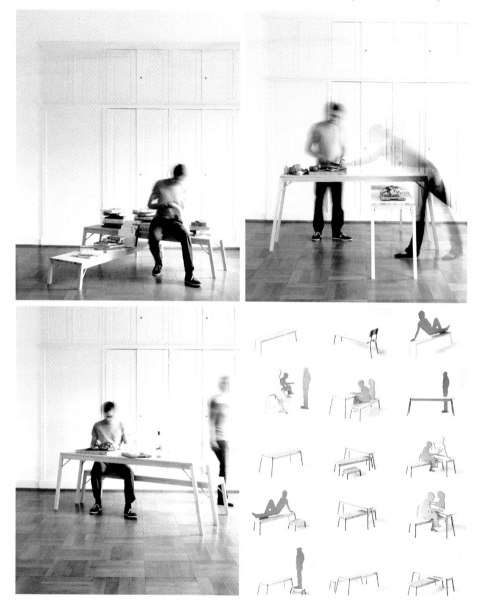

Kiwari—a Bench on Four Levels

Kiwari is a furniture system in which the height of pieces can be varied by simply switching the legs around, accommodating several different types and heights of furniture: bench, table, footstool and bistro table heights. The L-shaped legs are firmly attached to the underside of the table by wedges, that are released by a light hammer tap. To alter its form, the legs are swivelled by 90° and slotted back in again from the table end. A second tap and they are firmly wedged-in again. The entire table is constructed of ash wood, wholly without the use of screws or sundry metal parts.

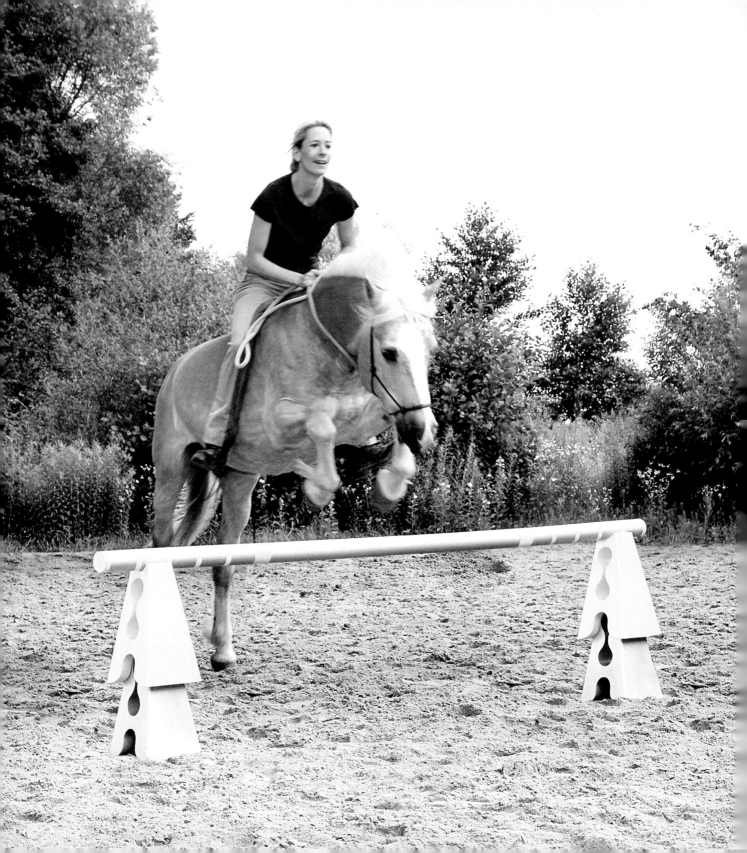

Training and Course Segments for Horse Riding

Britta Schlegelmilch

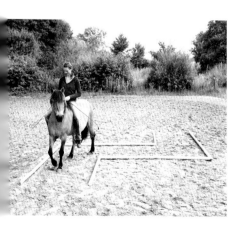

The design optimises the use of each part, thus reducing the number of overall parts required—while also increasing the system's range of uses. The design's handiness makes setting or clearing up a simple task, while they also have a visually "calming" effect on the training grounds. Additional elements required for different types of ground work exercises, such as gates and water ditches, could be designed and integrated in a second stage of development.

Simplicity

Christen Halter

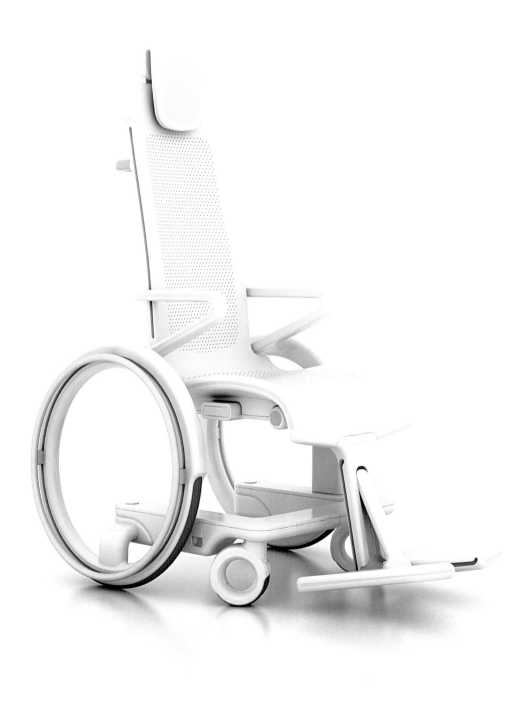

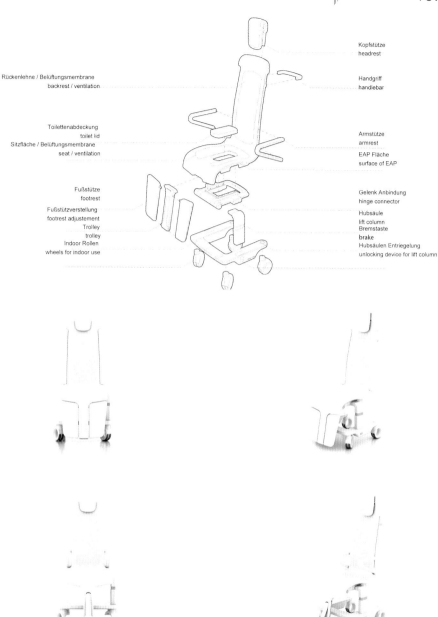

Rückenlehne / Belüftungsmembrane
backrest / ventilation

Toilettenabdeckung
toilet lid
Sitzfläche / Belüftungsmembrane
seat / ventilation

Fußstütze
footrest

Fußstützverstellung
footrest adjustement
Trolley
trolley
Indoor Rollen
wheels for indoor use

Kopfstütze
headrest

Handgriff
handlebar

Armstütze
armrest

EAP Fläche
surface of EAP

Gelenk Anbindung
hinge connector

Hubsäule
lift column
Bremstaste
brake
Hubsäulen Entriegelung
unlocking device for lift column

The stair lift itself is not fitted with a seat. Once the patient's trolley has docked onto it sideways, the seat, including the patient, is transferred from one unit to the other and the trolley removed. The stair lift is operated via a remote control unit. This controls all of the modules, which are identified via universal ports. Settings are programmed via the touchscreen and the current settings displayed on screen.

Artificial Limbs

Tillmann Beuscher

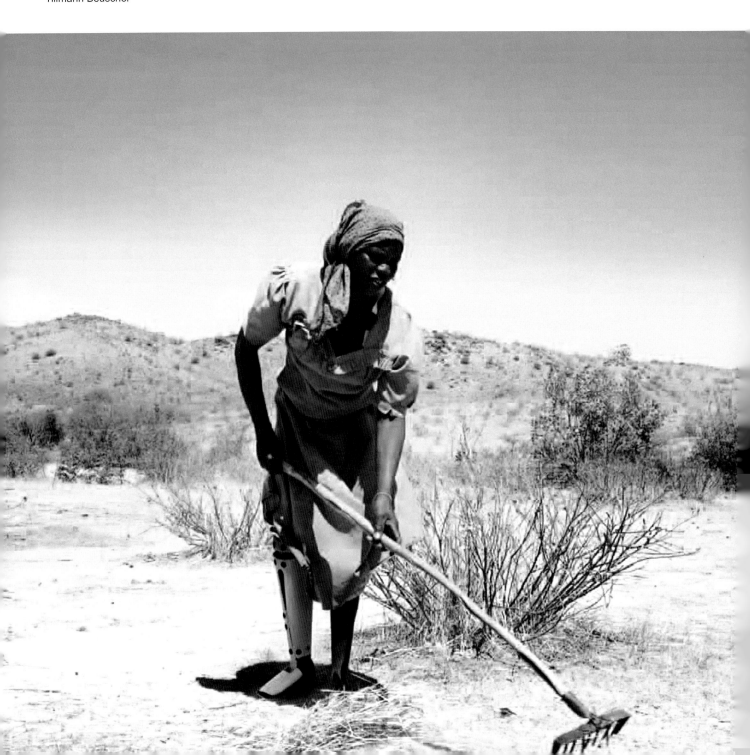

1 Prothesenschaft
 Prosthesis shaft

2 Konus Abwicklung
 Conical binding

3 Fussteil oben
 Upper leg part

4 Fussteil unten
 Lower leg part

5 Dämpfungsgurt Aufnahme
 Absorbing belt attachment

6 Dämpfungsgurt
 Absorbing belt

7 Bolzenschraube
 Machine bolt

8 Niete 1/14
 Rivet 1/14

9 Gurtschnalle
 Belt buckle

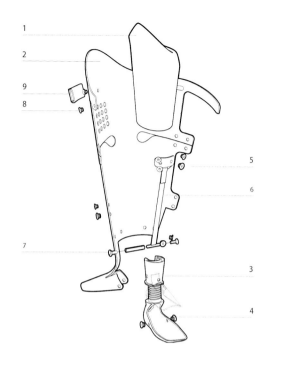

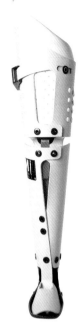

The prosthesis is designed to be used independently from cultural circumstances.

It is easy to use, self-adjustable for wearers and inexpensive to produce. It therefore fulfils its primary goal as a pragmatic first-aid type treatment for victims of land-mines and other explosive remnants of war. Its all-round flexibility helps to mitigate commonplace barriers in its field, and also facilitates a smooth transition to the use of a permanent prosthesis. The design focuses on an issue of great import: the psychological disorders that land-mine victims are so often tormented by—on top of their physical injuries—and the social isolation these disorders generally usher in.

IDL

24h 01h 02h 03h 04h 05h 06h 07h 08h 09h 10h 11h

Auburn University
[美国] 奥本大学

GMT

IDL

13h 14h 15h 16h 17h 18h 19h 20h 21h 22h 23h 24h

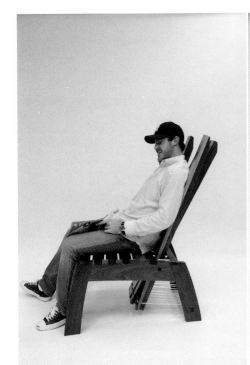

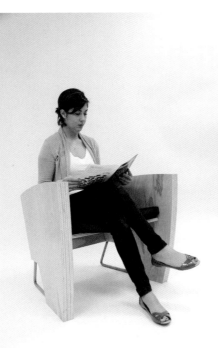

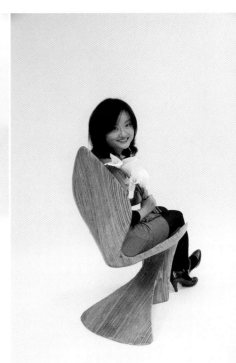

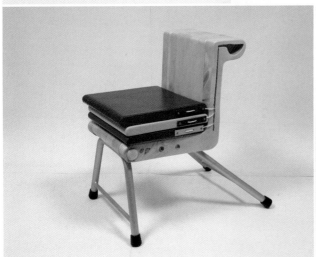

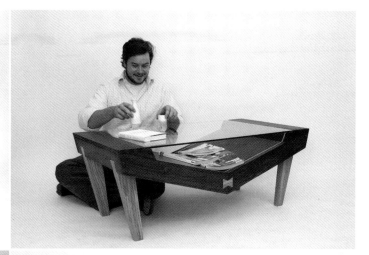

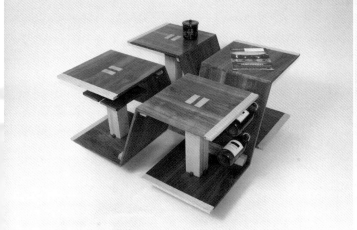

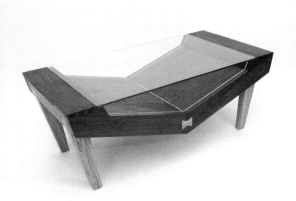

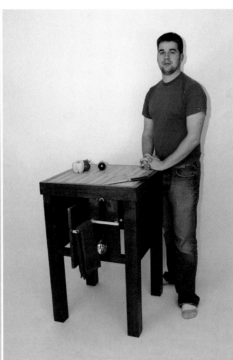

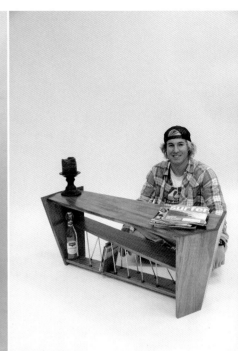

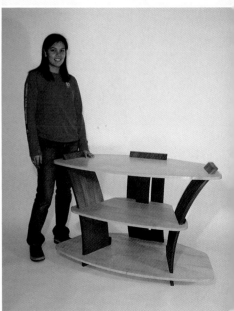

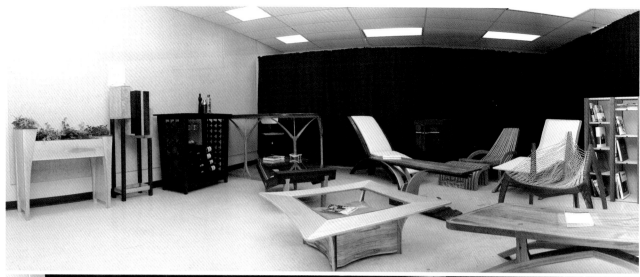

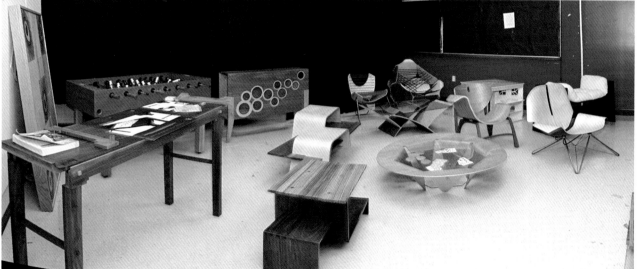

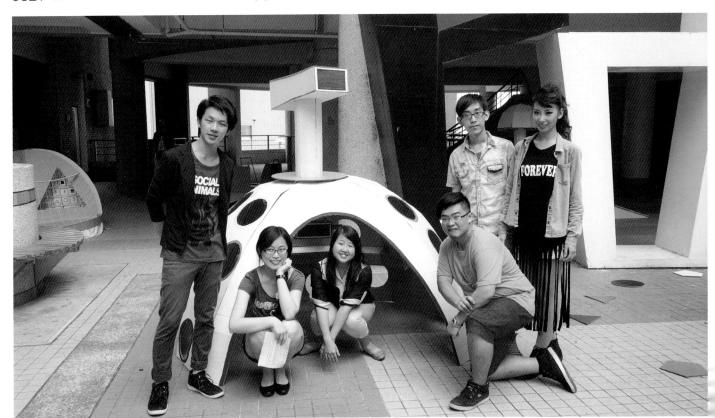

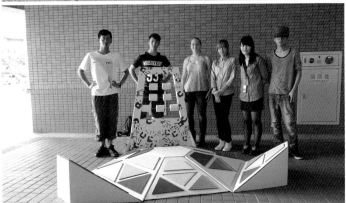

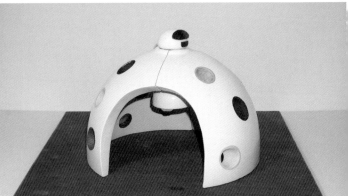

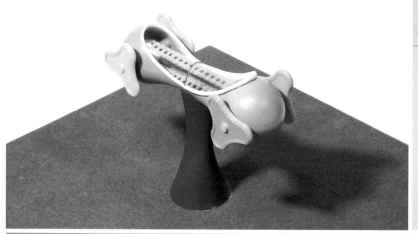

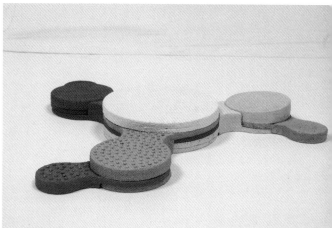

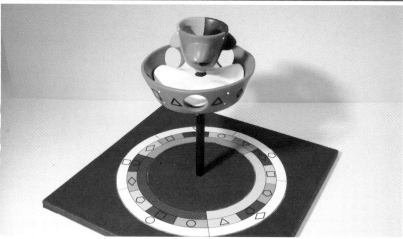

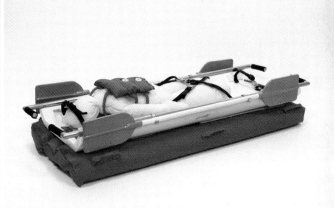

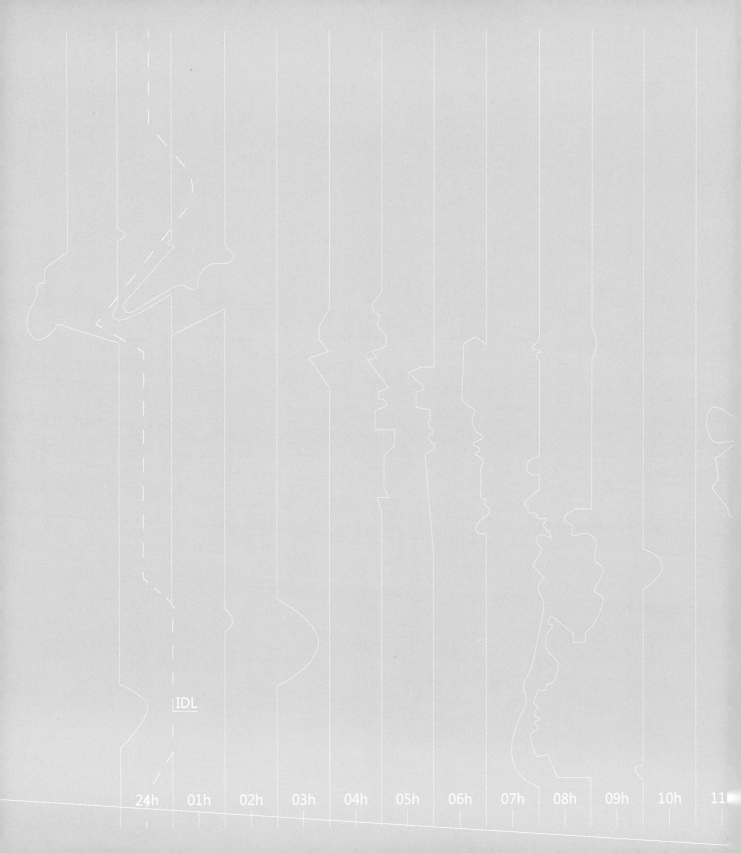

IDL

24h 01h 02h 03h 04h 05h 06h 07h 08h 09h 10h 11

National University of Singapore

[新加坡] 新加坡国立大学

Blindspot

Selene Chew
Coventry University

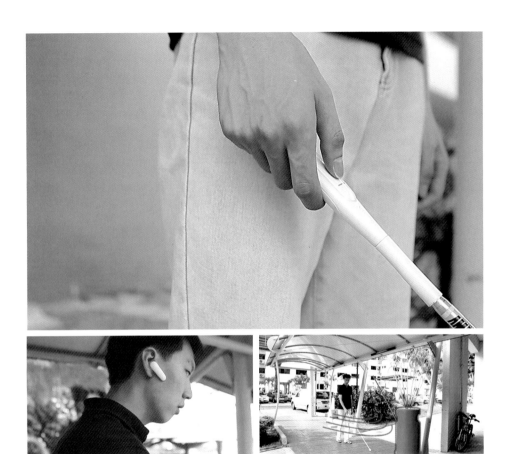

Expand the Social Horizon of Visually Handicapped

The Blindspot concept comprises a white cane with a built-in mobile phone, ultrasound sensor and tactile navigator. The system can detect objects to steer the user around obstacles. It also spots friends in the vicinity by alerting the user whenever friends check in nearby via geolocation services such as Foursquare. The navigation interface helps guide the user to meet them, thus addressing their social needs.

Fil'O

Liow Wei Ting

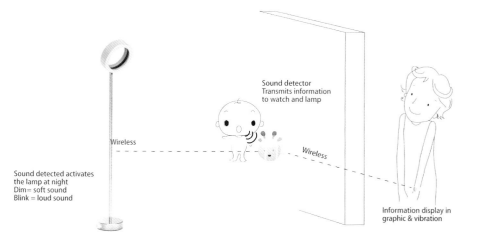

Sound detector
Transmits information
to watch and lamp

Wireless

Wireless

Sound detected activates
the lamp at night
Dim= soft sound
Blink = loud sound

Information display in
graphic & vibration

A Watch for Deaf Parents that not only Tells Time

Fil'o is a domestic parenting aid for deaf parents with hearing children that helps in communication within the home environment. It is a concept that comprises of three familiar items. A watch for deaf parents that not only tells time, but also informs about their children as well. It alerts parents by sending out vibrations and graphics based on the sound received by the device in the child's toy.

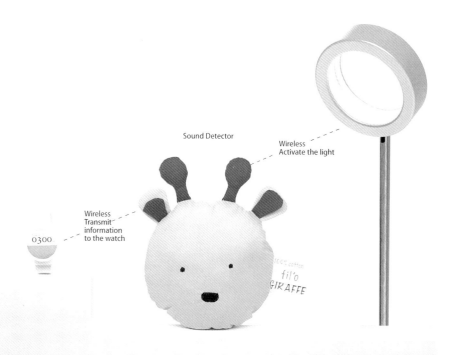

Sound Detector

Wireless
Activate the light

Wireless
Transmit
information
to the watch

0300

100% cotton
fil'o
GIRAFFE

Information display in
graphic & vibration

a soft toy that is close to the child
which to receive the sound of the child

dim/blink light lights up,
at night when sound detected
if reached a certain sound level

Rock on

Liren Tan

Interactive Rocking Chair—Rock On is an interactive rocking chair with an interchangeable activity boards designed for special needs children with Attention Deficit Hyperactivity Disorder(ADHD), who constantly needs to seek vestibular stimulations in a classroom context. Rock On seeks to redesign the off-task area in a special needs classroom through a series of fun looking rockers with different activity boards to keep these students calm and engaged.

Active Learning

Interchangeable Boards

Sit and Rock to Modulate

Feel the Textured Alphabet

Activity Board: Learning Alphabets

Press to Hear Alphabet

ReAble

Roger Yeo Wei Ming
Coventry University

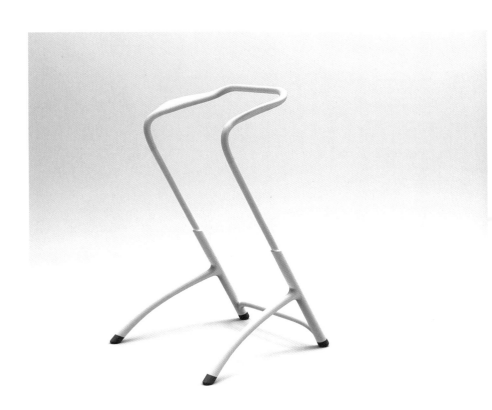

Achieving Active Independent Living

ReAble, a mobility aid built to help the elderly live active and independent lives. The walking frame has an enhanced grip and a twist-lock feature that folds the frame for portability. Roger Yeo Wei Ming, a National University of Singapore graduate, designed ReAble for his grandmother. He said:"Seeing her struggle with everyday activities such as walking,inspired me to design ReAble. Since she started using the walking frame, she has become more active and happier too!"

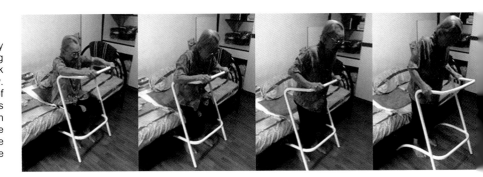

Try Box

Felix Austin, Por Min Yi

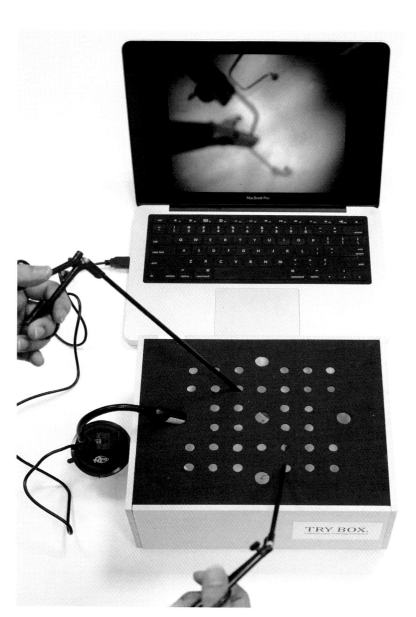

A Low-cost, High-realism Laparoscopy Simulator

Despite an increasing technological improvement in the area of surgery, many surgeons still rely on the most simple but effective tool to practise basic skills of laparoscopy such as suturing, hand-eye coordination and depth perception. Although such tools are widely available, there is a need for an upgrade to meet the expectations of a newer breed of surgeons who grew up with computer games. Try Box is an intermediate version of a laparoscopic training simulator that incorporates multi-port insertion, coordination training with a partner and a realistic experience, yet portable and low in cost.

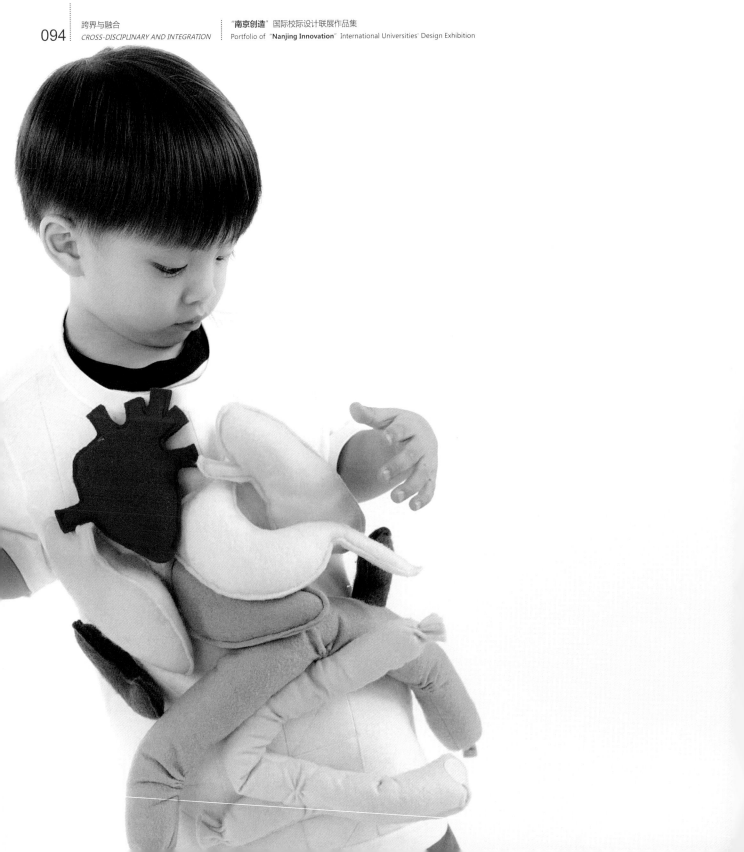

ZIGZIG was inspired by how we as children, or even adults, are fascinated by using our own bodies as an instrument or a platform for play. Targeting children ages 3~8, where pretend play and construction play are instrumental in their development, ZIGZIG aims to foster creativity through uninterrupted free play that allows children to play on the go.

ZIGZIG consists of two components, a shirt and a series of soft toys specifically designed to stimulate different scenes and play experiences. These components are stored in a clear transparent bag to allow for ease of play and identification. ZIGZIG can also be designed for various educational themes, such as learning more about our internal organs.

Valerie Tan, Yu Yue Yucas

ZIGZIG

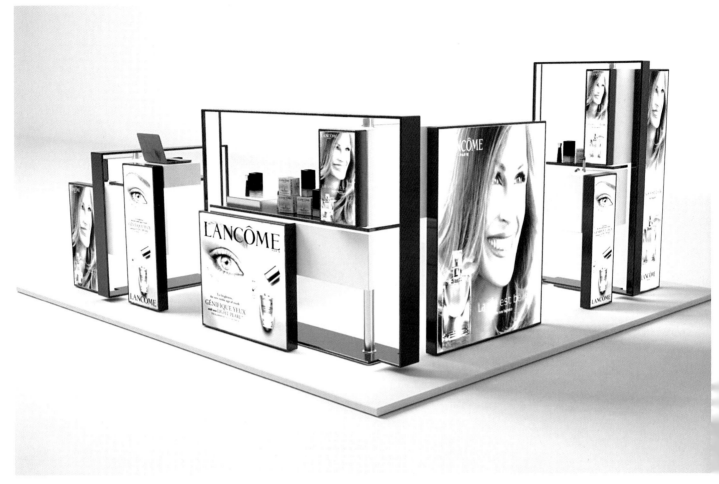

Flip

Kwek Wen Shu, Amy Chua

PRAGMATIC/ TRANSPORT

A modular retail system inspired by windows and their graceful articulation.

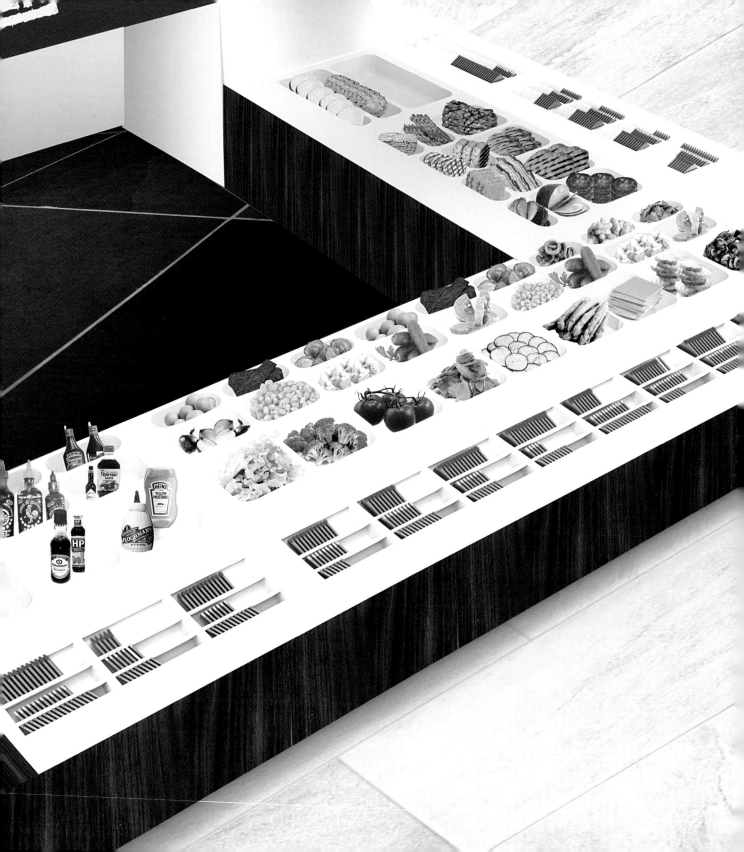

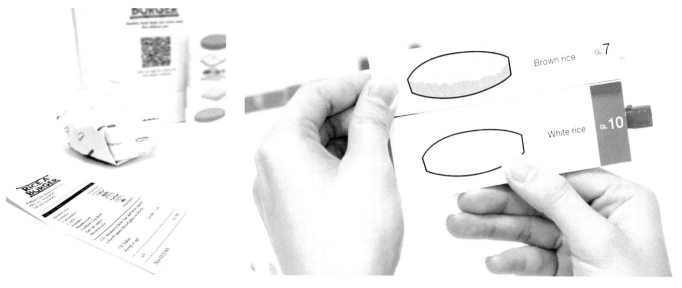

There is a common misconception that diabetes is only caused by consuming sweet food. However, is it not that simple. Diabetes is mainly caused by diet with high Glycemic Index. Staples such as white rice, white bread are actually one of the main causes of diabetes due to their high Glycemic index. Cutting down on them will greatly reduce the risk of diabetes.

The main goal of our store is to cultivate a habit of being conscious of what we eat. This concept food store introduces a new food movement to raise awareness about prediabetes and educate about Glycemic levels, then to ultimately cultivate a habit of healthy and conscious dieting.

Tan Boon Han, Yew Jing YuanYuan

RICE-A-BURGER

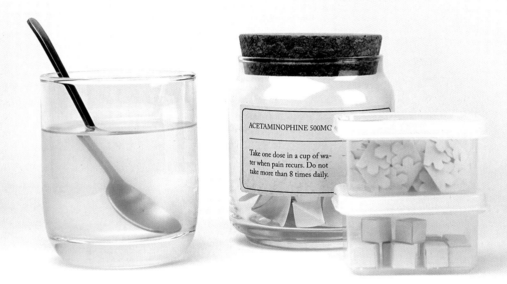

Blooms

Chan Min Yun

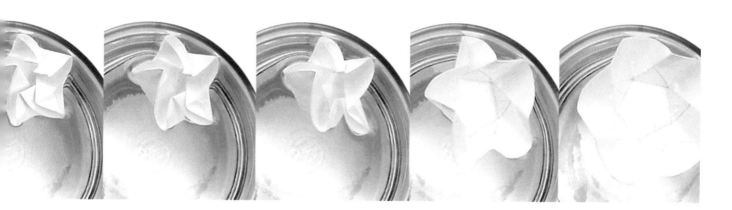

Although being able to afford medication means that one is well taken care of, the notion of medication has always been dreaded.

Three common medicines, amoxicillin (antibiotic for children), acetaminophen (menstrual relief) and paracetamol (pain relief and fever) are repackaged to bloom in water while releasing the medicine before it is consumed.

The experience of watching the blooming medicine serves as a form of emotional relief in addition to physical relief from the medication; by slowing down our pace, creating a moment to take a breather, and reflect on what we are blessed with.

Luxury is feeling blessed in the face of adversity.

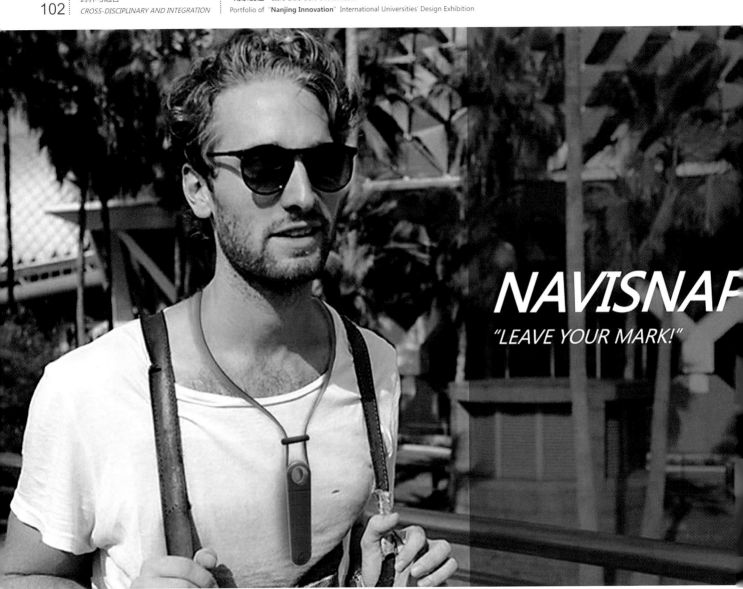

NAVISNAP

"LEAVE YOUR MARK!"

Navisnap

Eason Chow, Hwang Jie Wei

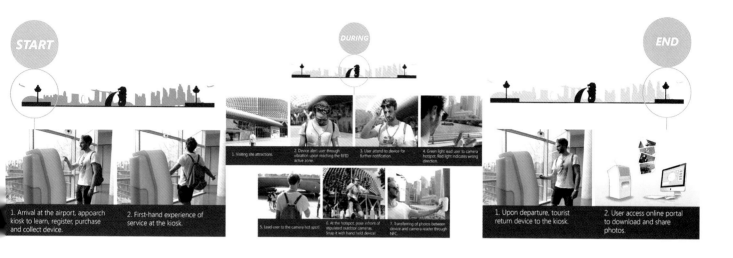

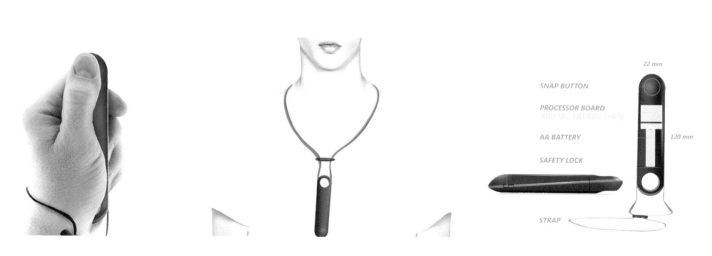

SNAP BUTTON

PROCESSOR BOARD

AA BATTERY

SAFETY LOCK

STRAP

22 mm

120 mm

A new photography experience for tourist to leave their memorable mark on various tourist attractions!

IDL

24h 01h 02h 03h 04h 05h 06h 07h 08h 09h 10h 11

**The Ohio State University
at Columbus**

[美国] 俄亥俄州立大学

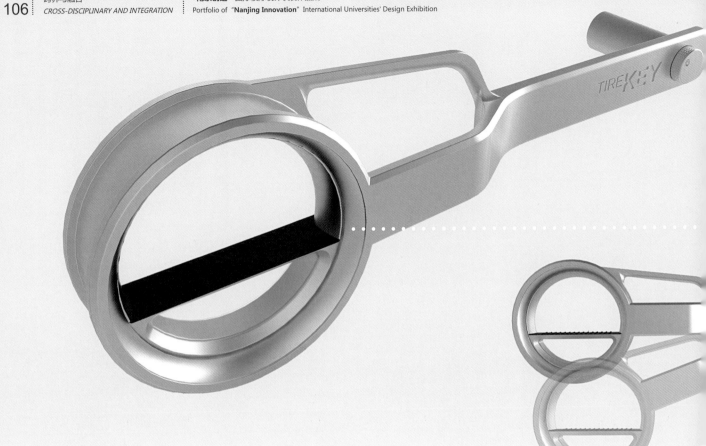

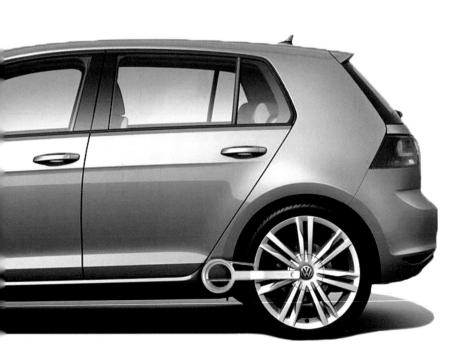

TIRE

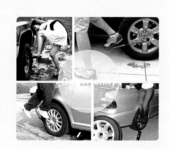

While women on average struggle with the upper body strength needed to change a flat tire, some men also have trouble successfully completing the same tasks. Research proved that the method women and men most often use to compensate are the same: standing on the lug wrench to break the lug nut free.

Two integrated handles allow for comfortable use of the lug wrench's ratcheting feature. Once the lug nut is loosened, the pinch-free foot pedal and associated bar can be used as a handle. This design is an improvement from the current lug wrench as it provides users with a comfortable place for their hands, allowing form and function to exist in tandem.

The **360° rotating foot pedal** allows the user to safely stand on the lug wrench and leverage their lower body strength as a method of successfully removing even the tightest lug nuts. The design takes any unnatural feeling away simply because it's designed to stand on. The Tire Key's foot pedal, much like a bike pedal, keeps the user's foot parallel to the ground, providing confident footing without worry of slipping off in any type of weather. Current wrenches on the market are designed with a minimal bar that doesn't take hand or foot placement into consideration.

ORBIT

Improving Dental Patient Experience

Tom Doyle

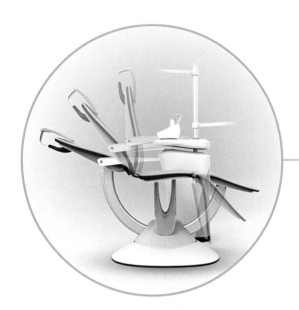

Reclining Ring

The ring acts as a structural and functional element of the chair. As the patient reclines backwards, his feet are lifted comfortably off the ground for the proper position for treatment.

1.Easy Seat Enty

2.Improved Posture for Communication

3.Increased Patient Involvemer

Pivoting Patient Sink

The sink pivots out towards the patient,
to prevent the them from leaning
over sideways.

Arm Rests

The arm rests rotate down with the
seat back to adjust to the body position
of the patient.

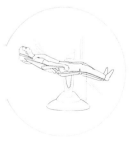

4.Easy Reclining

5.Improved Ergonomics

Research

Tension

Most patients have no clue what to do with their
hands during the procedure, and choose to fold
their hands in their laps—a sign of nervousness and
tension. It was an obvious sign of discomfort.

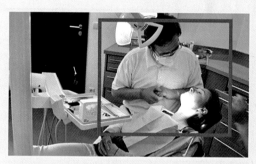

Communication

The body position dynamic between the patient
and dentist is one of dominance versus exposure—
patient is fully reclined, and has to physically look up
towards their dentist who sits over them.

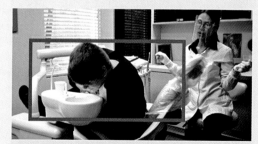

Ergonomics

The patient had to sit up and lean over to use the
spit sink. The dentist commented that this is even
more difficult when the patient is fully reclined.

USE SCENARIO

The child is sitting at the table eating their breakfast when he or she realizes that their favorite cartoon is on soon.

He or she turns to climb out of their chair down from the table and grabs their Bumble Cup.

The child clentches their Bumble Cup in their mouth to free up his or her hands to support themselves as they climb down.

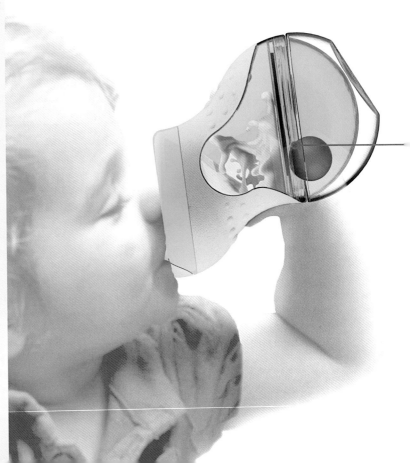

bumble cup

Protecting Your Favorite Smile

Stephen Kaes

He or she grabs onto the edges of the chair and table to support their climb while their Bumble Cup hangs from their mouth.

As the child quickly turns their head with Bumble Cup in their mouth, the weight shift of the ball bearing creates momentum that tosses the cup from their mouth.

He or she slowly turns their head to prepare to climb down with Bumble Cup in their mouth.

If the child falls while attempting to climb down from the table. The weight shift of the ball bearing creates momentum that tosses the cup from their mouth.

Bumble Cup's irregular momentum carries the cup far away from the landing zone of the fall.

Ball Cavity *that the ball bearing sits in when tipped back. Holds the ball steady while drinking.*

Lid *BPA free polypropylene. Silicone spill stopper.*

Cup piece *BPA free polypropylene. Overmolded silicone. 200 ml*

Ball bearing *whirls around to create weight shift.*

Bumble piece *BPA free polypropylene.*

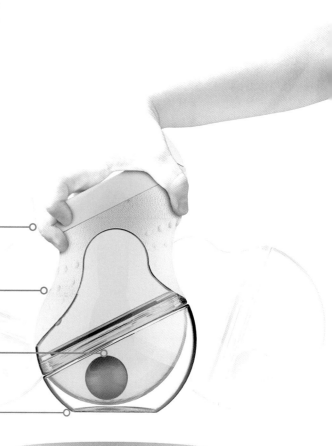

RESEARCH OVERVIEW

21% of respondents have suffered from HYPOTHERMIA. Wet clothing, dehydration, and exposure to wind increase the risk.
- layers of clothing (dry)
- fluids
- food
- insulation (heat reflecting blanket)

25% of respondents have suffered from HEAT EXHAUSTION. Resting feet up, head down is important when faced with heat exhaustion.
- liquids
- pour water on head & body
- remove excess clothing

62% of respondents have suffered from SPRAINS while out on a trip. They are quite common when hiking, anytime the ground is uneven, or boots aren't laced up properly.
- elastic (ace) bandages)
- SAM splint (malleable)

75% of respondents have suffered from MINOR CUTS & BURNS on almost every trip. Cooling and cushioning a burn within the first 30 minutes will reduce the pain and depth of the injury. Sanitizing and covering a cut will reduce the possibility of infection.
- moleskin
- medical tape
- adhesive bandages
- water
- topical antimicrobial agents

95% of respondents have suffered from BLISTERS. Blisters can form when boots are not properly fitted, or when socks get wet, lumpy, or wrinkled. It is important not to pop blisters after they have formed.
- moleskin
- medical tape, waterproof
- topical antimicrobial agents

1 After the Main car pack is opened, the smaller pack becomes visible.

2 After unzipping the pack, it lays flat on the ground. Many of the components are not visible and are crammed together.

3 On the bottom of the pack, the day pack is attached with velcro.

4 The day pack is very full and is held closed by a zipper.

60% keep their medical kit in the TOP of their pack.

17% keep their medical kit in the BOTTOM of their pack.

10% keep their medical kit in the SIDE of their pack.

13% keep their medical kit in the FRONT of their pack.

All percentages results of a survey of 45 individuals involved in mountaineering and outdoor adventures.

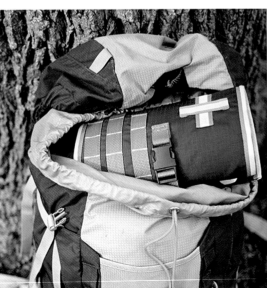

SCENARIO

1 When injury occurs, evaluate the situation and pull out med kit.

2 Undo the clasp and le

RE:ACTION

Intuitive First Aid

Kate Mansfield

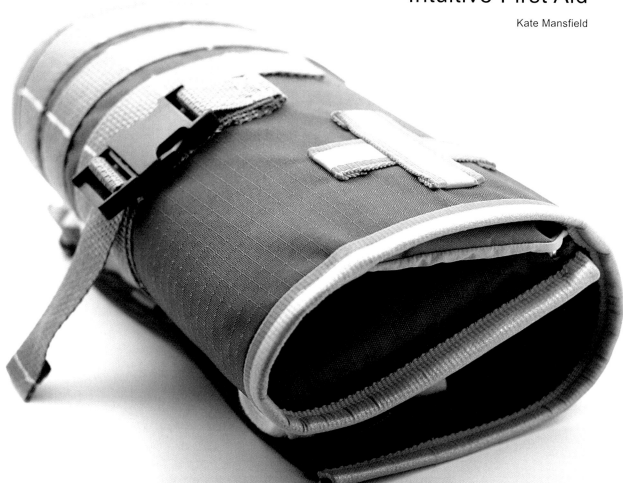

Flip the center pockets open and pick out info card that corresponds to your injury.

4 Read the card and pick out the necessary items to treat your injury.

5 Treat injury.

6 Put card back, fold pockets in.

7 Roll up and clasp med kit.

Existing Problems

Entering	Leaving

Cannot find the ticket

No time to organize things

Exceeds 1 minute, pay extra 2 hours

Emergency

Parking rate display is not user friendly (difficult to locate features)

No operators

Pay system in dark environment

Gate or pay station malfunction

Orientation to insert card is not intuitive

User forgot their wallet, cannot go thru gate

Task Analysis

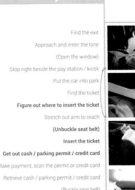

Find the exit
Approach and enter the lane
(Open the window)
Stop right beside the pay station / kiosk
Put the car into park
Find the ticket
Figure out where to insert the ticket
Stretch out arm to reach
(Unbuckle seat belt)
Insert the ticket
Get out cash / parking permit / credit card
Make payment, scan the permit or credit card
Retrieve cash / parking permit / credit card
(Buckle seat belt)
(Close the window)
Leave the lane

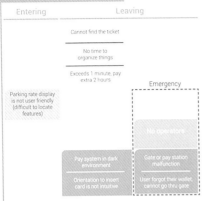

Design Opportunities

Task Analysis Find opportunities in each step

Pull the car beside the ticket dispenser
Stretch out to reach for the ticket
Pay the fee

Existing Problems Focus on specific problems

Lost tickets
Reaching distance to the interface
Confusion while making payment

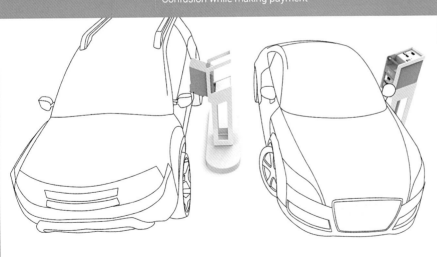

Flip Out Position

For larger vehicles, the user flips the module forward and uses the upper interface.

Normal Position

For mid-size vehicles, the user interacts with the lower interface.

Gas Station Facilities

Sheldon Shi

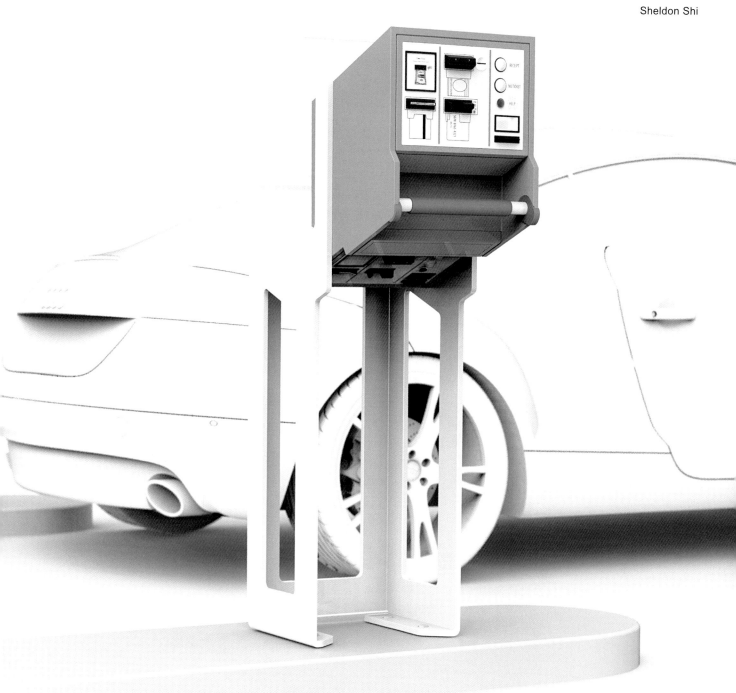

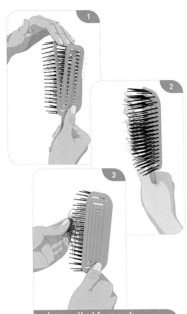

when pulled forward...

the gradual elevation of frames loosen the trapped hair for hassle free removal.

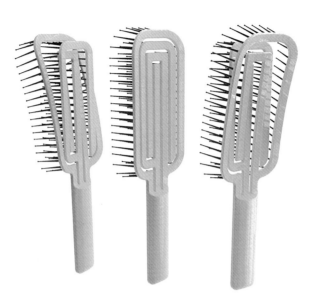

The brush head is essentially constructed in two parts which are intermingled in a maze pattern: the void and the structural frames. The void is in between the structural frames that are fixed at the handle area but free at the other end. This configuration triggers flexibility and subsequently allows users to bend the brush head with a pull of a fingertip.

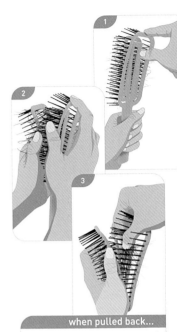

when pulled back...

frames flare out in multiple layers, initiating accessible gaps to clean trapped hair between the bristles.

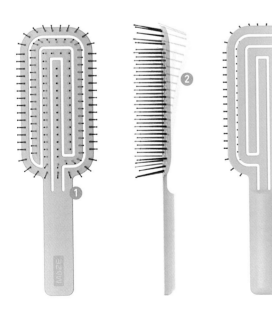

Sustainable lifestyle

Unlike traditional eco design solutions, MAZE hairbrush promotes a sustainable design through user involvement that runs beyond physical attributes (materials, processes, etc.).

1. Cost-effective design

Different from common hairbrushes in the market, MAZE hairbrush minimized parts and materials to reduce the overall cost in production. The main unit is injection molded in one part and nylon brushes are installed through a standard automated assembly process.

2. Inclusive structure

MAZE hairbrush facilitates solutions through movements. Contrary to the construction of traditional hairbrushes, multiple cantilevered frames configure the surface of the hair brush. With the fragmentation of the surface, the brush head flares open in arched layers when frames are bent.

3. Functional pattern

At a glance, the void loop serves as a decorative pattern; but plays a significant role in the function of the product. It initiates controlled flexibility within the structural frames and creates gaps for easier and quicker access to trapped hair.

M4ZE
Sustainable Hairbrush

Scott Shim, Morris Koo

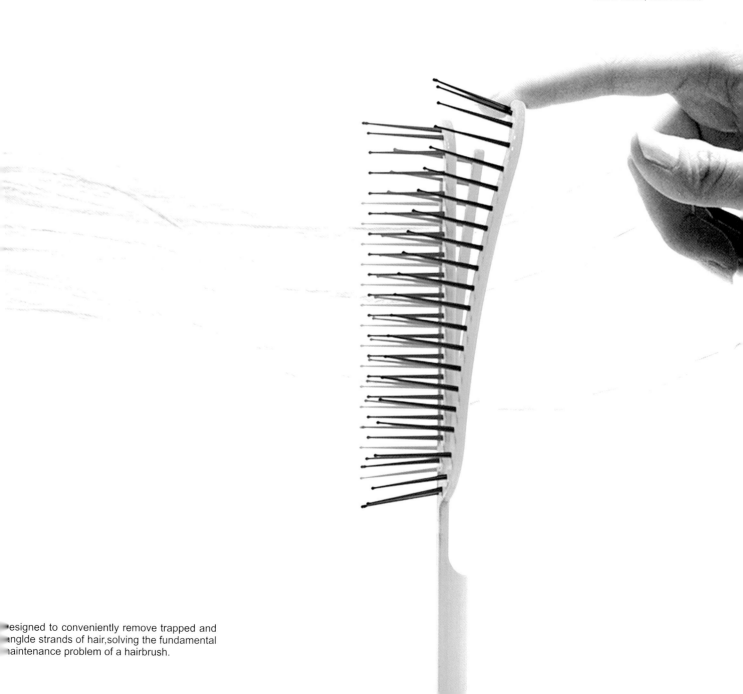

esigned to conveniently remove trapped and
anglde strands of hair,solving the fundamental
maintenance problem of a hairbrush.

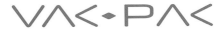

VAK·PAK

Vacuum Food Sealer Backpack

John Vanderveen

**Vacuum seals
food on-the-go**

Usage Features

The Vac-Pac is a hard shell bag that enhances backpacking by allowing the user to enjoy more foods during long trips. The built-in vacuum pump seals the food in bags and prolongs their freshness. This allows them to bring food that they typically could not be able to due to spoiling.

It also gives them the options of storing food they catch or pick. Finally, it minimizes valuable space taken up by their food. The entire product is made as a hard good, which gives it extra durability for the rough environment it will encounter.

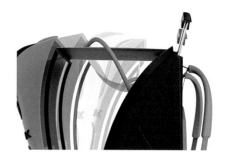

◆ Fabric shelf, pump handle and pump hose all hide away seemlessly for a smooth, integrated appearance

Assembly Parts

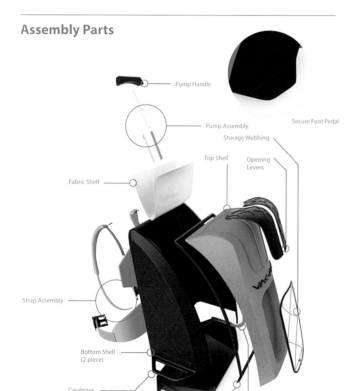

Pump Handle

Pump Assembly

Secure Foot Pedal

Storage Webbing

Top Shell

Opening Levers

Fabric Shelf

Strap Assembly

Bottom Shell (2 piece)

Carabiner Loop

Shelf Loop

Air Hose

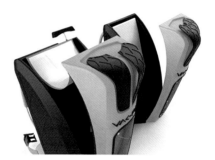

◆ Two dedicated levers: One pulls ring and shelf with it, the other leaves fabric folded down in bag for easy access

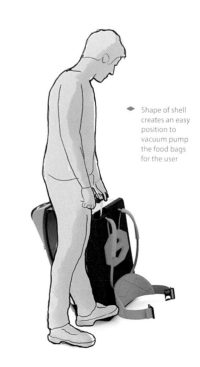

◆ Shape of shell creates an easy position to vacuum pump the food bags for the user

SWITCHUP
Material Handling System

Ben Wilco

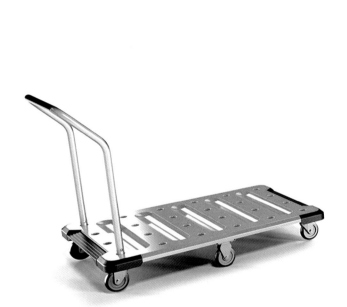

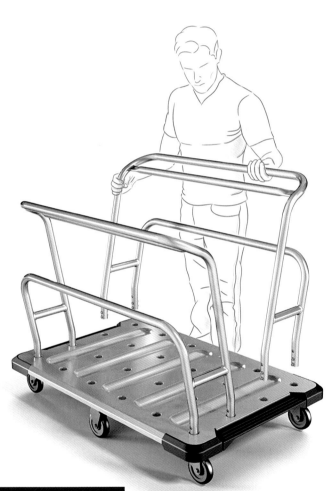

HANDS DOWN SAFER \ LOAD AND LIFT WITH EASE

If you've ever smashed your fingers when setting something heavy down on a flat surface, or had trouble sliding your hands underneath it to pick it back up, you will appreciate the stamped channels in the platform of the SwitchUp cart. Keep your fingers free and clear for safer every-day lifting and loading.

PLUG AND PLAY \ CHANGE IT UP ON THE FLY

When you are working in a 104,000 sq ft big-box home improvement store, the uses for a utility cart can be endless. The SwitchUp utility cart supports ad-hoc use with its quick-change rail system. Big-box retailers carry tens of thousands of products that come in all shapes and sizes. The SwitchUp cart empowers the employees to figure out which rails they need and change them on-the-fly to make their jobs easier or safer. Custom rails could be designed and purchased for specific needs without investing in a whole new cart for each purpose.

A utility cart designed for ad-hoc use that helps you take the changes as they come

☐ Start with existing setup　❶ Attach the unlocking clips　❷ Pull the bars out of the base　❸ Push the new bars into place　▶ New setup is ready for use

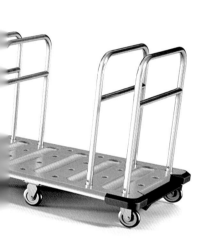

CONTROL THE ROLL \ DON'T LET IT GET AWAY

A cart loaded with large or heavy items that gets away from you can make you feel like you've got a runaway train on your hands. The SwitchUp cart features two convenient large pedal activated brakes on each end of the cart so you can stop and go with the flick of your foot. With the easy to use brakes the cart will sit in place right where you stop it.

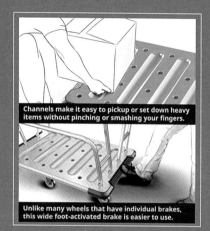

Channels make it easy to pickup or set down heavy items without pinching or smashing your fingers.

Unlike many wheels that have individual brakes, this wide foot-activated brake is easier to use.

INTERVIEWS & OBSERVATION

During interviews and observations at big-box home improvement stores, two common themes were found. There were issues with control/safety, and with the variabilty of items/uses of the carts.

Wandering and rollaway

Small and large items together

The base is designed for stamping in sheet metal to form the rigid platform structure.

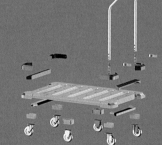

Removable injection molded corner bumpers and other detachable parts allow for repair and replacement.

The rail tubes house a bent spring steel locking mechanism with 4 pins that keep it secured to the base. The spring bends to allow entry and snaps tight when the rail tube is in position.

IDL

24h 01h 02h 03h 04h 05h 06h 07h 08h 09h 10h 11

Politecnico di Milano
[意大利] 米兰理工大学

GMT

IDL

13h 14h 15h 16h 17h 18h 19h 20h 21h 22h 23h 24h

AROUND
Office Furniture System for Social Areas

Marianna Fantoni
Politecnico di Milano Scuola del Design

The working environment has changed due to the transfor mation given by technology This fact has influenced and wi continue to greatly affect,not only the archetype of the office but also the way we work and interact with other people. is,therefore,no coincidence that more and more frequently w are talking about flexibility.

The fixed workplace is losing its meaning, in favor of a nomadi way of working. that is more effective in terms of productivit and assisted by the potential of devices that are getting smalle and smaller.

On the other hand, it's never been clearer to everyon before, how important it is to be able to work as a tear within a company,to be competitive.So it is inevitable that th

the Island

L—1450 mm
H—1050 mm
D—450 mm

the Booth

L—1496 mm
H—1220 mm
D—548 mm

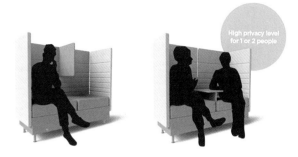

the Niche

L—1694 mm
H—1105 mm
D—748 mm

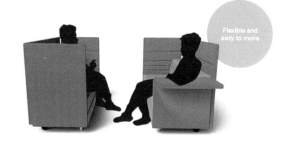

appearance of the office should be shaped on the new standards of flexibility in order to foster collaboration between individuals even from different departments.

To become a great workplace,therefore, it is necessary to focus on employer engagement,in order to improve the quality of the relationship between the employee and the employer,their colleagues and the core values of the company.Based on these assumptions Around was born:a furnishing system for social areas of the office, is able to meet the different business needs and offers different levels of privacy.It is designed to focus attention on the need to improve the quality of human relations on the workplace.

The aim of this thesis is to show how it is possible that this could be done by proposing a series of furniture designed to stimulate more direct communication and interaction between people.The project proposal has been designed for the traditional office, but considering the new identity of the workplace is normal to imagine it set in a lounge area of an airport or a train station,as well as in a hotel.

Gisella

Pasquale Belmonte
Supercvisor:Prof.Francesco Zurlo
Scuola del Design,Politecnico di Milano

Gisella is a sitting device born from the contamination, between cantilever chair and a horse saddle.

it is designed to recruit and retain a neutral sitting postur (anatomical hip angles similar to those found in the absence gravity)

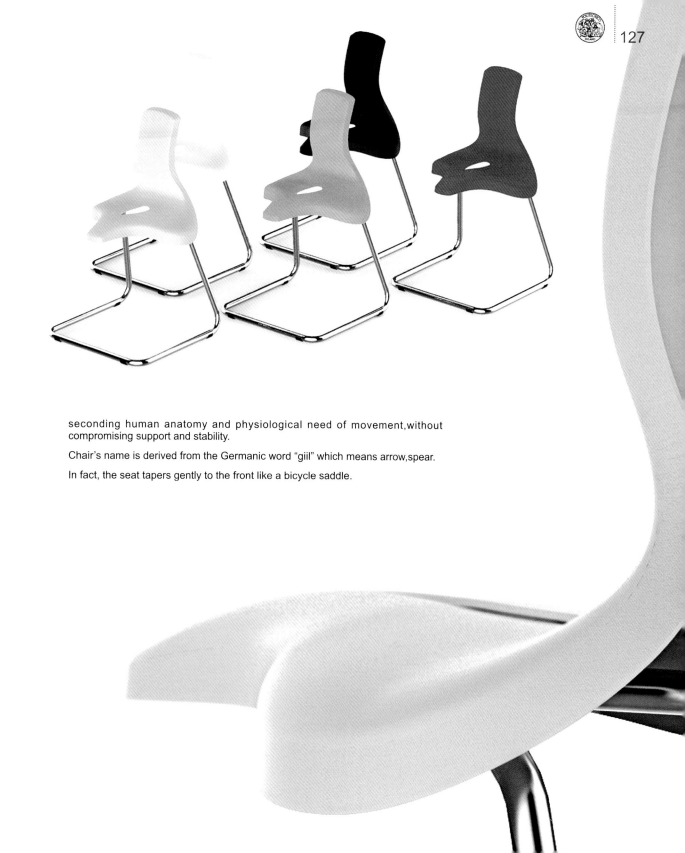

seconding human anatomy and physiological need of movement,without compromising support and stability.

Chair's name is derived from the Germanic word "giil" which means arrow,spear.

In fact, the seat tapers gently to the front like a bicycle saddle.

blaze

Politecnico di Milano
Tiziana Ponzio

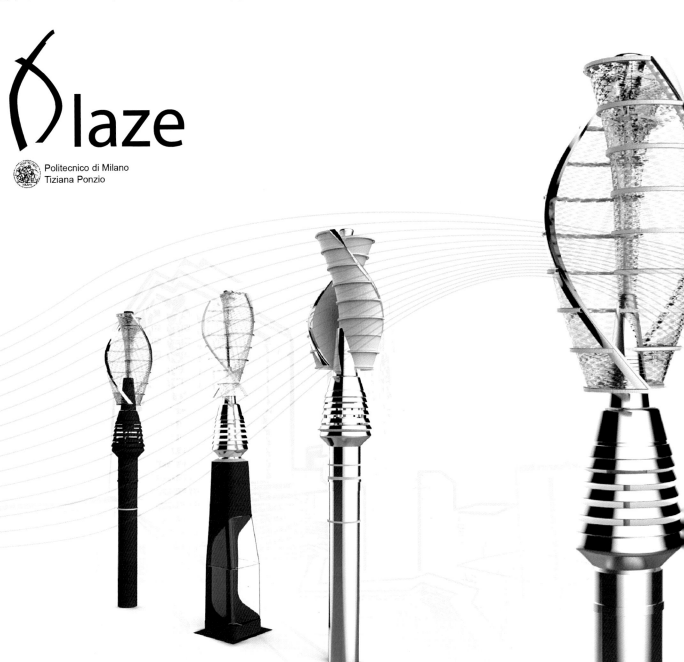

The project aims to use the technology of the Mini-Eolic integrating in it to the dual function of forced air extractor. Blaze is an eolic chimnet and it is inserted as the final part of a heatiing and ventilation air system in an apartment, but it is also designed to provide the energy needs for some of the utilities of an apartment building.

The chimney has been designed to be adaptable on every types of flues already on the market or it can be inserted into a passive ventilation house with a special solar flue designed to complete the system. The chimney is made of stainless steel.

The middle part is designed in order to make the "venturi" effect, the upper part instead hides the alternator of the eolic system. The turbine (200kWh) provides enough power for the common lighting of a condominium.

Politecnico di Milano_Tiziana Ponzio_tizianaponzio@gmail.com

Golden Age

Prevent Hand Arthrosis with Your Daily Beauty Care

Anna Chiara De Zan, Silvia Desideri, Giorgia Alletto

Golden age is a collecion of cosmetic packaging that allows the user to practise hand exercise,which can prevent artrosis,according to medical studies.

The beauty of hands is not only appeatence,but also the health of tendons and joints.With few daily movements,the health condition is improved and the user is not bored,frustrated,nor alienated while practising these healthy and useful exercises.

The target are baby-boomers ladies,who want to keep hands active,young and pain-free;the reference brand is Shiseido,with its philosophy:beauty is the harmony between form and spirit.

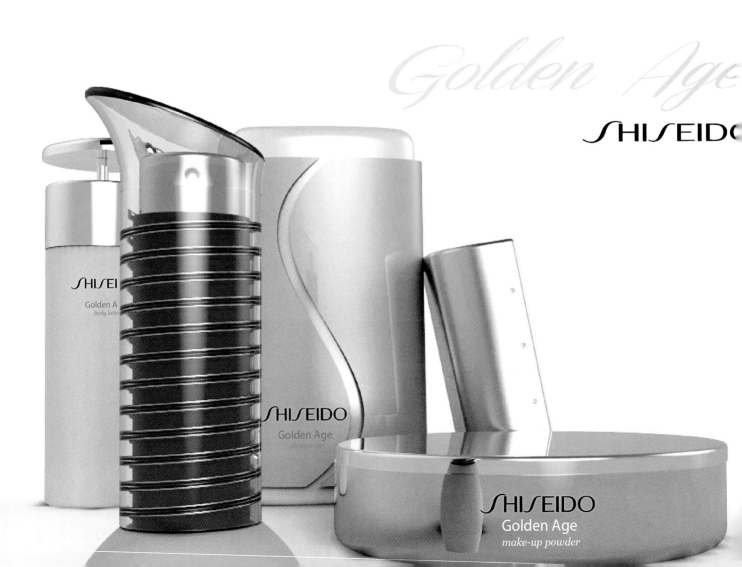

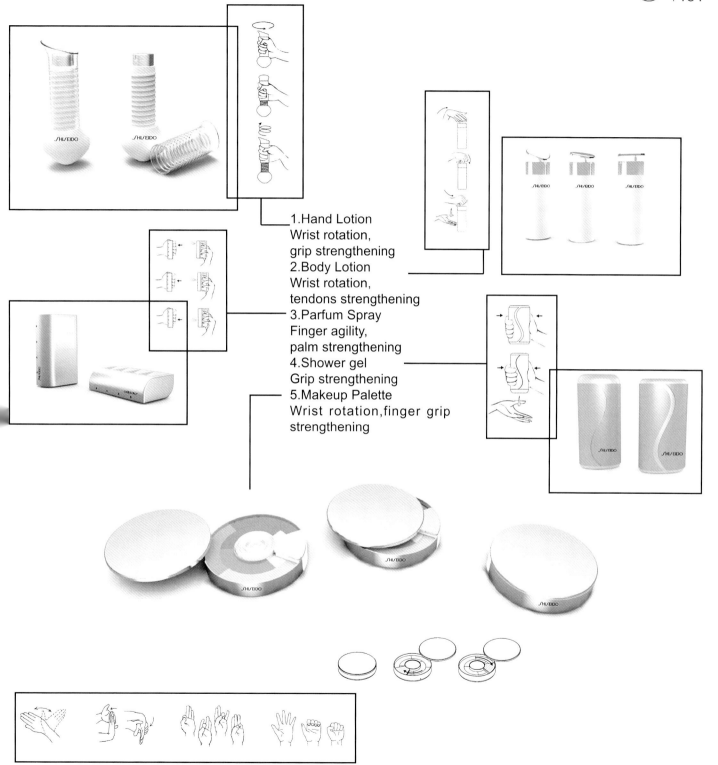

1.Hand Lotion
Wrist rotation,
grip strengthening
2.Body Lotion
Wrist rotation,
tendons strengthening
3.Parfum Spray
Finger agility,
palm strengthening
4.Shower gel
Grip strengthening
5.Makeup Palette
Wrist rotation,finger grip
strengthening

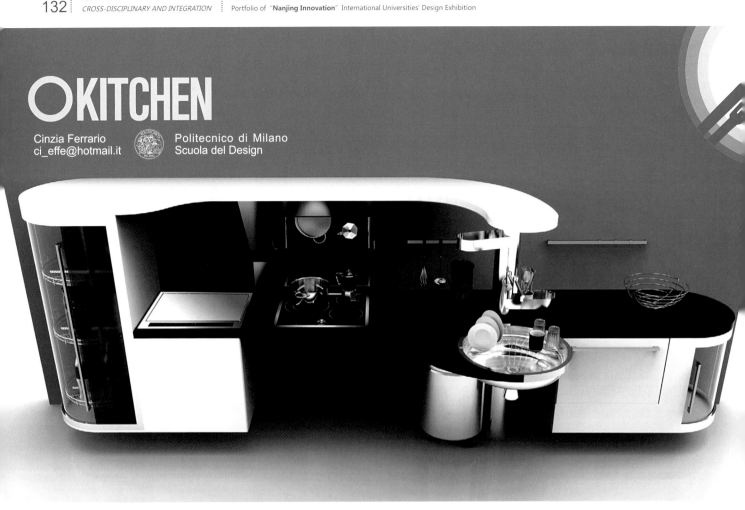

OKITCHEN

Cinzia Ferrario
ci_effe@hotmail.it

Politecnico di Milano
Scuola del Design

OKITCHEN springs from the need to carefully assess requirements and produce a kitchen that is not only practical,but also aesthetically appealing, while focusing on details.

Designed for absolute practicality for everyone using it, based on the principles of Design for All. The innovative solutions of the kitchen are the sink and the hood. The sink is designed to support paraplegic, disabled and elderly people, during the washing operations. The hood is composed by a mirror panel,which reflects the food contained in the pot on the cooker.

In this way the disabled can see inside the pot, and cook safely.

OKITCHEN is designed for our wellness.

OKITCHEN

Politecnico di Milano
Scuola del Design

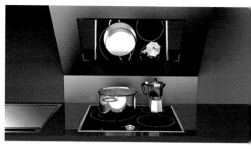

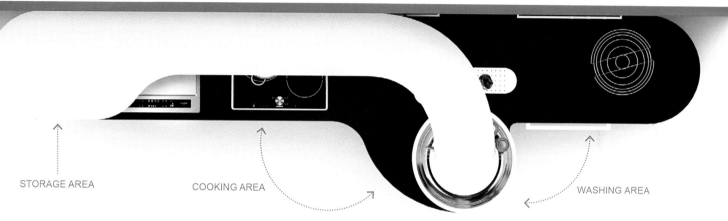

STORAGE AREA

COOKING AREA

WASHING AREA

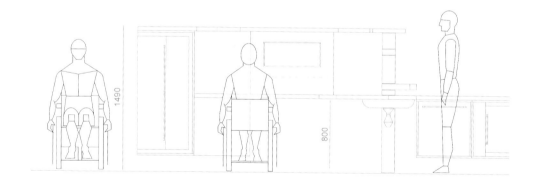

Silvia Zenzeri - s.zenzeri@gmail.com
Politecnico di Milano - Facoltà del Design

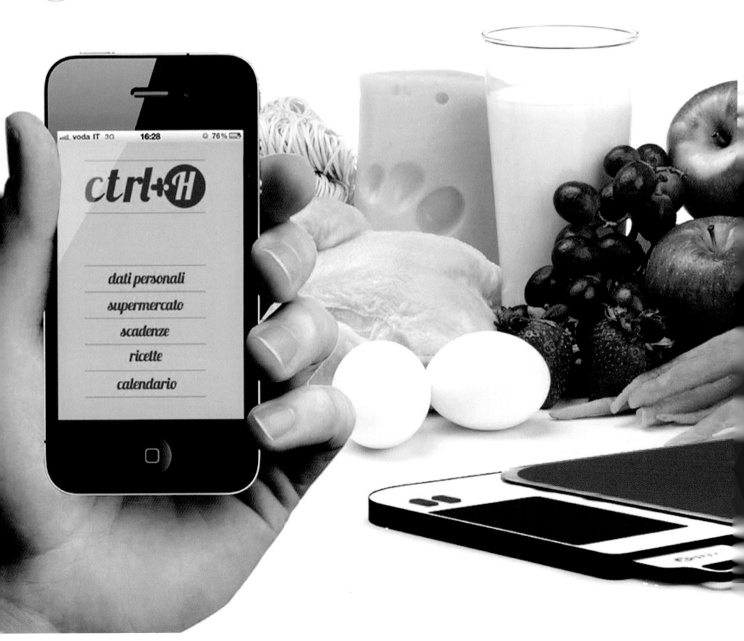

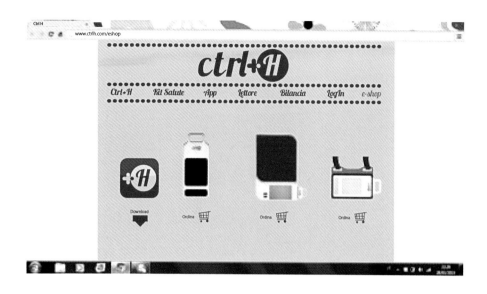

The kit Ctrl + H is a set of products and services designed for a user who discovers he has old age diseases related to food, such as diabetes mielito extremely common in people of advanced age.

The kit is composed of a reader / key that links the different aspects of the process. In fact, it is a barcode reader that brought with it the place of purchase, store and send all the data to the application of the product, which acts as a storehouse of information about the expiration dates of the products in the home and combines recipes with food present.

Once you have fnished your purchase at the store the reader can also be used as a key to understanding the products through a balance, which is able, through the stored data, to decipher the products and calculate values that are important for users suffering from diseases related supply.

Politecnico di Milano - Facoltà del Design

ctrl+H

The "Design for the Moment", the progressive change of modern life, the centrality of user and the change of user needs are the points from which we start to design the company's strategy for the 2030.

In a society that compresses the user and squashes the days between what he has done and what he will do,where specific needs are growing and new technologies of rapid prototyping and Scan3D are evolving, in the 2030 KIS will convert its structure by opening a new section called "Design Your Space".

The product system is based on newborn technologies that is moving towards an important evolution, both for the use of new materials, for the cost lowering and the decrease in the size of the machinery, with the possibility to have the technology directly at home.

We believe that the only way for KIS to continue to excel in the field of plastics processing is to expand their vision of the market, trying to reach new groups of users, adding a total service that wraps the user.

From this beginning, we develop the idea to give at the user the possibility to produce an highly personalized object, that can meet the individual need more than any other configured object. Stecco is a system designed by Cruna Design Studio for KIS.

It aims to completely change the traditional containment system, giving maximum transformability and mutability to a static system such as a bookcase or cabinet TV.

The strength of Stecco is given by the modular and maximum customization accessories containment.

These consists of five basic modules screwed between them, so as to be able to decide the ideal height for their needs, and a series of accessories that can be chosen from the catalog KIS or designed in first person by the user thanks to the service "Design Your Space".

Francesco Forcellini
Andrea Lombardini
Francesco Pace

Stecco
Politecnico di Milano
Scuola del Design

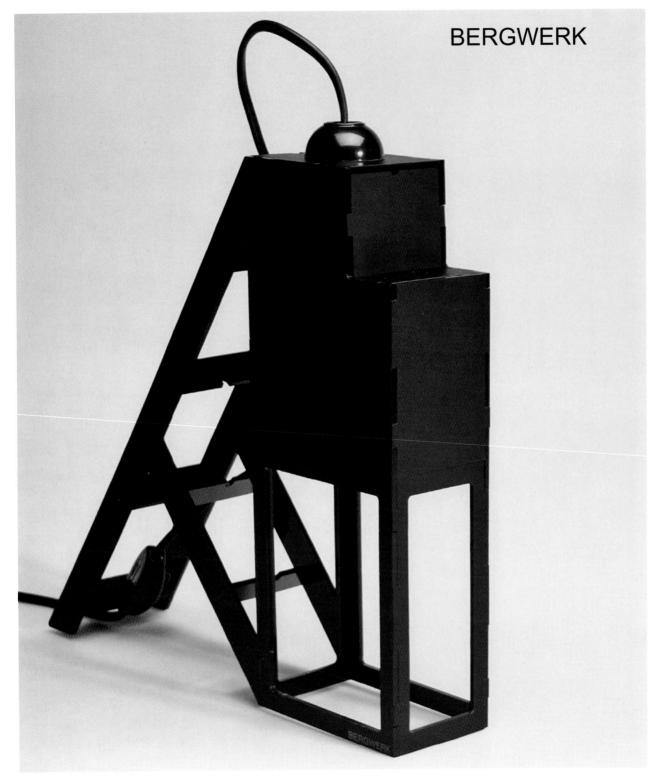

BERGWERK

Bergwerk, that means "mine" in german, is a project that take inspiration from the research taken by the Bacher the late 1970s to 1990s, for carrying at home a small building.

The lamp is made in black and satin PMMA and takes some geometries of the structures photographed by the German couple. It has a geometric shape that makes the disassembly of the object.

By holding the lamp vertically the bulb is hidden: invisible in the darkness, harmonic with the structure, it's seems buried inside the object. Its presence is indicated by the attack at the top, that connect the inner part to the external part by the same structure, almost like a small winch. From the first position the light is very similar to a lantern light, intimate and moderate. A light from the top to bottom draws geometries from lower openings on the support surface.

Instead by placing the object horizontally the light does an acute angle and becomes almost like a pointer, enlarging the area of illumination considerably.

This double conformation allows a quick change of ambient light, also by the addition of small holes in the pieces used as fairleads. The lamp can easily be used as a wall lamp or as a floor lamp always with a double conformation, obtaining different results of lighting.

The color of the object is black, as if the coal, extracted from the mines, became an integral part of the structure used to extract it, inextricably linking the structure to its function.All this means that the object has its own intrinsic value even when it's turned off.The pieces, needed to build the object, have been designed for maximize the ease of installation and the consumption with material waste minimization.

Following this design logic, we were able to place two lamps on the same plastic sheet of size 790 mm × 384 mm.

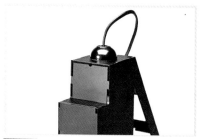

Francesco Forcellini
Francesco Pace

Bergwerk
Politecnico di Milano
Scuola del Design

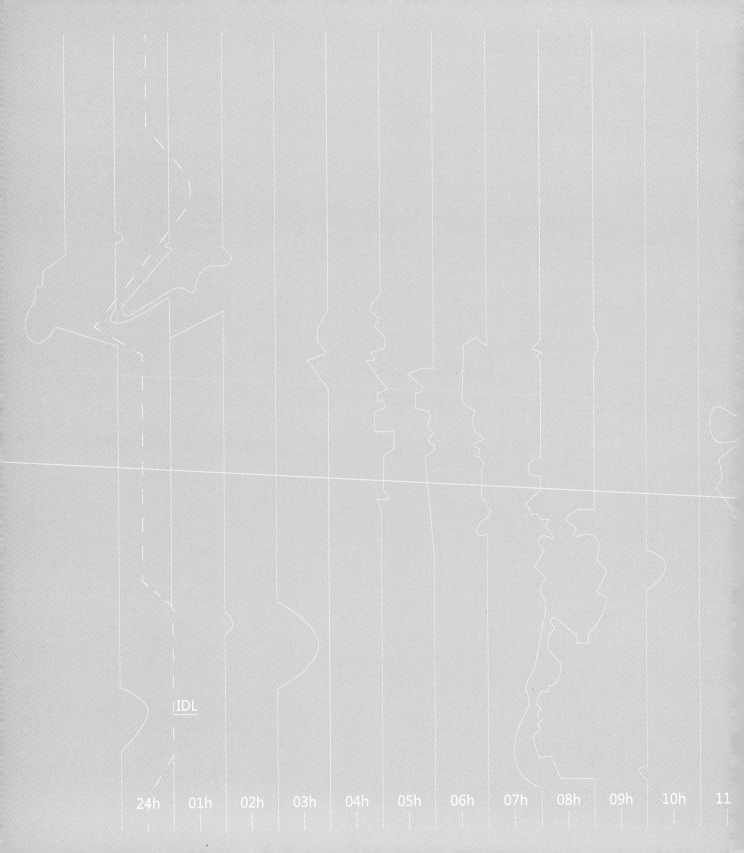

IDL

24h 01h 02h 03h 04h 05h 06h 07h 08h 09h 10h 11

Yunlin University of Science and Technology
台湾云林科技大学

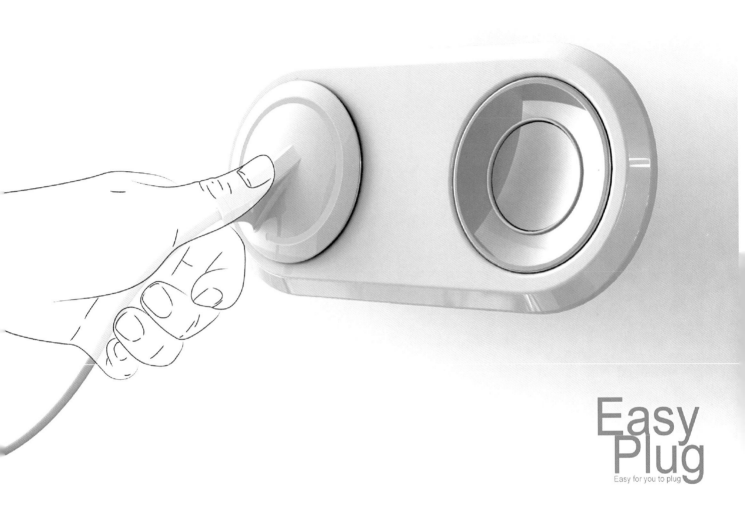

Easy
Plug
Easy for you to plug

Easy Plug

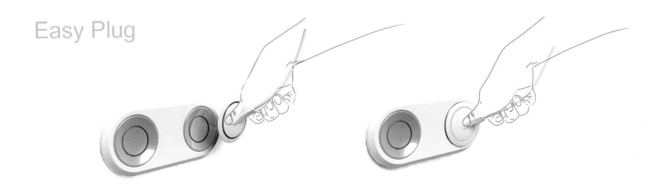

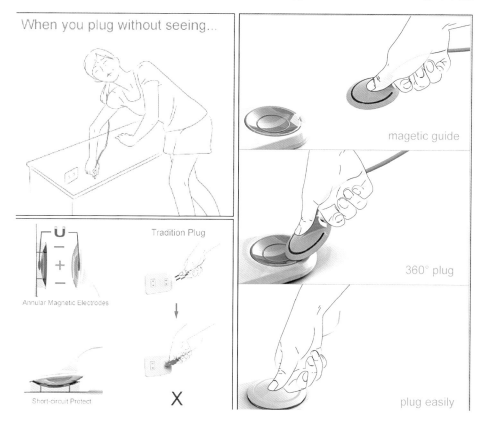

荣获　2013 IF 概念设计奖（全球 4~10 名）

Easy Plug 荣获 2013 IF 概念设计奖全球 4~10 名之奖项，一种任何角度都能轻易使用的插头插座组合设计，同心圆的电极设计，解决了传统插座需要特定角度方向才能插入的缺点，并巧妙运用磁力吸引的特性，以便使用者在看不见插座的情况下也能轻松使用。

台湾云林科技大学　设计团队：创设系　王清良　副教授
创设系　黄瑞闵　同　学
创设系　吴品絮　同　学

Easy Plug

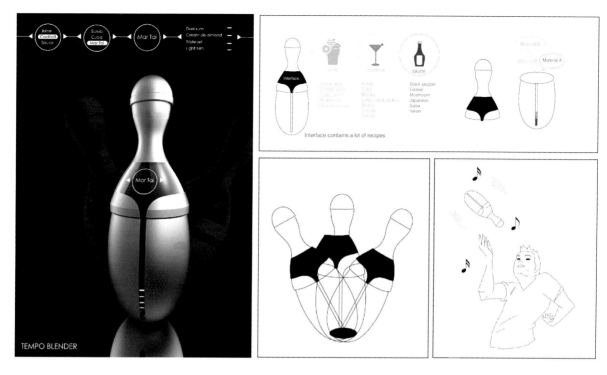

荣获　2012伊莱克斯设计竞赛第17名
本设计让听觉和烹饪来做连接，Tempo Blender是一个能够让任何人轻松料理酱料或是调制美味鸡尾酒的食物调理机。只要根据调理机界面上面的步骤加入所需原料与比例，再来一个花式甩抛动作搭配上音乐节奏来获得电力，就可以用环保节能的方式来得到美味的菜肴。试想，当你在调制泰式酸辣酱时，搭配上泰式音乐节奏来甩抛Tempo Blender，满足的不只是味觉，也可以让听觉随着烹饪过程一起被启发。

台湾云林科技大学　设计团队：数媒系　曾谁我　副教授
　　　　　　　　　　工设所　万芙君　同　学

Tempo Blender

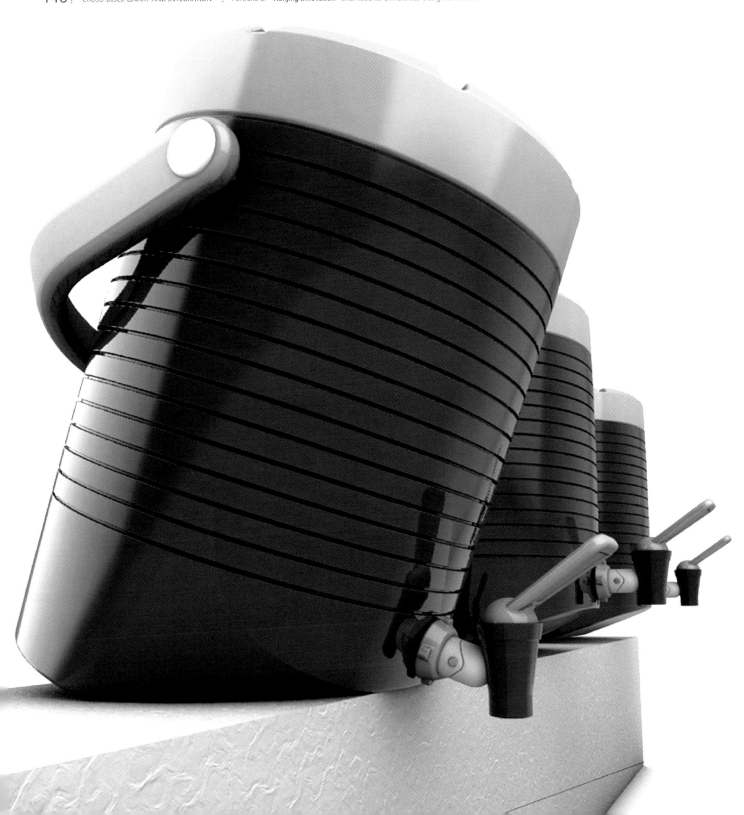

荣获　2012国际红点设计概念奖
欢乐的派对中总少不了饮料助兴而盛装茶饮与果汁的饮料桶则是必需品，但每当饮料桶里的液体逐渐减少时，人们的习惯总是把饮料倾斜着倒出，直到一滴不剩才肯罢休，因此我们以一种轻松的角度站立的方法来改善！

台湾云林科技大学　　设计团队：工设系　蔡登传　教授
　　　　　　　　　　　　　　　　创设系　杜瑞泽　教授
　　　　　　　　　　　　　　　　工设所　谢宏忠　同学

Tilt 20

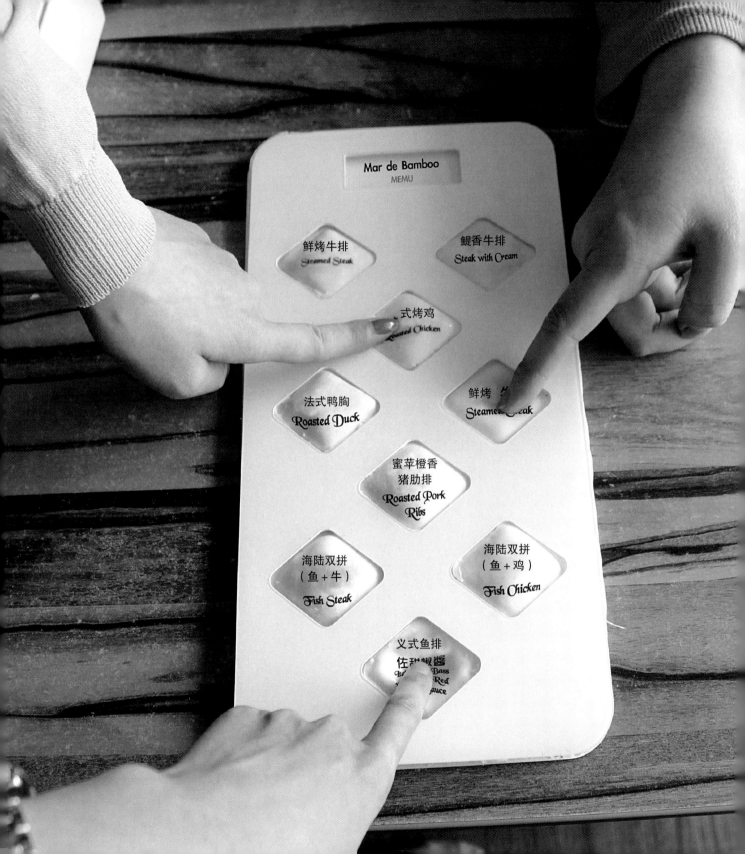

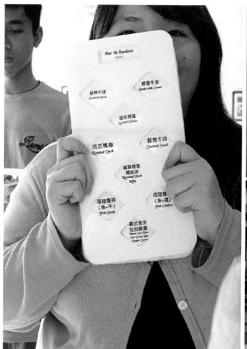

荣获　第15届阿基米德国际发明展暨发明竞赛 金牌

市面上的菜单大部分都以划单的方式，使用完之后立即丢弃，增加不必要的垃圾。Reuse Menu是可重复利用、不浪费资源的菜单。点餐时只要把想点的菜名轻轻按压至凹下，凹下的菜表示要点的菜，点好后递给服务员即可。改变以往的点餐方式，在客人点餐时和服务员划单之间寻找另一种互动。

台湾云林科技大学　设计团队：设计所　杜瑞泽　教授
　　　　　　　　　　　　设计所　陈扬峻　同学

Reuse Menu

N⊕SE Know YOU

Hemostatic Tablet

Ice compress and hemostasis

Made up of Silica gel.
Fit for any nose shape.

N⊕SE Know YOU

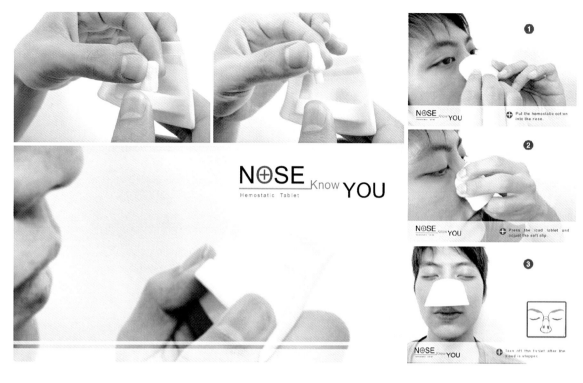

荣获　第 41 届瑞士日内瓦国际发明展览会 银牌

Nose Know You 能让患者轻松快速止血，产品表面上有个帮助患者压住鼻梁的设计，除了能将穴道压住，同时也有冰敷功能，而在内部则有塞入鼻孔内的棉条帮助吸收鼻血，让鼻血不会滴出，不至于弄脏衣物与环境。产品特点：①有冰敷、止血功用；②材质使用硅胶，依鼻型可做调整，符合每个人的需求。

台湾云林科技大学　设计团队：设计所　杜瑞泽　教授
创设所　洪于婷　同学
创设所　张韵弦　同学

Nose Know You

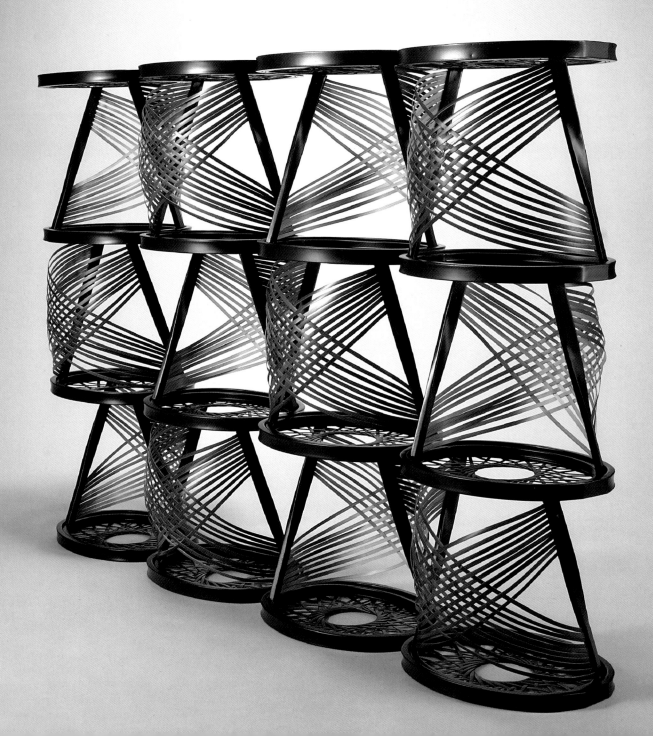

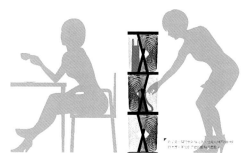

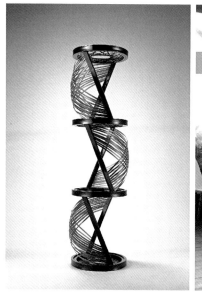

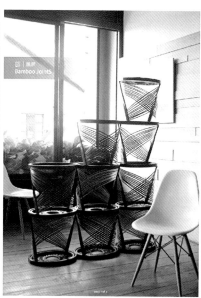

荣获　2012国际红点设计概念奖

"竹本固，空性直，竹心空，竹节贞。" 以竹的姿态为元素，运用仿生手法，设计出了这组可以层叠、组合以及拥有置物功能的屏风。屏风每个单元为一个竹节意象，层层叠起就有如竹生般的形态。侧柱运用了旋转的效果，让整体更加有层次感。

台湾云林科技大学　设计团队：创设系　陈启雄　教授

设计所　蓝康华　同学

设计所　宋倍仪　同学

Bamboo Joints

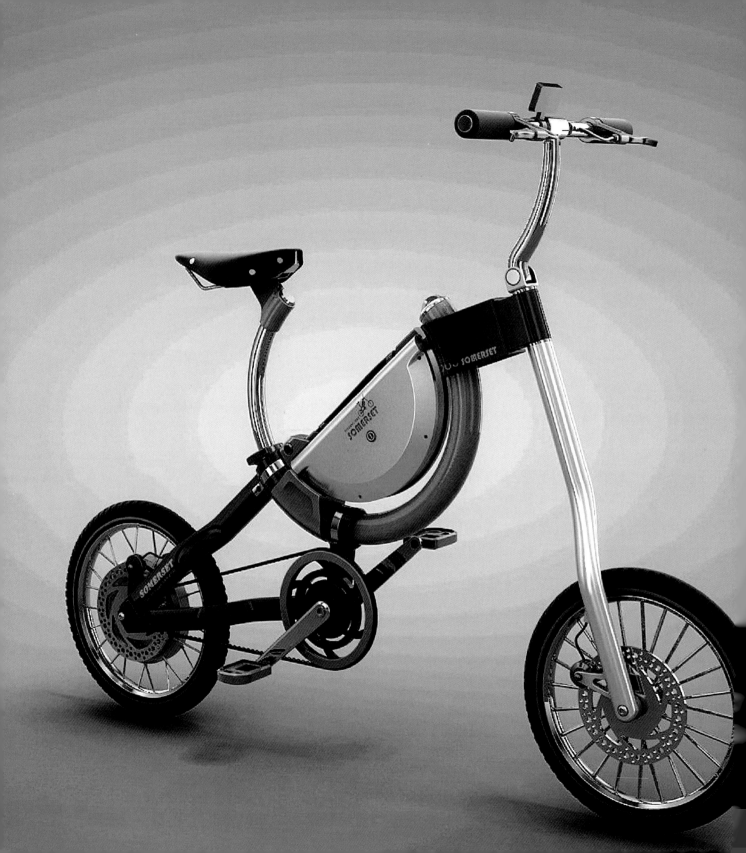

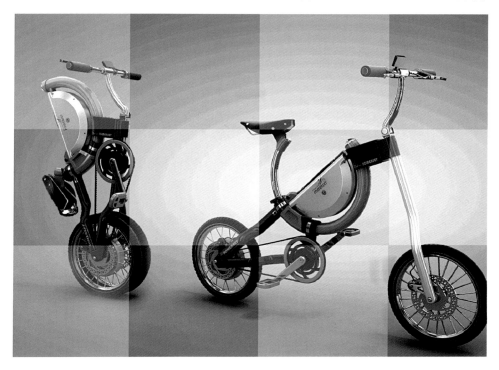

荣获 2012 德国纽伦堡国际发明展览会 银牌

2012 德国纽伦堡国际发明展，其中 2 项银牌由工设系陈鹏仁老师指导学生：张朕维、邱元泰设计的折叠式移动载具及其接合模组／电脑折叠自行车获得。本创作可解决在公共交通工具上推行及托运之不便，折叠后易于推动，改变传统折叠后造型仿佛废铁般难以行走的窘境，原车架加上锂电池与轮毂式马达可以轻易改装成电动自行车。目前该设计已获得 2011 台北国际发明暨技术交易展览会金牌、2011 韩国首尔发明展览会银牌、2012 年第 40 届瑞士日内瓦国际发明展览会铜牌，以及第 15 届 IBDC 全球自行车设计比赛银牌及巨大奖。并已根据设计做车体应力分析测试，商品化程度相当高，整体而言极具开发价值。

台湾云林科技大学 设计团队：工设系 陈鹏仁 讲师

工设系 张朕维 同学

工设系 邱元泰 同学

折叠式移动载具及其接合模组／电脑折叠自行车

Happy Paradise

Growth Record for Children Memories

Bike Size: 1524mm × 800mm × 900mm
for 137~163cm Child

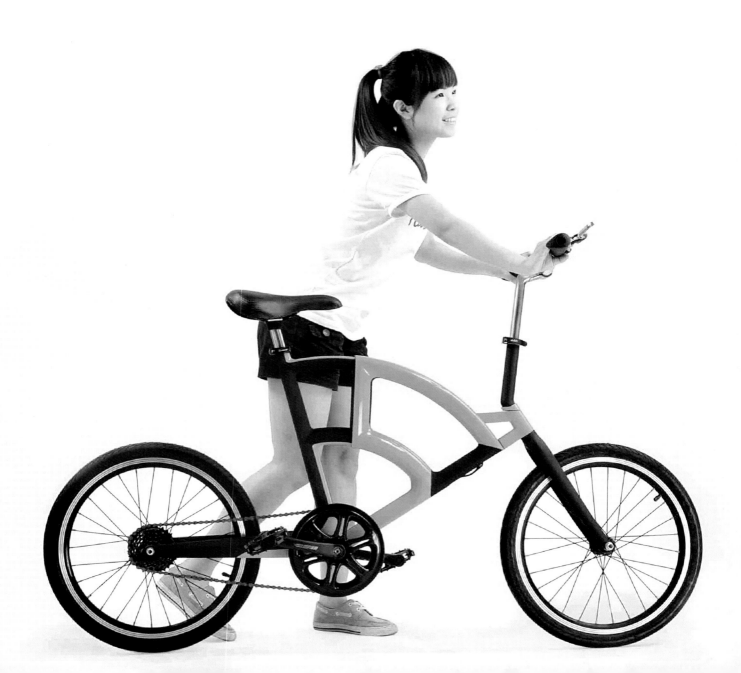

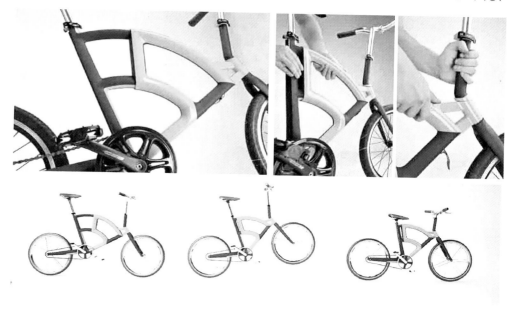

荣获　2013 伊朗国际发明展览会 金牌

本校工设系陈鹏仁老师指导许舜闵同学的作品，参加 2013 伊朗国际发明展获得金牌佳绩，该设计系以快速成长中的孩童为使用对象，由扇形伸缩方式改变车体关键点的尺寸架构，使座点与握点的调整范围加大，以配合孩童每个时期的身高，同时又能保持结构强度，达到延伸自行车产品生命周期的目的。

台湾云林科技大学　设计团队：工设系　陈鹏仁　讲师
工设系　许舜闵　同学

可延长生命周期之青少年用变形自行车

荣获　2012 国际红点设计概念奖 Best of the Best
Not Copy Machine 作品获得海报设计类 Best of the Best 之奖项。其创作理念为：现今社会在教育儿童成长的过程中，父母往往会以主观的想法教育儿童，并认为自己的想法对孩子是最好的人生规划，也因而期望孩子完全依照自己的想法成长。但孩子的潜力是充满无限可能，孩子的人生是充满无限梦想。因此父母不该用既有的想法，局限孩子的发展潜能，应多关心孩子内心真正的想法与梦想。期待，从旁协助指导孩子开阔视野，确立人生的发展目标。Not Copy Machine 意在表达：孩子不再是父母的"复印机"，父母不再是"直升机父母"！

台湾云林科技大学　设计团队：视传系　管付生　教授
视传所　魏均寰　同学

Not Copy Machine

荣获　2012高雄放视大奖 金奖

故事描述三个相依为命的女人，妈妈、奶奶与阿祖。一天，患老年痴呆症的奶奶忽然不见了！焦急的妈妈不得已推着瘫痪的阿祖，开启一整天的寻亲之路。奶奶到底跑到哪里去了呢？妈妈伤心、绝望又疲惫，三个女人三代间的甜蜜与女性的坚强，随着故事发展即将一路延展。

《三个女人》呈现最真实的女性精神，感动人心，除荣获 2012 年放视大奖动画类金奖，同时获得 2009 年漫画创意竞赛第 2 名、2012 年台湾技专院校电脑动画竞赛优胜、2011 年台湾经济主管部门 4C 数位创业竞赛动画剧本入围等多项殊荣，全系师生共享荣耀！

台湾云林科技大学　　设计团队：数媒系　陈世昌　教授

数媒所　陈小雅　同学

数媒系　林玉婷　同学

Three Women

IDL

24h 01h 02h 03h 04h 05h 06h 07h 08h 09h 10h 11

Tsinghua University

GMT

IDL

13h 14h 15h 16h 17h 18h 19h 20h 21h 22h 23h 24h

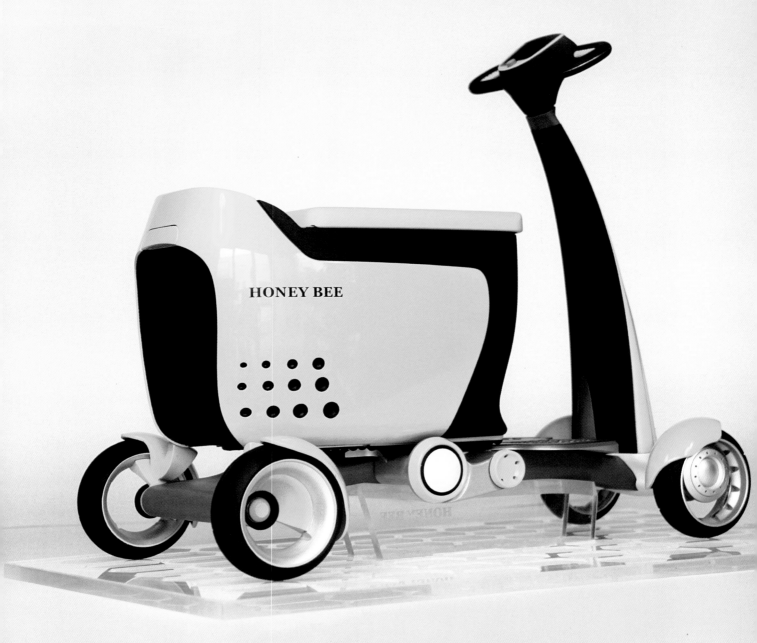

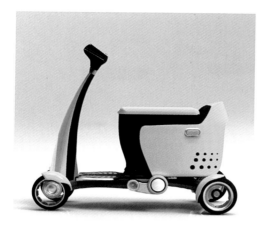

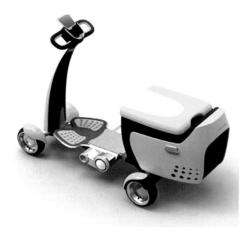

This design through clever folding structure, makes a shopping cart easily realize shopping and travel tools the convert each function. The elder not only can use its shopping cart function at the supermarket, but also can use its travel tool function go to supermarket and home easily. This design makes the elderly features, shopping, travel functional integration, and properly resolves the elderly because of the decline in physical function leading to the difficult problem of shopping.

Qu, Chen
Academy of Art & Design, Tsinghua University

Shopping Trolley for Elder Chinese

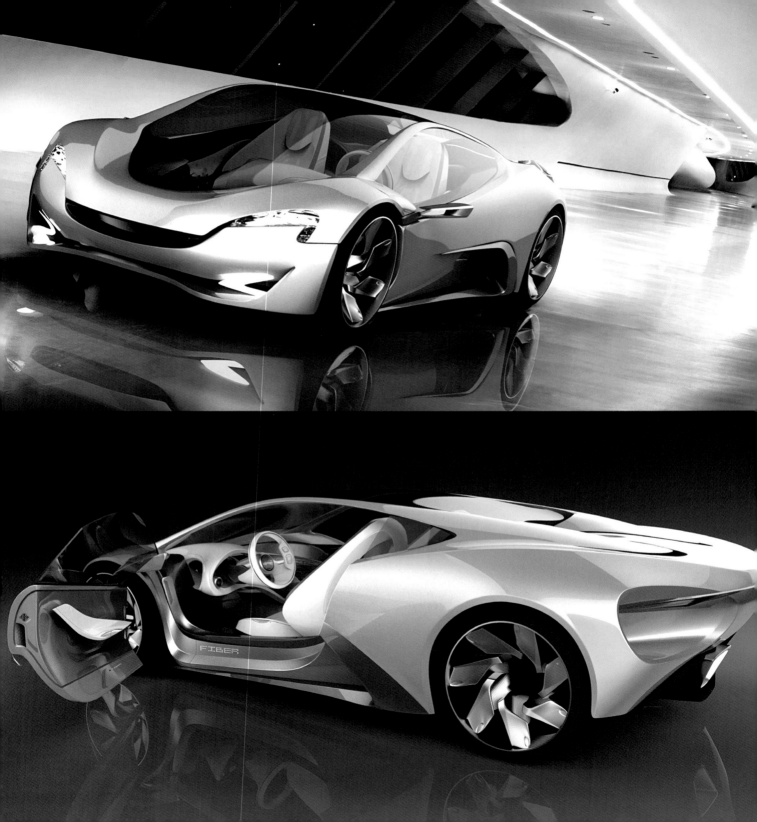

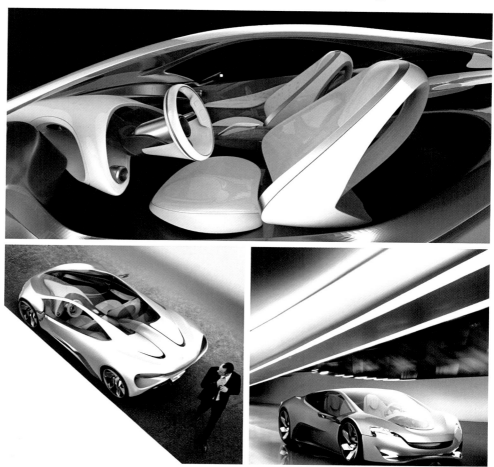

The continuous development of urban transportation system affects people's choice of travel mode. Highly developed urban public transportation system, convenient car rentals and other new travel modes change people's demand on urban family cars. At the same time, automotive energy is experiencing a period of transition since its development. How to lead young consumers to choose green and environmental new energy vehicles in terms of design, while satisfying people's new demand on urban family cars, and how to grasp the development trend of car styling are problems that automobile designers are required to consider and solve.

Huang, Hao
Academy of Art & Design, Tsinghua University

Peugeot Eco Concept 2020

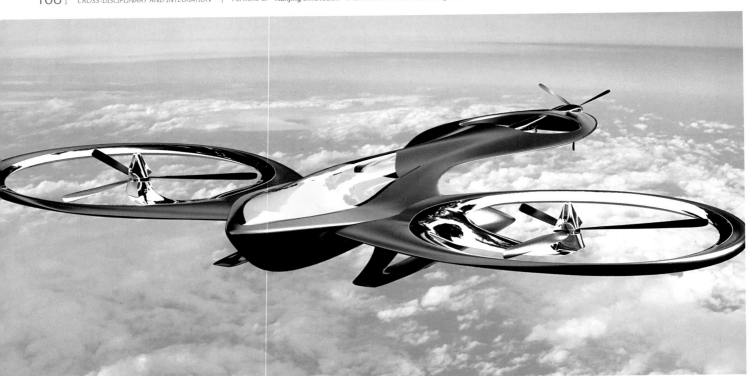

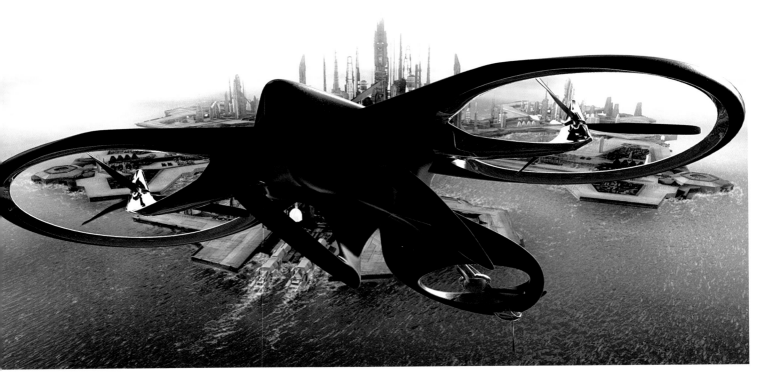

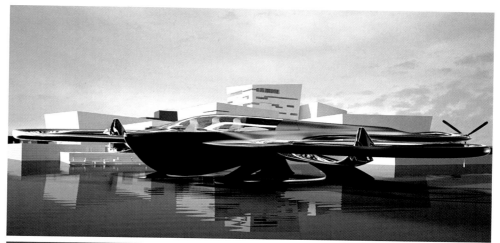

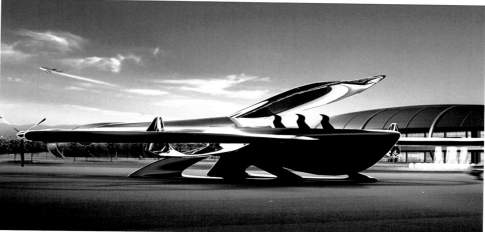

Technology and pleasure are always inherently related. Whenever new era of technology took part in history, new fashion of entertainment also appeared resultantly. On the other hand, technology may also gradually change the habit of considering previous products such as aero-crafts. As the notion of speed, digitalization, science, efficiency etc. has changed significantly.

Throughout the years, the concept of aero-craft may also slightly change. As we look into the future and grasp some of the possibility of the potential lifestyle, private aero-craft could be hint of an incoming prosperous era of the combination of technology and pleasure.

Zhang, Liguo
Academy of Art & Design, Tsinghua University

Multi-propeller Private Aero-craft

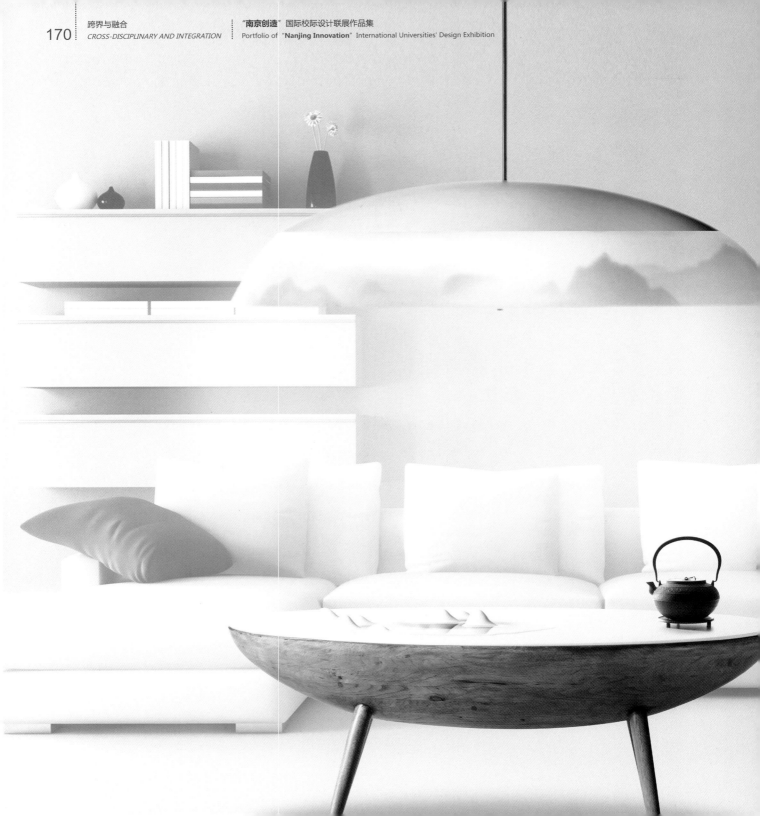

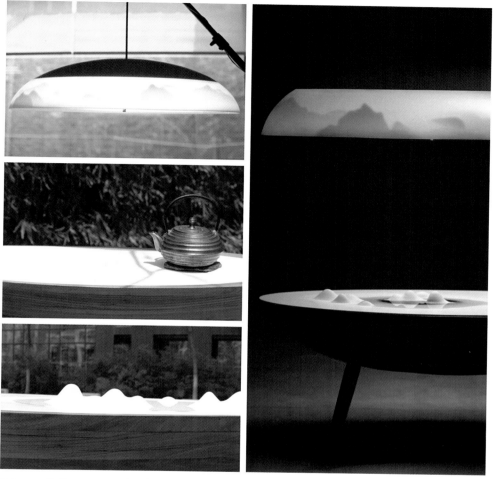

Tea – meditation ,as a modern tea set, wishes to convey a sense of nature , peace and simplicity to the tea drinker. The tea drinker can accomplish self-cultivation and meditation when drinking tea. Design Idea: Inheriting the traditional Chinese tea culture and perusing the integration of man and nature, the design incorporates the pleasant landscape into the elements of furniture designs, which engages the sense of visual, hearing, touch, smell and taste of the drinker to builds a personal moment of pleasant and relaxing by clean contours. Product Selection: Products use the precious Quercus mongolica (a kind of precious plant) and DuPont's corian as the raw materials. The artistic conception of China watercolor painting is expressed by using the corian's good light transmission. The table bottom is made of nature wood that is cordial nature and combining with the modern family living environment and creates a new concept of drinking tea.

Gong, Lin'na
Academy of Art & Design,Tsinghua University

Tea – Meditation

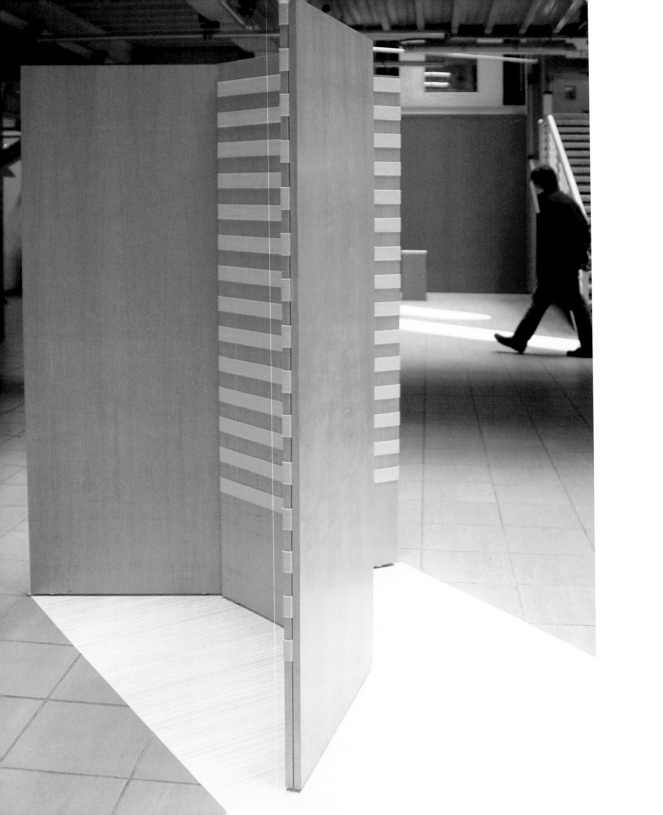

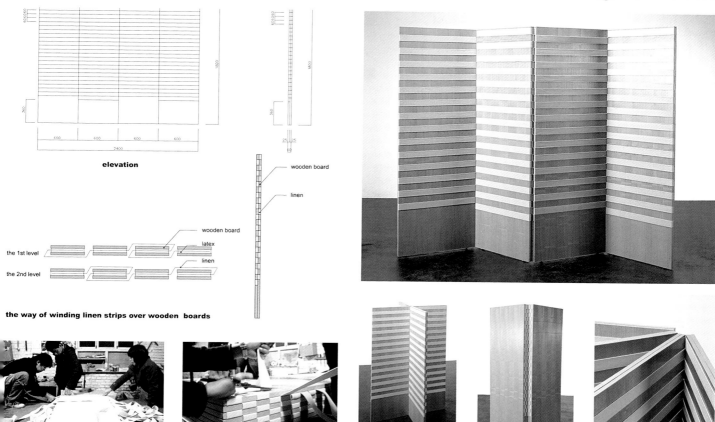

elevation

wooden board

linen

wooden board
latex
linen

the 1st level

the 2nd level

the way of winding linen strips over wooden boards

esign inspiration comes from the folding method of the Chinese traditional furniture—folding screen—and the Beijing's old toy: Face Off.

he design is combined the properties of traditional space divider and the toys in order to design a new folding screen full of creativities and has a sense f modern constructivism. Owing to its special structure, users can create quite lots of intriguing space dividing methods than ordinary by the means of rning four different panels.

sing linen and wood as materials, skillfully wind linen strips over wooden boards in an interlaced way when placing the two pieces of boards together, us to make into being a construction which can be turned and rotated freely.

ast but not least, the wheels go in 360 degrees are installed at the bottom of the folding screen, which simplify the moving process.

Wei He, Jia Bao, Jing wang, Yufeng Shi, Chen Shu
Tsinghua University

Folding Screen—Softness

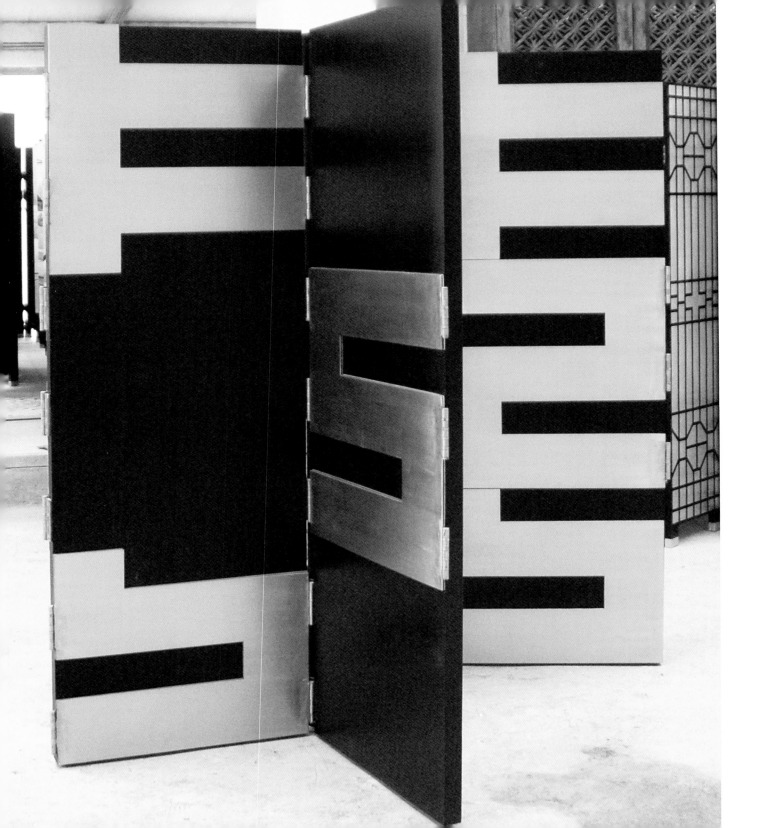

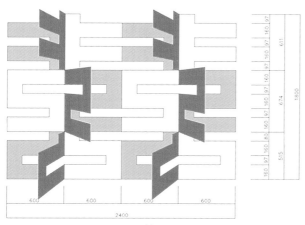

Elevation of the Character " 囍 "

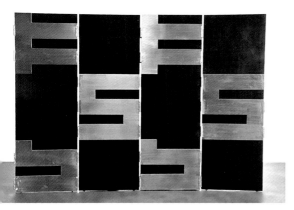

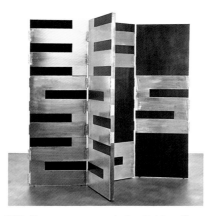

With the same concept, the Folding Screen—Happiness was designed by our team as well. This new one is made of brass and wooden board.

The Chinese Character " 囍 " means happiness and success, which is commonly seen at occasions such as weddings.

The Pattern is similar to a piece of paper-cutting, which has an amazing effect due to 6 large hinges and 12 joints to combine copper patterns together. Accordingly, the various of interesting and abstract shapes could be transformed from Chinese character " 囍 "(Happiness) while people use it to divide space by different means.

Wei He, Jia Bao, Jing wang, Yufeng Shi, Chen Shu
Tsinghua University

Folding Screen—Happiness

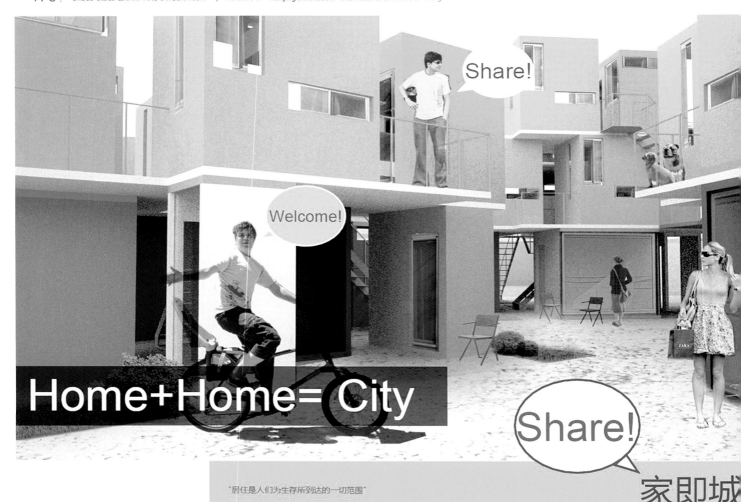

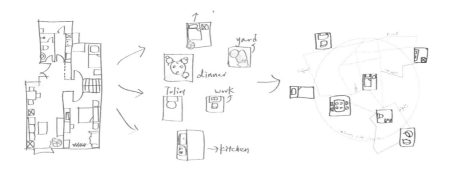

Home × N=City

Xie Junqing
Tutor: Liang Wen, Cui Xiaosheng
Academy of Art & Design,Tsinghua University

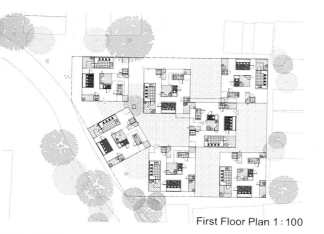

First Floor Plan 1 : 100

The housing condition of young people is a social subject receiving increasing concern in recent years. The methods to offer young people both economically affordable and efficient housing has become a popular issue drawing designers to this fascinating exploration. With the investigation of the current living conditions, needs and housings of young people in Beijing, this design tried to redefine the meaning of "living" by exploring the relationship between living and city with a background of urban area. By developing the ideas and methods about sharing resources, the living costs of young people should be reduced, the intercommunications between them are expected to increase. With these ideas, measures were proposed for the reconstruction for the residential area on Xixie Street, Beijing where young people are the majority among the residents.

This design is not limited to the interior, but takes urban development, social change, and modern people's behavior and lifestyle into consideration as well. The result of the design is the understanding of life and an attitude to live of a young designer.

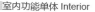

室内功能单体 Interior

Dual House

Peng Zhe, Wu You
Tutor: Su Dan
Academy of Art & Design,Tsinghua University

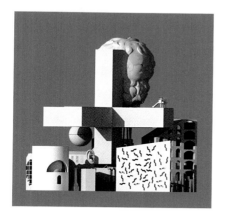

The Dual House is concerned about the new possibility of the transformation between the tangible one and the abstract one. Usually, in terms of architecture and space, abstraction equals the "value", including use value and symbolic value. The tangible one is the "objectiveness" that encompasses the form, the material and the scale. For objectiveness itself, is there any possibility to break through this closed and self-referring symbol system?

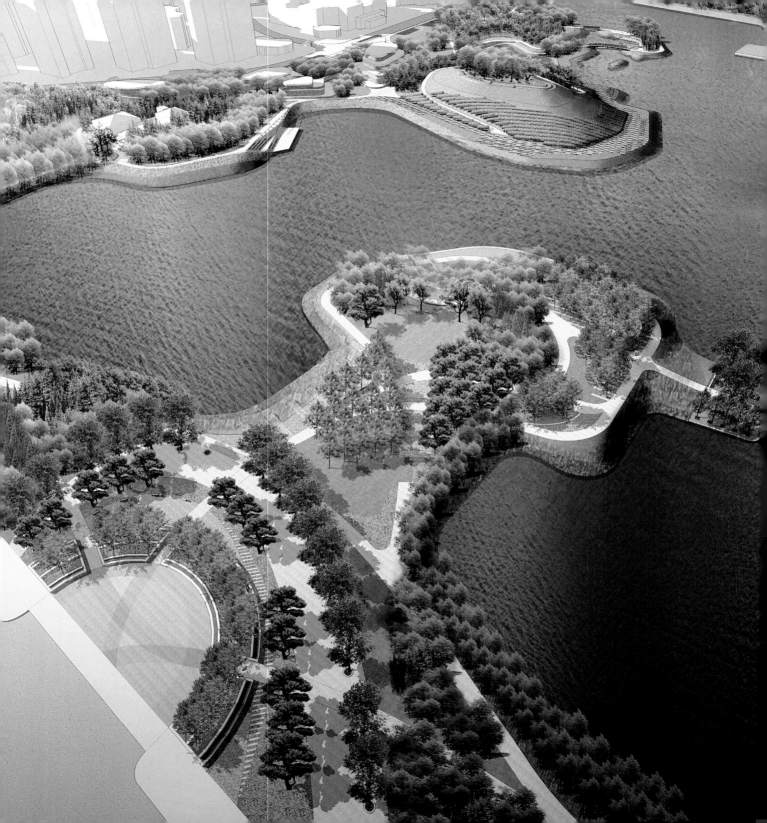

Edge is one of the most significant elements frequently considered in landscape architecture design. In this renovation of Chaoyang Park, Beijing, it determined the relationship between the artificial nature and the adjacent urban environment.

The primary method was to manipulate with elements such as earth, planting, low density commercial buildings, circulation and field, in order to form continuous change from both the urban side and the park side. This move would bring adjacent community and passing by tourists into the park through the visual attractions created by multiple components of landscape elements including visual corridors, lookouts, playgrounds, fields and hills.

Hao, Peichen
Academy of Art & Design, Tsinghua University

Permeability of Edge

北京奥运
场馆旅游交通图
BEIJING OLYMPIC VENUES
Tourism and Transport Map
科技篇 Technology

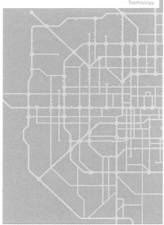

前言 Foreword

"科技奥运"是北京2008年奥运会的三大理念之一，它涉及场馆建设、信息通信、环境保护、能源利用、智能交通、奥运安全、运动科技等多个领域。本篇重点介绍场馆建设、信息通信和太空设计中高新技术的应用。

2008年北京奥运将借助计算机信息、建筑结构、新技术、环境保护以及人性化设计等各方面向应用带来更多的新思想、新技术。"鸟巢"和"水立方"以其全先进的创新的建筑的架构成为北京奥运地标性体育建筑；奥运期间卫星、移动、互联网等全方位的网络通信建设，可以让世界各地的人们感受到极具奥运特色的便捷；数字北京信息亭为人们的日常生活提供了的多服务；政务查询、交通违法查询、使民缴费、免费路书打印等诸多功能；"祥云"火炬以高水平的节能的环保技术为基础，成为本届奥运会的一大亮点。让我们一起纵览历届奥运会使用的新技术，领略高科技给我们带来的神奇魅力。

As one of the three philosophies of Beijing 2008 Olympic Games, Hi-tech Olympics involves many fields such as venue construction, environment protection, energy use, intelligent transport, Olympic security and sports technologies. This chapter focuses on application of hi-tech in venue construction, communication and torch design.

World leading new ideas and new technologies are applied in Beijing Olympic venues in terms of design concept, building structure, energy preserving, environment protection, people-centric design and so on. The 'Bird's Nest' and 'Water Cube' become unprecedented landmark sports buildings based on their complex architecture and super complex architecture; satellite mobile, internet and other all dimensional communication networks will offer people around the globe convenient access to Olympic information during the Games. Digital Beijing Kiosks will offer people such benefits as e-maps, government information search, traffic violation search, online payment of various fees and free printing of route information; and the "Luck Cloud" Torch, a result of Chinese culture and modern technology, becomes a highlight of this Olympic Games. Let's go over new technologies used in previous Olympic Games to experience the charm offered by hi-tech.

信息通信 Information Communication

08年奥运会注注将着信息技术的盛宴。通过卫星、移动通信、互联网、IT特别是宽带、3G、高清数字电视及多媒体终端等技术的应用，人们将能随时随地获取比赛信息。

The Beijing 2008 Olympic Games will be a feast of information technology. With the application of hi-tech in satellite, mobile communication, internet, IT, especially broadband, 3G HD digital TV and multimedia devices, people will be able to get access to competition information anytime anywhere.

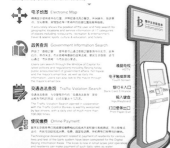

数字北京信息亭 Digital Beijing Information Kiosk

数字北京信息亭是指设置于公共场所，基于计算机信息网络、利用触摸屏、信息搜索、多媒体等技术为社会提供公益信息和增值服务的自助式终端设备。信息亭是"数字北京"利民工程的重要组成部分，也是"数字奥运"的重要辅助项目。信息亭通过安放在市民和游客出入活频繁的，最时的公共服务场所，出行公交查询信息的地标性体育建筑；市民和游客游最查询首都经就化等就的全息。奥运会期间，信息亭还将通过触摸屏、幕和高清数字电视向公众馆持服务信息，赛事、销售订票，专为众服务于奥运会。

Digital Beijing Information Kiosk refers to computer network based self-help devices that offer public service information and value-added service for the society through touch screens, information search, multimedia and other technologies. Providing Beijing residents and people coming to Beijing with free authoritative and timely public service information, public transit transfer information and geographic information, the information kiosk offers all residents and tourists the Capital's benefits brought about by informatization. During the Olympic Games, the information kiosk will also broadcast competition agenda and events through touch screens and HD digital TV on big, as well as sell tickets, serving the Olympic Games in an all round way.

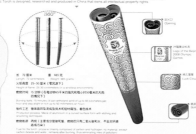

电子地图 Electronic Map

电子地图能准确地显示用户所在的地理位置，并帮助查找地理位置、服务设施等17类超过10万条的信息。涵盖政府部门、银行、超市、邮局、旅行社、景点、体育、文化、教育以及酒店等。

It accurately shows the position of the user and help search for geographic locations and service information of 17 categories of places including restaurants, hotels, government, banks, post offices, travel & leisure, sports, culture & education, and hotels.

政务查询 Government Information Search

用户可以通过"首都之窗"的窗口，查询到北京市政府各部门机关的相关政务信息及法律法规，并向市长信箱发送电子邮件进行问询求助，市长信箱收到后回复。

Users can search through the Window of Capital for latest policies and regulations including Beijing today public announcement of government affairs, for inquire and the mayor's email box, as well as track the information, users can easy talk to the mayor through the mayor's email box.

交通违法查询 Traffic Violation Search

交通违法查询与北京市交管局合作推出，市民可以通过信息亭，查询自己车辆的交通违法信息并缴纳罚款，信息亭内置10万条违法信息数据。

The Traffic Violation Search opened in cooperation with the Traffic Control Bureau, is warmly welcomed by taxi drivers, with a daily visit of much more than 100,000 time.

便民缴费 Online Payment

信息技术发展使得众多居民各项日常生活缴费不出家门即可实现。比如交纳水、电、煤气等各项费用，手机费缴纳，都可通过信息亭系统自动完成。

Technological development related to payment of residents for various fees and rest of the bank system have been completed for the Digital Beijing Information Kiosk. The kiosk is now a small scale pilot operation and residents can make payment of such daily rates as water, electricity, fixed and mobile phones automatically through the system.

免费打印路书 Free Printing of Route Information

市民可以通过信息亭查询公交线路，并可免费打印查询结果，以便了解转乘线路及目的地。

Users can search for and print out information of public transit lines so as to find their transferring lines and destinations.

火炬 Torch

"祥云"火炬不仅在燃烧稳定性与抗外界环境适应性方面达到了新的技术高度，而且在工艺方面使用铝镁合金材料进一次成型技术和环保油墨、着色技术，燃料为丙烷，绿色又安全环保。它是包括知识产权在内研发的产物，拥有完全的自主产权。

The Olympic Torch, known as "Luck Cloud", not only represents a new-level technological height in terms of burning stability and adaptation to environment, but is made of aluminum in a curved cone surface form with etching and anodizing techniques in production process, light and eco-friendly with propane as fuel. The Beijing Olympic Torch, is designed, researched and produced in China that owns all intellectual property rights.

火 炬 质 量 545 克
Length: 72 centimeters Weight: 985 grams

火炬高度 72 厘米
Height of flame: 25-30 centimeters (in a wireless environment)

燃烧时间 15 分钟（在微分钟3千米的情况下每秒1.5米的大风情况）
Burning lasts 15 minutes (it can withstand wind of up to 65 kilometers per hour and stay alight in hot up to 50 millimeters an hour)

制作工艺 铝镁合金在高温烧下进行材料加工、等处理
Production process: Made of aluminum in a curved surface form with etching and anodizing techniques

燃料成分 丙烷又富含有部分丙烯，燃烧时污染排放少、火焰明亮，适合户外环境下的火炬燃烧
Fuel for the torch: propane is mainly composed of carbon and hydrogen, no material carbon dioxide and soot remains after burning, thus eliminating risks of pollution

结构材料 材料采用薄壁的铝合金轻型铝合金材料简体制作是环保的可持续性材料，使用的是下部分中间层注塑，既好看不伤手也不伤人
Material used: the whole body uses lightweight quality aluminum alloy and hollow plastics that are recyclable; organic cement paint is used at the lower part of the torch that feels good and is uneasy to fall off

科技结合人性化设计 Architectural Technology with People-centric Design

很多创新的技术应用在水立方的游泳池设计中。户外的跳水池和板凳高度由一电脑自动控制，给运动员一个舒适的下潜环境。看台比赛时水的暖光和潜水员和运动员的视线角度的多重设备，提供3D的观看等等。这些设备会给观众带来全新的观看体验。

Many innovative designs are applied in the swimming pools in the Water Cube. For instance, outdoor air is guided to the water surface of the pool, and the bank at finish with hoses can give visual and sound signals. Other hi-tech equipment includes optical device that can identify the relative position of an athlete, and multiple-angle 3D image playing system. These devices will give spectators better experience to watch games.

国家游泳中心（水立方）National Aquatics Center (Water Cube)

国家游泳中心又称被"水立方"，位于北京奥林匹克公园内，是北京2008年奥运会的主场馆之一，也同国家体育场"鸟巢"一道成为北京奥运会地标性建筑群之一。它与国家体育场分别于北京城市中轴线北段的两侧，共同构建2008年北京奥运会公共的主体建筑群。

2008年奥运会期间，国家游泳中心承担游泳、跳水、花样游泳、水球等项目的比赛，奥运后成为高含活水上运动中心，集游泳、运动、健身、休闲为一体的中心。

水立方的建筑设计灵感来源于英国剑桥数学家Kelvin在1887年提出的"空间分割"理论，这一结构是基于了一种全最有效有效的气泡矩阵结构的方案，它将建筑外膜包成自然界中最稳定的结构，这种结构又是最有效的气泡分割结构，解决了托顿气泡理论上三种不同表面建筑中的难题。

The inspiration of structure design of Water Cube comes from the "Spatial Segmentation" theory, which, the micromolecular structure of water is enlarged to the size of a building structure with the most effective segmentation model comprises of three different surfaces, Tour differences and construction in Water Cube solves the greatest math problem in the world by following the most effective segmentation in architecture.

New polyhedron frame system is applied in the walls and roof structure of Water Cube. The rectangular steep pole chords, round steep pole braces and welding ball nodes are combined to form a network structure. As a form of segmentation, the 3,416 sq km span steel frame integrates architecture, structure, mechanics, fine chemical, materials science and computer technology, as well as creates a sustainable frame form that not only reflects the strength of the structure but delivers a natural and romantic space in perfect harmony between man and water.

建筑结构 Architectural Structure

多面体钢架结构 + 膜结构

场馆档案 Facts and Figures

建筑尺寸：长 177米 × 宽 177米，高 30 米
Size: 177m long×177m wide×30m high

建筑面积：79537 平方米
Construction area: 79,537 sq m

席位：永久 4000个 / 可移动 2000个 / 总计 11000个
Seats: 4,000 permanent seats,2000 movable seats,11,000 temporary seats

运行功能：游泳、跳水、花样游泳
Function during the Games: swimming, diving and synchronized swimming

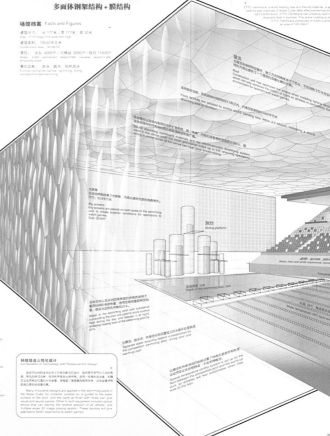

奥运科技第一次 Technologies Used for the First Time in the Olympic History

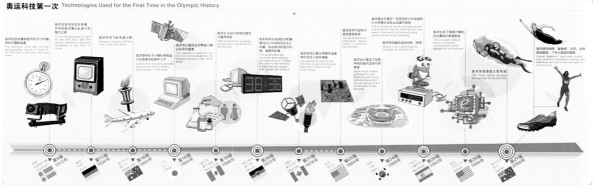

国家体育场 National Stadium (Bird)

国家体育场第1届林匹克公园建筑群内的中央位置，是2008年奥运会的主体育场。为图际奥委会合成形成。直有独特性的大跨度钢架结构成为史的建筑的大看空上。它比以下 f 可见一个类别的精巧，和材的结构如同一个巨大的支架网络编织一体。

Located in the centre of Beijing Olympic Green, National Stadium, for the Beijing 2008 Olympic Games, It forms pleasant contrast in appearance architectural technology enables the challenging and structure, forming an arc web of twisting steel structures along the full of vitality, whose radical novelty but simplicity makes it becomes sports achievement and an Olympic heritage.

场馆档案 Facts and Figures

建筑尺寸：258,000平方米

Map of Beijing Olympic

Ye Chao
Tutor: Lv Jingren
Academy of Art & Design, Tsinghua University

"2008 Beijing Olympic venues tourism and transport map" is universal knowledge version of 29th Olympic game in Beijing. It is a set of Infographic, which based on geographic information, timeline and visual data. The whole work is divided into six theme maps of Venues, Environment, Humanity, Technology, Transport, and Achievement, in order to record and display the complete process of 2008 Beijing Olympic Games. Each theme map includes two sides. One side, we try to collect and analyses a large number of materials related to the six themes, then use infograhic and illustration as major visual language instead of large amounts of text information, to show the situation about Olympics and the big change of Beijing. Some infografic are challenging to display, such as the Construction of environmental protection in Olympic Forest Park, the 120 famous tourist spots in Beijing, the use of technology of the Water Cube (National Aquatic Center), the emotion change of the public in the whole process of 29th Olympic games. And the other side, we marked out the location information related to each theme on the Beijing map, aim to reader can easier to use and research. We want to offer not only accurate, timely and deep information of the Beijing Olympics, but also a fresh visual reading experiment to the reader and traveler.

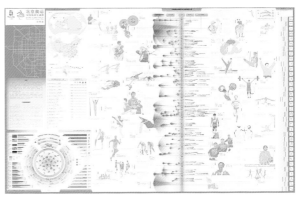

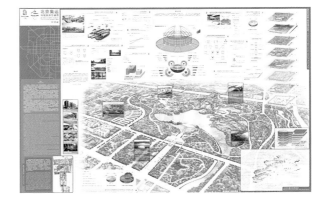

Idea: The tangible sound, a recreation of musical note of Guqin, whose elements include strings, panels and fingering. They resemble Chinese characters at first sight but are actually a combination of symbolic expression. I fused such visual simplification rules with my redesign process and integrated traditional Chinese music with the modern ones to express its modern visual effects.

High Mountains and Flowing Water

Wang Chen
Tutor: Wang Hongwei
Academy of Art & Design, Tsinghua University

Jieqi (Twenty-four solar terms) was used to indicate the alternation of seasons and climate changes in ancient China, it was also a traditional calendar about agriculture, which by Chinese sages concluded on climate and phenology change, embodies the concept of "harmony between man and nature" in Chinese traditional culture. In this work, the designer extracted the image of "air flow, seasons change", symbolization the concept of "air", and make it penetration in the set of words. The characters is based on Chinese pictograph, every Jieqi have two words which sharing some common parts of each other, in this way the two words isomorphism as a symbol. According to the change of temperature in the four seasons, the designer adjust straight andcurve lines in the characters, to express people's psychological feelings during different phenology and different seasons, it just like 24 faces of the seasons and people. The 24 leaflet books can be spelled out a complete ring, you can panoramic all the solar terms of one year at the same time, this image also suggesting that the cycle of life and time, evoke the warm memories of people.

Yan, Chaoran
Tutor: Wang Hongwei
Academy of Art & Design,Tsinghua University

Jieqi (24 Solar Terms)

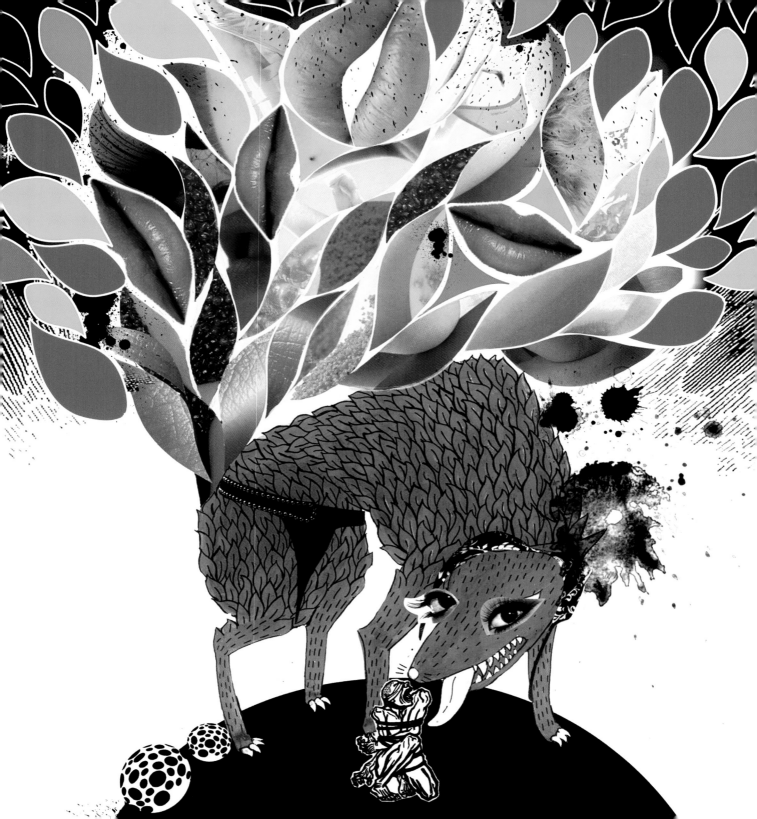

In the process of creating figures of fantasy, it's meaningful to consider how to extract inspiration and technique of expression from traditional culture and figures, how to reflect social problems through the design which concerns and involves the times, and how to show the meaning of tradition-based innovation to the present age. Using figures of ancient spirits and ghosts and their implication in illustration is actually a technique that "using the past to disparage the present". So above all, it's of great practical significance to recreate these ancient figures between the real world and the unreal one.

Song, Chen
Tutor: Yuan Bo
Academy of Art & Design, Tsinghua University

Monster

IDL

24h 01h 02h 03h 04h 05h 06h 07h 08h 09h 10h 11

Zhejiang University

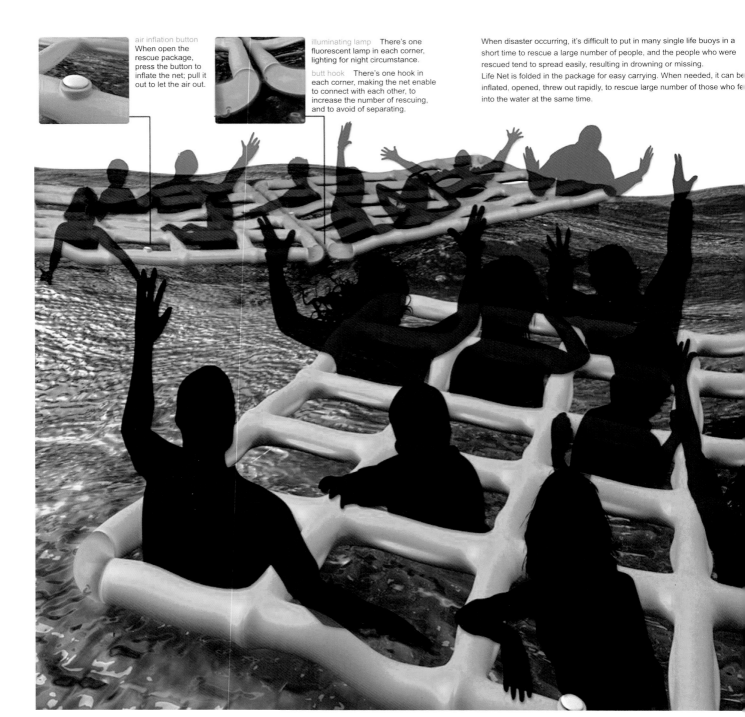

air inflation button
When open the rescue package, press the button to inflate the net; pull it out to let the air out.

illuminating lamp There's one fluorescent lamp in each corner, lighting for night circumstance.

butt hook There's one hook in each corner, making the net enable to connect with each other, to increase the number of rescuing, and to avoid of separating.

When disaster occurring, it's difficult to put in many single life buoys in a short time to rescue a large number of people, and the people who were rescued tend to spread easily, resulting in drowning or missing.
Life Net is folded in the package for easy carrying. When needed, it can be inflated, opened, threw out rapidly, to rescue large number of those who fell into the water at the same time.

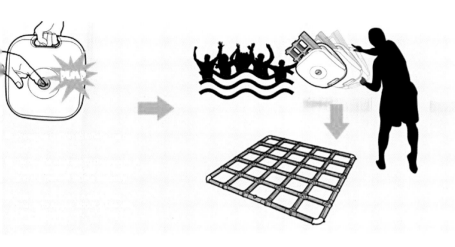

Life Net 是一个网式水面救生系统。传统的救生圈在救援时反应速度慢，且一个救生圈只能在同一时间给一个落水者使用，当发生大规模海难时，需要大量的救生圈，且被救者很容易漂散开，面临新的危险，因此传统水面救生设备无法及时起到有效的救援作用。为了解决这个问题，浙大学生创意了"网式救生系统"的概念。平时，压缩折叠的救生网储存在一个救生包中，发生海难时，按下按钮就能在短时间内给救生网充气，将救生包抛向落水者，救生网在瞬间膨胀打开，形成一个漂浮救生网，可在同时救援数十人，单个的救生网还能互相连接，形成更大的救援系统，避免被救者分散失踪，而救生网四角的荧光灯更有利于夜间的营救。

设计者：陶　骏　李　冰　李欣睿　高珊珊
　　　　李振鹏　赵晓亮　马太郎

Life Net

Home of Firefly

设计者：李 琼 秦笃印 彭俊杰

Home of Firefly offers a dwelling and feeding place for the fireflies, and uses the natural firefly light as a stand street light, ecological and natural, bringing us back to the childhood memory.

ECOLOGY & NATURE & MEMORY

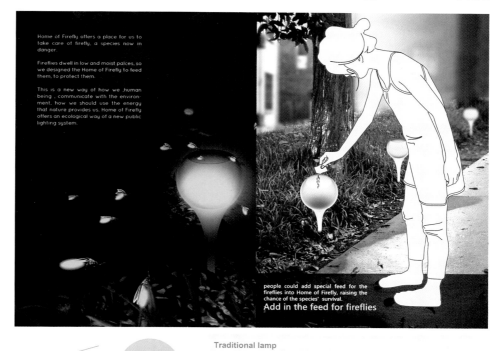

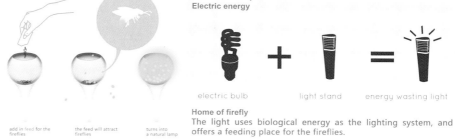

Home of Firefly 是一盏利用生物能（萤火虫本身的光）而发光的地灯。同时它为这种即将灭绝的生物提供一个获取食物和居住的地方。人们可以在灯内放入萤火虫的食物从而吸引萤火虫过来，与此同时也照亮了夜行的路人。它是一种全新的公共照明方式。

Ad-tramp

设计者：汪佳希　沈美盈　彭俊杰
　　　　张乐凯　应咪娜

AD-TRAMP IS A POSTER CABINET HOME FOR THE HOMELESS.IT USES THE HEAT GIVES OFF FROM THE COMMERCIAL CABINET LIGHT, KEEPING THE TRAMPS WARM AND SAFE.

Tramps are a large group of people that need the care from the society, and the lives of homeless people can be difficult during the winter. Ad- tramp offers a home for the homeless people using the heat from the poster cabinet to keep them warm. Most importantly, it causes no other waste of energy, needing just the original light energy of the commercial cabinet, and make use of the energy.

Ad-tramp 为一款为都市流浪者设计而设置在广告灯箱中的概念住房。它利用了商业用广告灯箱自身产生的热量，让该住所空间保持温暖和安全。

Wheel+Chair is a wheelchair without a chair.

It is designed to help the disabled people in the very poor regions who could hardly afford a wheelchair. The user could easily attach the devices we designed to the chair they already have optimizing the local materials and resources.

Wheel+Chair is not only a design but more of a low carbon action as well as humanity care.

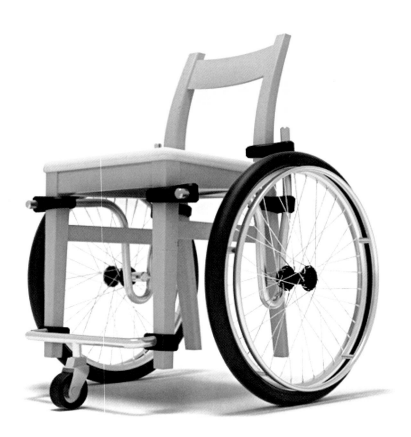

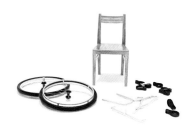

HOW TO USE

❶ Find a chair you already have
❷ Attach the key links to the chair you find
❸ Fit on the wheels

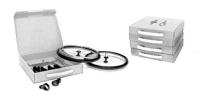

Social responsibility

Designed for the poor regions where people could hardly afford a wheelchair, but with special design the people could use their own chair as part of a wheelchair. The cost of Wheel+Chair is very low, so this could be philanthropy or even a governmental action.

Sustainable Design

Wheel+Chair integrate and optimize the local resources as part of the wheelchair, which could greatly cut down the production expenses. Thus the user could assemble the wheels to their own chair easily with designed structures.

Easy Transportation

With demountable structure, the product is easy for transportation or delivery.

一张没有椅子的"轮椅",这张轮椅的奇妙之处就在于设计本身并没有把座位设计进去,只考虑车轮,因为只要拿一把随处可见的椅子安在这套车轮上,瞬便就变成了轮椅,非常适合灾区需要,而且成本又低。

设计者:孙　欣　彭俊杰　罗哲宁

Wheelchair without Chair

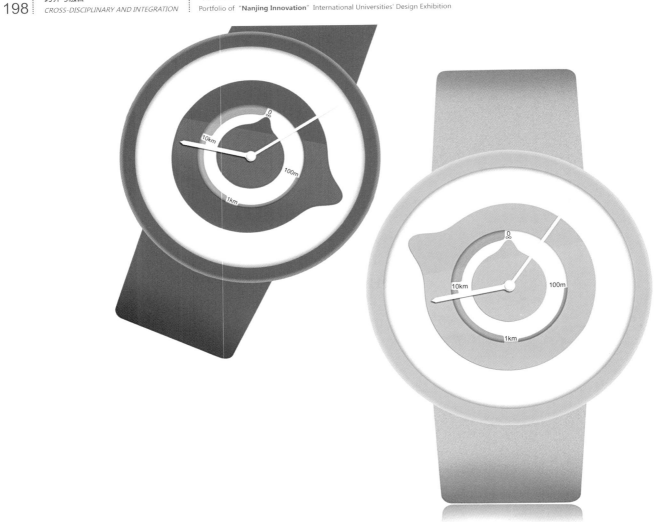

Always Together

设计者：侯国涛　李文杰　胡　一　潘佳琪

Always Together

"Always Together" are twin watches designed to get people closer. They use GPS technology and can easily help you find your partner's oritentation and distance from you.

The big cam of one watch always points at another one. And the little cam displays the distance between the two watches. The distance is divided into 4 parts, in each of which the little cam moves evenly. While it moves slower and slower from one part to another part.

»Design for Whom

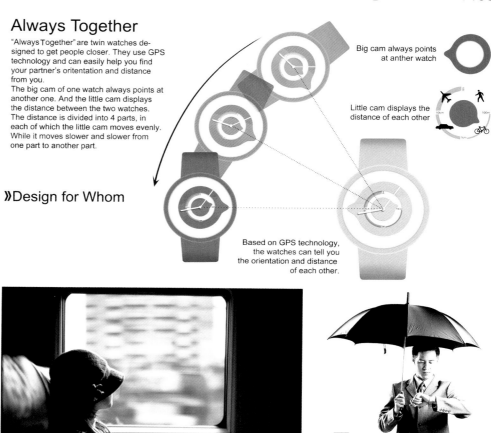

Big cam always points at anther watch

Little cam displays the distance of each other

Based on GPS technology, the watches can tell you the orientation and distance of each other.

"Always Together" will tell you where she/he is

Always Together 是一款为情侣特别设计的手表，该手表基于 GPS 技术，能够让你很容易地知道同时佩戴此款情侣手表你的他 / 她现在何方。

Fly Asher

设计者：唐智川

我们是否总是担心房子清扫干净了没有？特别是清扫顶棚，它就更难处理了。该设计采用水母作为这个吸尘器的原型，采用"飘浮在空中"的氢气作为浮力。在清理天花板时，可以一手拉着一脚，控制方向。

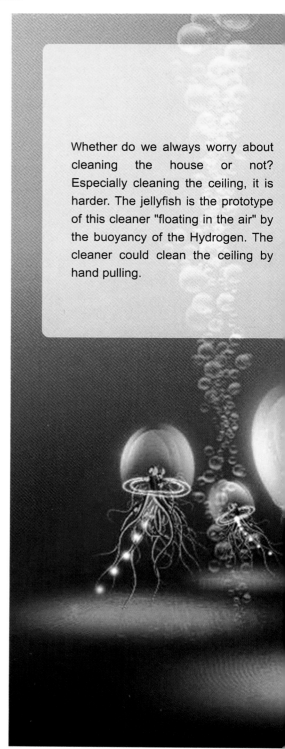

Whether do we always worry about cleaning the house or not? Especially cleaning the ceiling, it is harder. The jellyfish is the prototype of this cleaner "floating in the air" by the buoyancy of the Hydrogen. The cleaner could clean the ceiling by hand pulling.

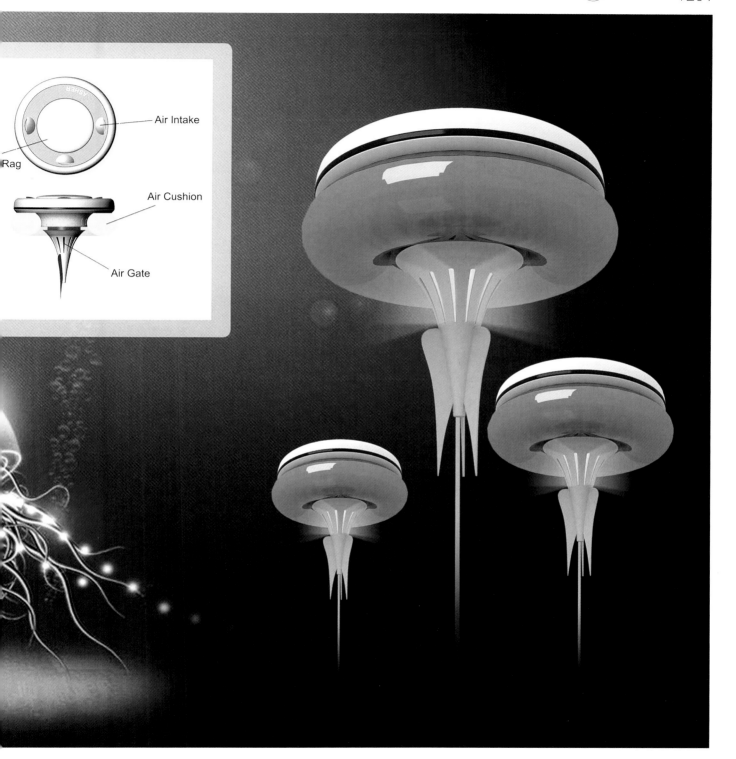

Air Intake

Rag

Air Cushion

Air Gate

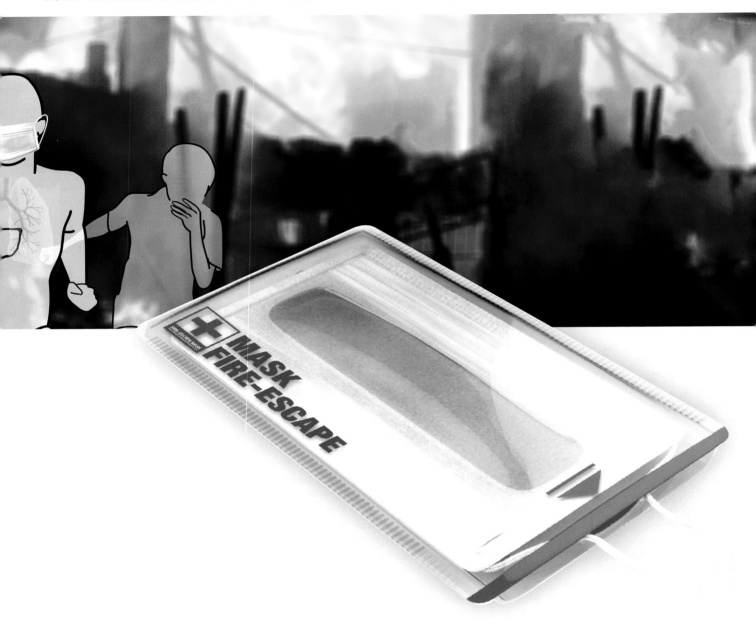

Fire Escape Mask

设计者：蒋婕雨　方子硕　胡滕文　童　上　池　承

Step 1
Pull out the mask out of package and the liquid is squeezed by the palstic slice posited at the opening.

The plastic slice The liquid

Step 2
As the mask pulled out,the liquid permeates and moistens the mask.

The slice squeezes the liquid

Step3
When the mask gets wet,wear it to protect against the smoke.

The liquid permeates the mask

SIDE VIEW

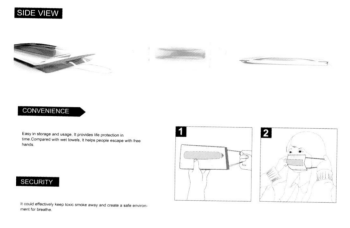

CONVENIENCE

Easy in storage and usage. It provides life protection in time.Compared with wet towels, it helps people escape with free hands.

SECURITY

It could effectively keep toxic smoke away and create a safe environment for breathe.

- AIR CLEANING

- DISPOSABLE1

- ENVIRONMENTAL MATERIAL

Fire Escape Mask 为一款特别的口罩，口罩中含有药物液体，戴着它能够在火海逃生。它有效地阻隔了可能会吸入的有害气体，在火灾中保护人们的人身安全。

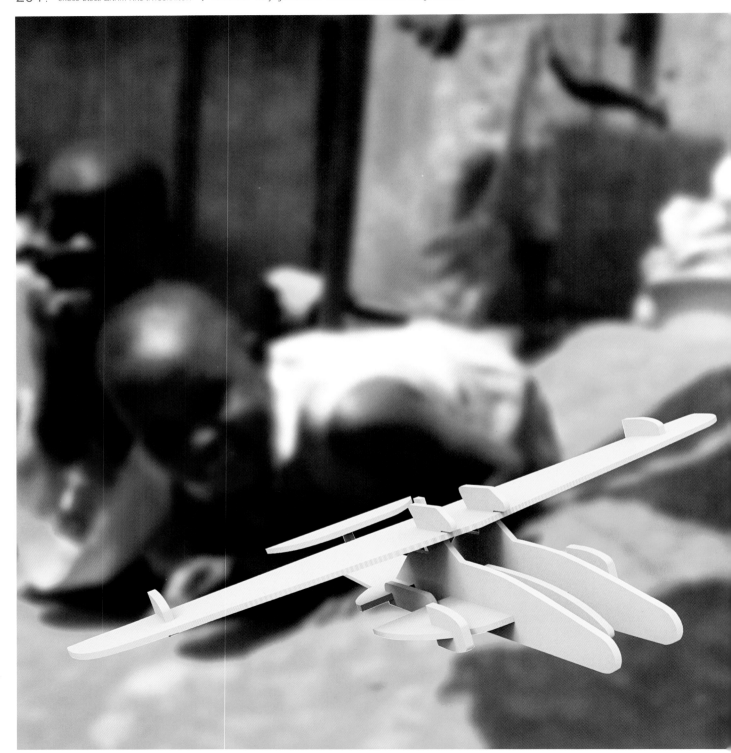

Internal Details

Paper Toys

设计者：朱宁宁　许天宁　汪佳希　吴　佳

Paper Toys 是将救援过程中不用的包装纸箱进行再设计，废旧纸壳可以搭成各种形式的小玩具，给灾区或是贫穷地区的小朋友玩耍。

In many disaster-hit areas, personal insanitation has always been a problem. Flexible private bathroom is a simple, portable and cost effective solution to this problem by offering a bathroom which can be packed as a flat plate, which makes the bathroom easier for bulk transport when needed. The flexible private bathroom will be useful to improve the quality of personal hygiene in disaster-hit areas, and makes users feel more secured (comfortable) while showering in the bathroom. What's more, it is a water-saving bathroom with 360 degree showers, a recycle system and a filter layer to ensure the quality of the water.

Flexible Bathroom

设计者：汪佳希　许天宁　张克俊

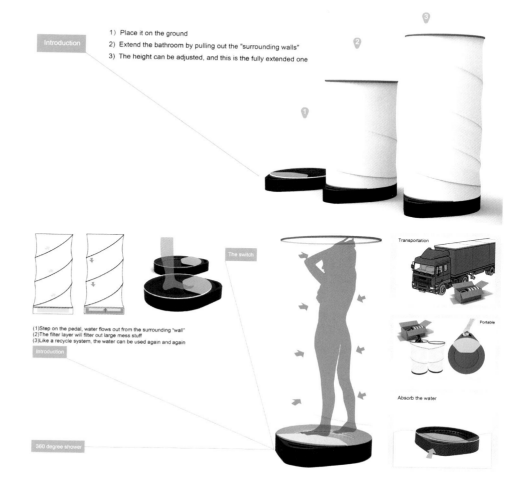

Introduction

1) Place it on the ground
2) Extend the bathroom by pulling out the "surrounding walls"
3) The height can be adjusted, and this is the fully extended one

The switch

(1)Step on the pedal, water flows out from the surrounding "wall"
(2)The filter layer will filter out large mess stuff
(3)Like a recycle system, the water can be used again and again

Introduction

360 degree shower

Transportation

Portable

Absorb the water

在很多灾害地区，保持个人卫生的清洁是一个很严峻的挑战。Flexible bathroom 是一款简易、可携带并且经济实用的公共浴室；由于可被压缩成扁平状，所以非常方便运输和放置，此外它能根据个人的身高进行调整，保护了人的隐私性。另外，它具有储水功能并能进行 360° 全方位的洗浴，底部的循环利用水系统和过滤层保证了水质。

可溶性纸钱设计

设计者：许天宁　朱鹏飞　王一鸣
　　　　管弘跃　汪佳希　孔　莹

烧纸祭奠古人是中国传统风俗，但我们都知道这不是一种环保健康的方式，既产生空气污染，又容易造成火灾，所以我们想做一些改变，既能寄托哀思，在满足烧纸这样形式的同时又能用相对环保的方式去实现。在生活中，糯米纸经常被作为包装，它在口中一吃即化，所以我们想用糯米纸替代纸张，用水融化的形式去实现。

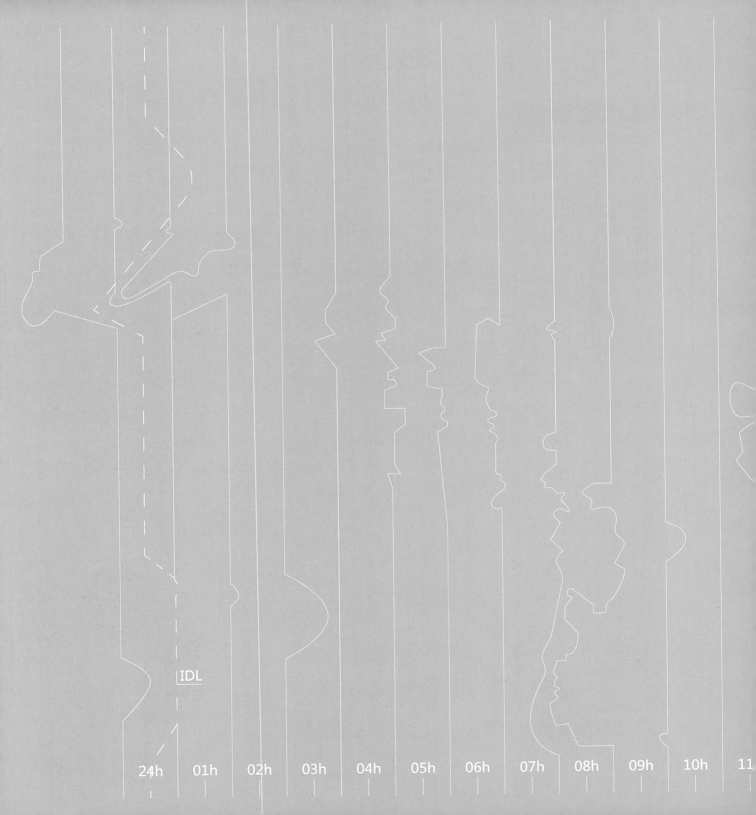

IDL

24h 01h 02h 03h 04h 05h 06h 07h 08h 09h 10h 11

**Wuhan University
of Technology**

三角组合多媒体音箱

Triangular Combination Multimedia Speakers

设 计 者：周盛花
指导教师：郑建启

It has a triangle assembly, simple and stable for a person. On the way of use, it is a integrated equipment, easily to moving, and it helps to save the space of the desktop. It can also separate two independent satellite boxes from its integrated body on the both sides. It is easily to put at the right angle, position to adjust the sound.

The satellite boxes are different from the white subwoofer. It has a black frosted texture, for increasing the friction when the satellite boxes embedded in the main body.

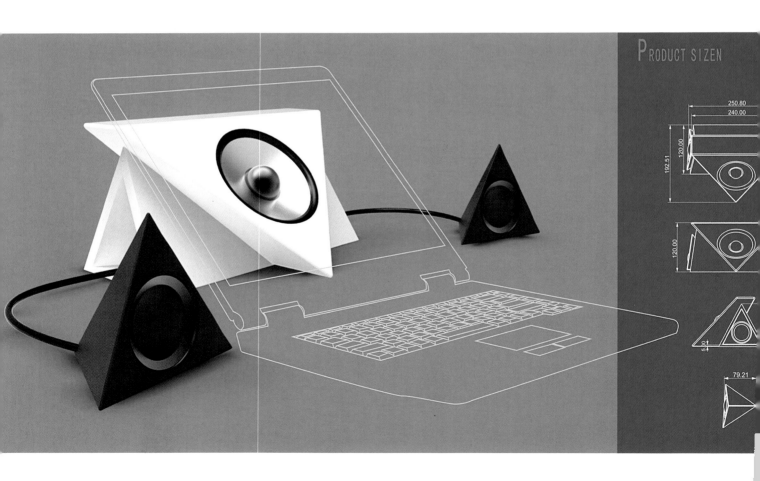

PRODUCT SIZEN

250.80
240.00
192.51
120.00
120.00
5.00
79.21

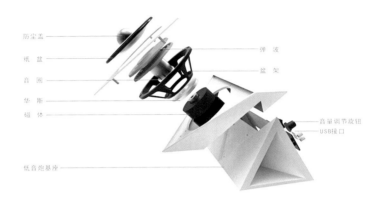

防尘盖
纸盆
音圈
华斯
磁体

弹波
盆架

音量调节旋钮
USB接口

低音炮基座

Subject subwoofer has 115mm diameter , height of 60mm, 4 inch bass audio speakers.
Satellite box has 53mm diameter, height of 30mm, 2 inch speakers.

DETAILS OF THE FIGURE

USB interface connects to some electronic products for charging, such as PC, mobile phones,
Its body has not too many buttons, which keeps the essence of the speakers.

健康游戏椅

Healthy Game Chair

设 计 者：江玉洁
指导教师：汤　军

In terms of associating that people would shake their bodies unconsciously when they are playing electronic games (especially athletics games), this design is aiming to collect motion signals generated by people's manipulation of the game chair. Then, the game chair will transmit the gathered signals to computers or televisions through the USB interface. Thus, the game chair could take the place of a joystick, to achieve the purpose of controlling the game.

In this way, when playing electronic games, people could drive the game chair shaking and moving to issue control instructions. So people could not only control the game, experience more realistic game scenes, but also get full exercised.

The design implemented a new and healthy way of TV and computer entertainment. It realized thinking entertainment and action entertainment coincidently, when players control their bodies to manipulate the games through this functional design.

多媒体音箱

Multimedia Speakers

设 计 者：冯安然
指导教师：郑建启

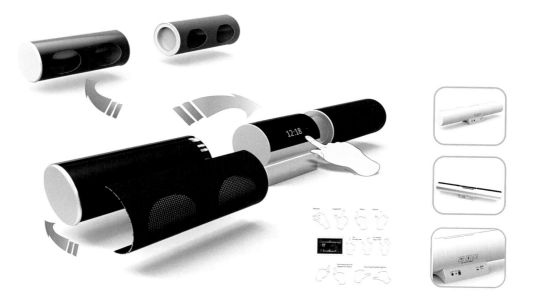

The product has a very special structural design and set grey as the main color. Since the metal silver can take more daily use. Metal silver is the additional color. This series design and color can fit the mainly market such as Apple. It is more easier for customer to use the stereo with an Apple product as a system.

To satisfy the daily use of customer and make it be more convenient, there is a CD player on the top of the product.

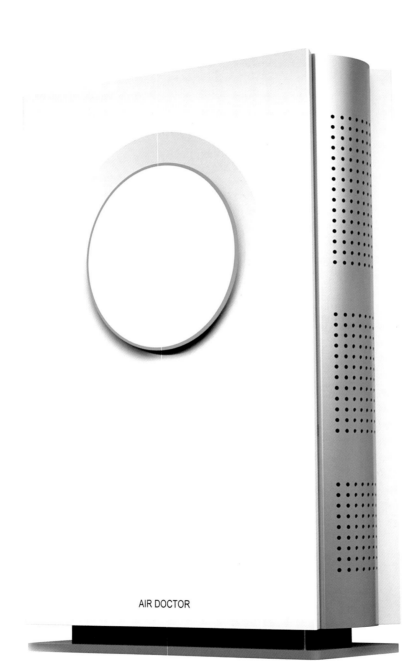

AIR DOCTOR

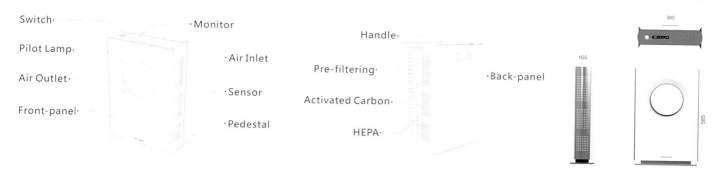

1. Detecting System

2. UI

设 计 者：常　浩
指导教师：黄雪飞

空气净化器

Air Doctor

婴儿推车

Baby Stroller

设 计 者：方江成
指导教师：黄雪飞

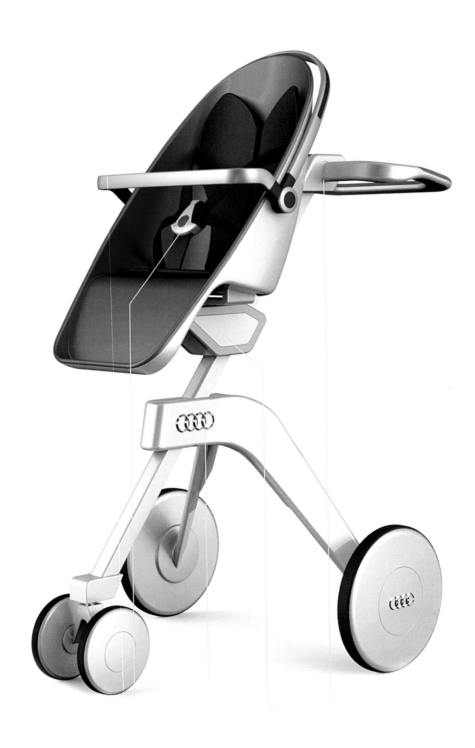

Details

Usage Analysis

❶

❷

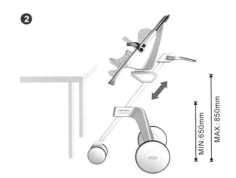

MIN:650mm MAX.:850mm

Currently, the young and the high cultural quality are increasing in parents' life. Strong health awareness, consumer power, consumer demands more related products with the baby, and a new generation nursery cultural instead of the traditional concept for bring up the baby. About the multi-functional, diverse quality products, high-quality service and professional guidance, as well as the humanized and emotional products, become the parents shopping concept in modern life.

The section stroller is based on promoting the communication between parents and children, so that children can have a good starting about the world. The traditional baby car seats can lift the seat to let the children and parents closer to the line of sight, is conducive to the interaction between parents and children, but it can be used as chairs used. In the internal five-point seat is safety, which prevent babies.

拉杆旅行箱

Pull Rod Box

设 计 者：韩 冰
指导教师：黄雪飞

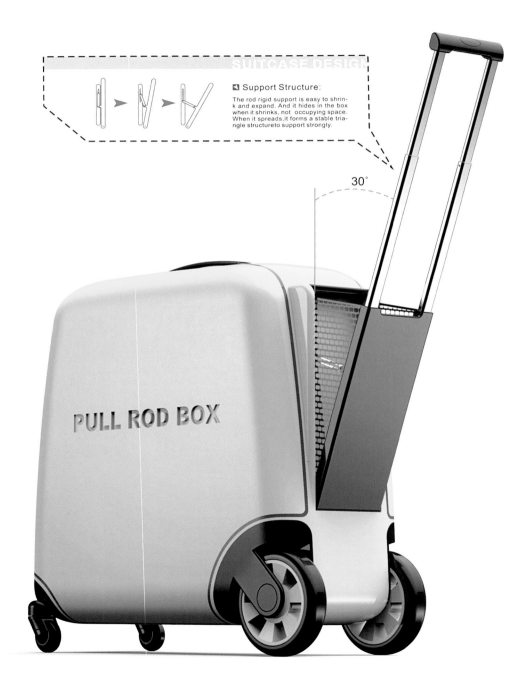

SUITCASE DESIGN

◀ Support Structure:

The rod rigid support is easy to shrink and expand. And it hides in the box when it shrinks, not occupying space. When it spreads, it forms a stable triangle structure to support strongly.

30°

PULL ROD BOX

The pushing-type suitcase combine cart with suitcase. It changed the traditional mod of transportation of the suitcase, from pulling forward to pushing forward. The change of the overall usage increases body stability in the process of transportation and reduces the weight of the hand. So it can save labors even long-time pushing. And compared to the traditional suitcase in used advantages, the pushing-type suitcase has greater space advantage.

The pushing-type suitcase can set the contraction and expansion of rigid support on the pull rod. The box between the pull rods added a hidden space so that redundant little luggage can be placed in a net bag at ordinary times. This improves the security in the process of transportation. The pushing-type suitcase improves the stability of the enclosure movement process as a whole.

The nets can be placed extra small luggage.

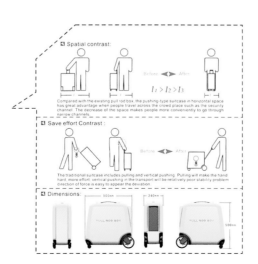

Spatial contrast:

$l_1 > l_2 > l_3$

Compared with the existing pull rod box, the pushing-type suitcase in horizontal space has great advantage when people travel across the crowd place such as the security channel. The decrease of the space makes people more conveniently to go through narrow channels.

Save effort Contrast :

The traditional suitcase includes pulling and vertical pushing. Pulling will make the hand hard, more effort; vertical pushing in the transport will be relatively poor stability problem direction of force is easy to appear the deviation

Dimensions:

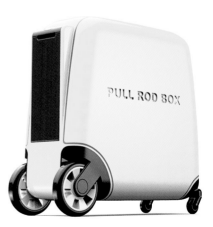

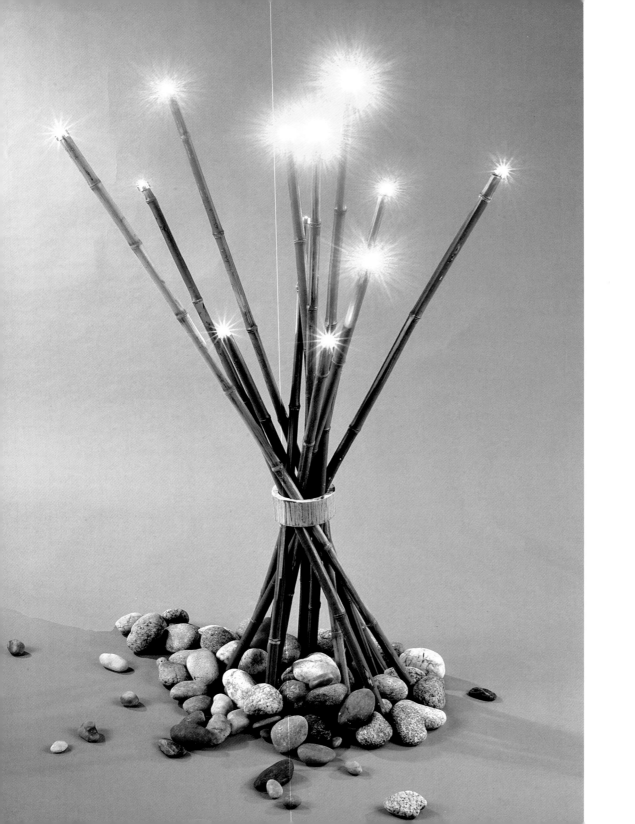

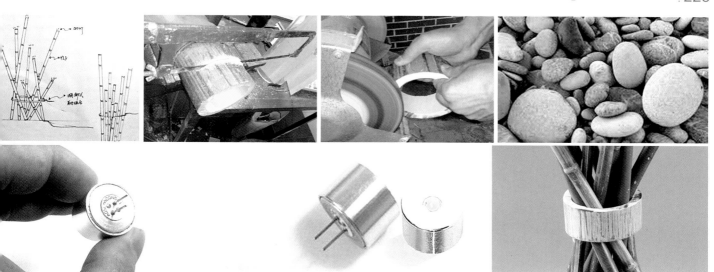

This is a green energy lighting design, inspired by the fireflies.

It uses the environmentally friendly bamboo and energy saving green LED light.

设 计 者：谭 浪
指导教师：胡 飞

"竹•萤" 灯具
Bamboo Lamp

自助式付款机

Self-Service Payment Machine

设 计 者：严斯倩
指导教师：孙　隽

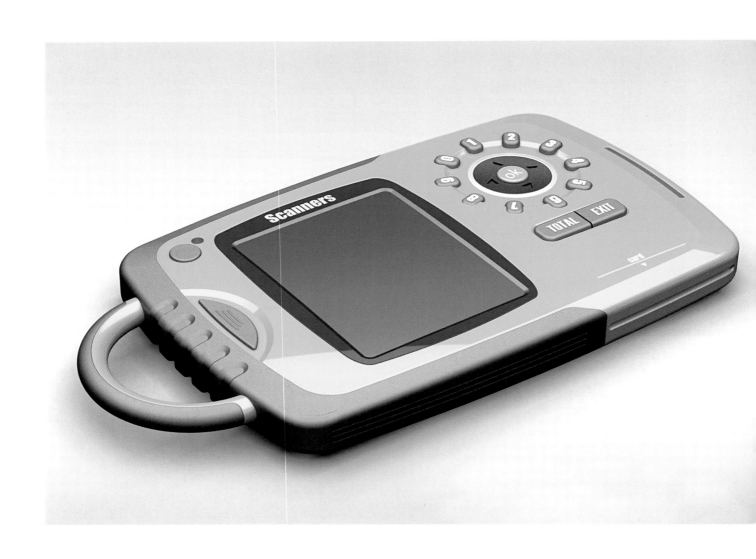

For large supermarket shopping is crowd, self-service payment machine namely gives you a check-out payment machine.

This machine is a small handheld device, a small light, customers can purchase goods by side edge scanning products.

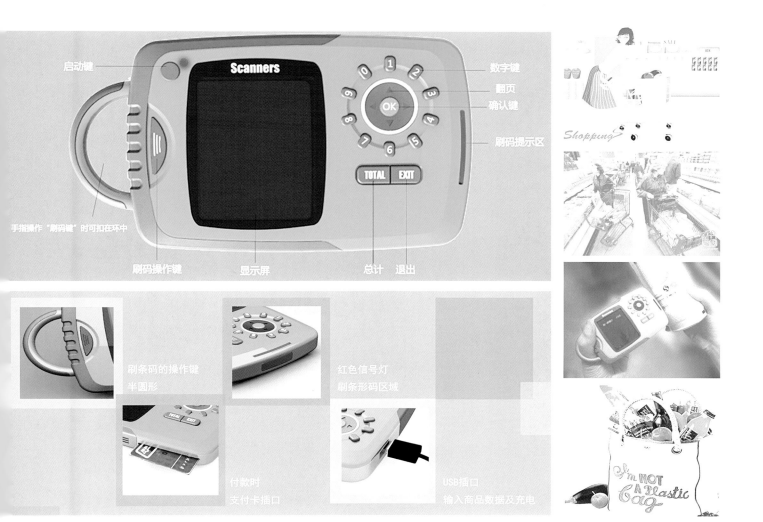

启动键
数字键
翻页
确认键
刷码提示区
手指操作"刷码键"时可扣在环中
刷码操作键
显示屏
总计 退出
Scanners
刷条码的操作键 半圆形
红色信号灯 刷条形码区域
付款时 支付卡插口
USB插口 输入商品数据及充电

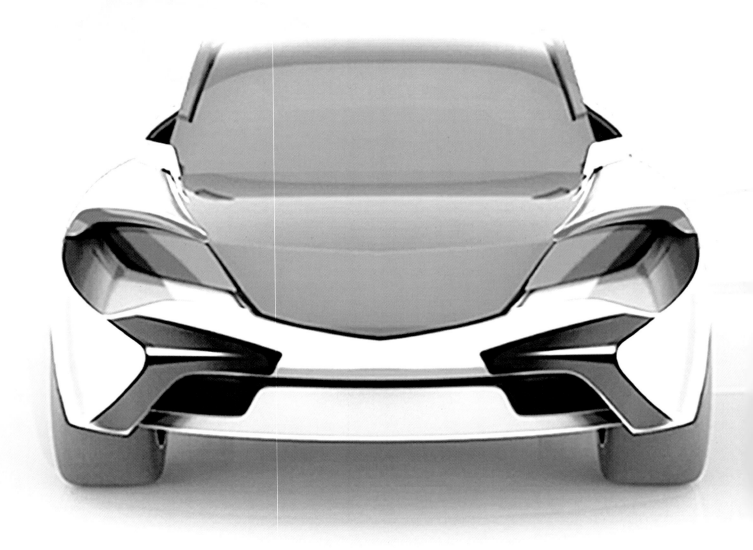

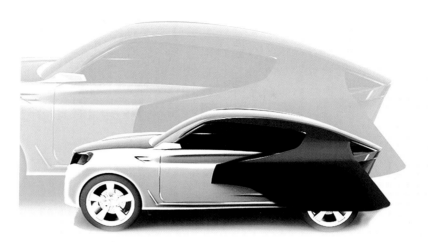

Between the sedan and SUV, the crossover SUV has a good flexibility and comfort. It can better meet the needs of young people n speed and movement, rather than the traditional SUV demand for energy.

In appearance, it draws a dress coat and bow a shape language, to give the product to the elegant noble temperament, psychological dentity is more able to get the target population. In the body structure, the use of lightweight materials to reduce the weight of he body to reduce the fuel consumption.

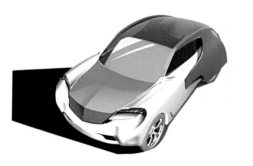

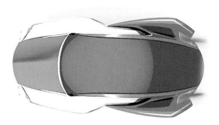

设 计 者：刁 奇
指导教师：柯常忠

跨界运动多功能车设计

Crossover SUV

Cobra 法拉利单座跑车设计

Ferrari Single Seat Sports Car Design

设 计 者：胡　科
指导老师：吴　婕

The body design was inspired by Enzo Ferrari and the design of front face was inspired by cobra, and this is the reason why it called Cobra. Body styling is elegant in aerodynamic, the spoiler will change its angle when the car running with a high speed. The surroundings of the car will be shown on a huge screen in the cab to the driver.

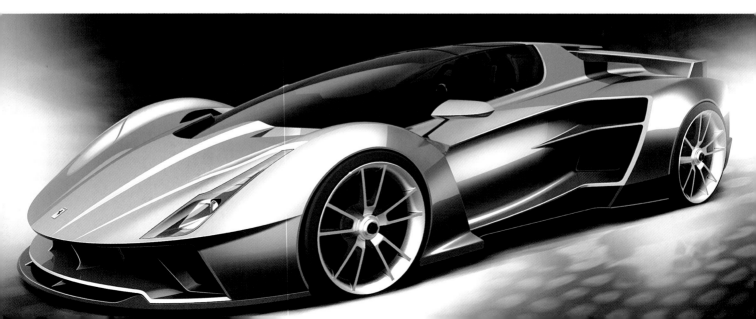

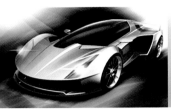
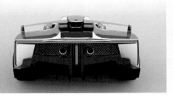
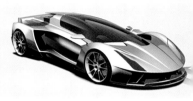

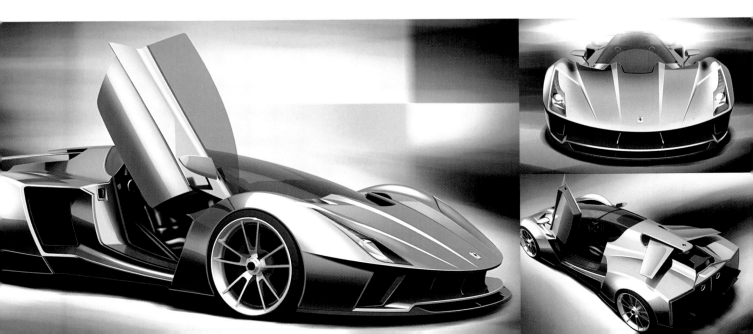

IDL

24h 01h 02h 03h 04h 05h 06h 07h 08h 09h 10h 11

南京理工大学
NANJING UNIVERSITY OF SCIENCE & TECHNOLOGY

GMT

IDL

"Super Farm" 在家经营的 DIY 农场
——儿童室内种植玩具

设 计 者：米大为　李　雪
指导老师：段齐骏

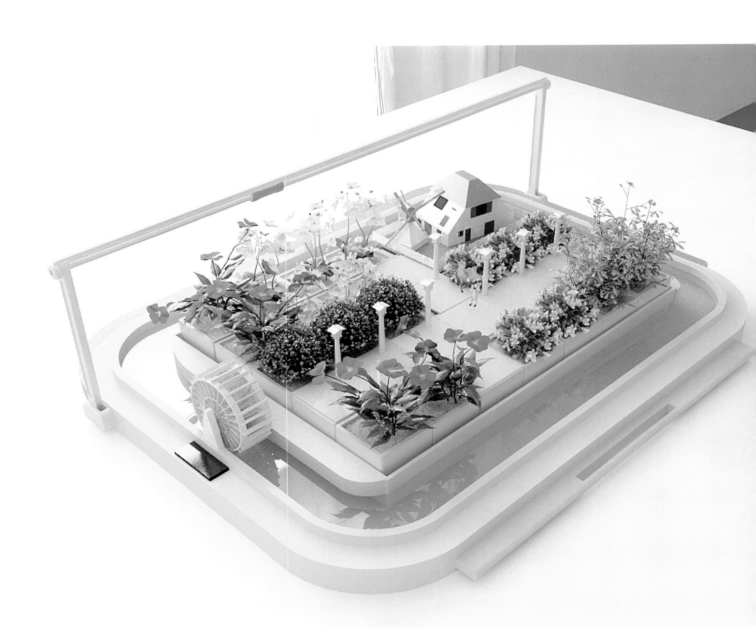

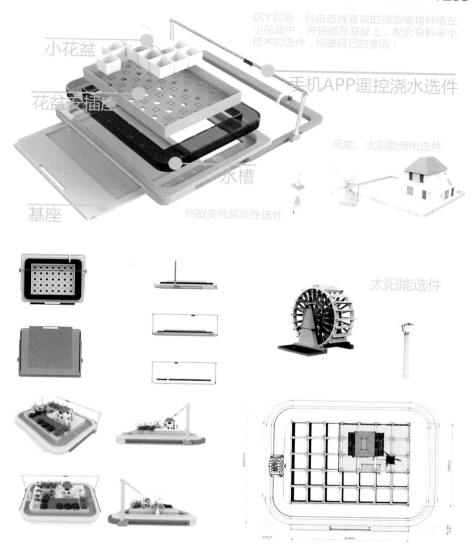

小花盆

花盆又插座

手机APP遥控浇水选件

DIY农场，自由选择喜欢的微型植物种植在
小花盆中，并拼插插在基座上，配合有科学小
技术的选件，构建自己的家园！

风能、太阳能储电选件

水槽

基座

热敏变色装饰性选件

太阳能选件

针对越来越多的孩子沉迷于网络电子游戏这
一现象，设计该款模拟农场种植玩具，借以
吸引孩子们的兴趣，达到寓教于乐的效果，
摆脱对电子游戏的依赖。玩具创意来源于网
络农场经营游戏，帮助孩子们在现实生活中
培养对自然生物的热爱。同时结合太阳能、
水能等简易的科学知识，让孩子们在玩游戏的同
时动手动脑，体验科学与自然带来的乐趣。孩子
们可以自由使用玩具配套的各种道具来亲自设计
自己喜欢的农场造型，家长也可以在这个过程中
指导，增加孩子与家长交流的机会。

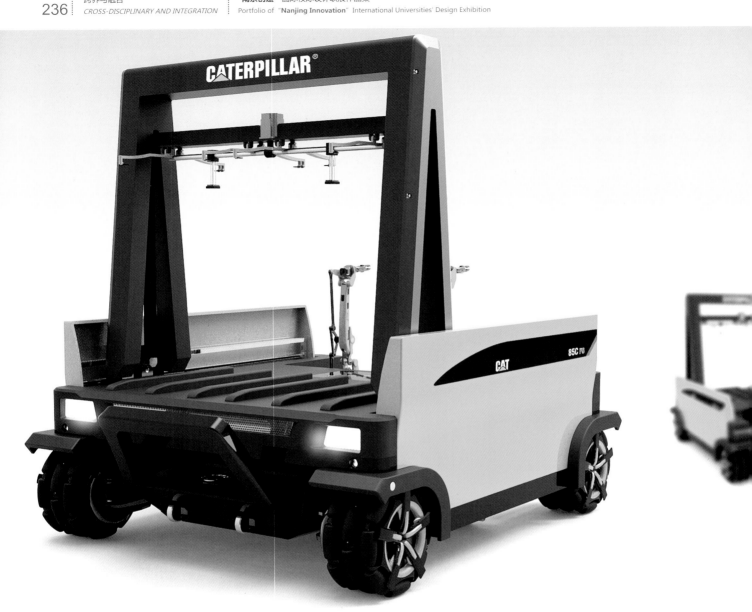

BrickBot

Grand Square Construction Robot

设 计 者：龚华超
指导老师：张　锡

Problems for Manually Paving Tiles:

Tough work	Working in the open-air, longtime stoop and squat.	
Low Efficiency	20 m²/day, project time always longer than 6 months.	
Low Precision	Easy to leave cavity and collect rainy water.	
Aging Workers	A lack of workers, esp. the young.	
High Cost	High labor cost and difficult management.	
Block Traffic	Blocking traffic with long project time.	

Automatic Laying Process (find more from the animation)

truss go back

truss come to front

lay tiles

Intermittent release of quick-drying cement

A pair of claws on truss grasps the top two tiles, then moved back along the rails with truss.

Claws down the brick to robot arms.

While truss returns, the robot arms lay 2 tiles, and save half of time.

After finishing paving one line, robot presses the tiles in reverse.

Easily Remote Control with Just Three Groups of Bottoms

1 By pushing '+','-', the controller can set the number for tiles paving. As showed in the picture, 49 is the number for the next line of tiles.

2 The 'Start'(green) and 'Stop'(red) bottoms allow the device to maneuver with great precise.

3 When the controller press 'left' or 'right', the robot will reset its arm, reverse on its line and shift its position for another line.

Without much staff training, it is designed to be easy. It is also obtained a easy operation, a comfortable use experience, good practicality, and strong flexibility, together with expandable and sound security as the system's features.

From One Line to Another

go forward to pave

reverse to press the line

shift position for next line

Size

The size is designed for the balance of flexibility, capacity of a grand square.

		85C FS (mm)*
A	Length	1700
B	Wheel Base	1300
C	Wheel Diameter	400
E	Side Baffle Height	790
F	Height of Truss	1600
G	Ground Clearance	190
H	Wheel Height	410
J	Width of Compaction	900
K	Width	1500

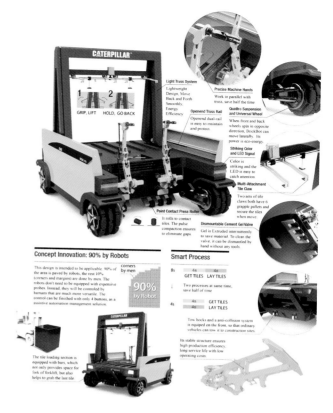

CATERPILLAR

1 2 GRIP, LIFT HOLD, GO BACK

Light Truss System
Lightweight Design, Move Back and Forth Smoothly. Energy Efficiency

Openned Truss Rail
Openned dual-rail is easy to maintain and protect.

Precise Machine Hands
Work in parallel with truss, save half the time

Quatro Suspension and Universal Wheel
When front and back wheels spin in opposite direction, BrickBot can move laterally. Its power is eco-energy.

Striking Color and LED Signal
Color is striking and the LED is easy to catch attention.

Multi-Attachment Tile Claw
Two sets of tile claws both have 6 grapple pallets and secure the tiles when move.

Dismountable Cement Gel Valve
Gel is Extruded intermittently to save material. To clean the valve, it can be dismantled by hand without any tools.

Point Contact Press Roller
It rolls to contact tiles. The pulse compaction ensures to eliminate gaps.

Concept Innovation: 90% by Robots

This design is intended to be applicable 90% of the area is paved by robots, the rest 10% (corners and margins) are done by men. The robots don't need to be equipped with expensive probes. Instead, they will be controled by humans that are much more versatile. The control can be finished with only 4 buttons, as a assistive automation management solution.

90% by Robot

corners by men

The tile loading section is equipped with bars, which not only provides space for fork of forklift, but also helps to grab the last tile.

Smart Process

8s	4s	4s
	GET TILES	LAY TILES

Two processes at same time, save half of time

4s	4s	
	GET TILES	
	LAY TILES	

Tow hocks and a anti-collision system is equiped on the front, so that ordinary vehicles can tow it to construction sites.

Its stable structure ensures high production efficiency, long service life with low operating costs.

Tiles construction on grand square results in an inefficient progress due to manual laying. BrickBot is a rapidly-laid grand square construction robot, which is based on very mature mechanical design and can achieve mass production. The prototype test has proved that it is 15 times faster than handwork in tile laying, exceeding 300 square meters each day. After tiles are loaded by the forklift, BrickBot constructs automatically under the supervision of only one person. Universal wheels can rotate in place to meet the route requirements flexibly and precisely. Construction of high precision can get rid of puddles from the rain. It symbolizes the future trend of automated construction by innovation of brick paving handcraft, increase of efficiency and precision, eco-energy solution and shortening of traffic control period.

LED Light
智能护眼台灯

设 计 者：鞠　云
指导老师：姜　霖

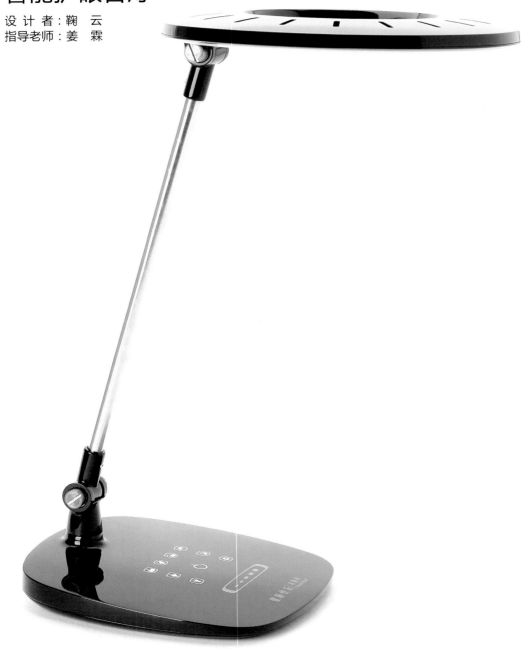

南京理工大学

毋庸置疑，光和人的关系是一个永恒的话题。本设计基于 LED 台灯的造型设计提出"品位、生活"的设计理念，即以其大气而不失细微的造型，凝重而不失飘逸的风格，简约而不失精致的风格，充分迎合现代都市的品位与个性。以"品位、生活"为设计理念，以鲜活的创新能力为基础，达到功能性与艺术性的完美结合，让使用者在享用高品质产品的同时享受更多高品位生活。针对 LED 台灯的护眼功能，充分利用其光源的低压直流驱动、无频闪、极低功耗、光线集中、环保、使用寿命长、易于控制等诸多优点，增加多媒体模式、负离子发生器、光敏感应、同步移动终端等功能，打造出造型与功能完美结合的全自动智能调光 LED 护眼台灯。

55 颗 LED 灯珠环形矩阵排列，确保无阴影照明。
50cm 最佳高度，人性化，关爱用户，内置光敏电阻。
智能调光系统设有扬声器播放美妙音乐，负离子发生器释放清新空气。造型低调，优雅，极致简洁，轻薄，尽显高贵品质。

海洋音乐会——儿童手摇音乐盒

设计者：罗丹 历 昕 许 璇
指导老师：段齐骏

南京理工大学
NANJING UNIVERSITY OF SCIENCE & TECHNOLOGY

蜗杆和共轴齿轮　音板　音筒

设计的科学性也主要体现在两个方面。

A. 因为音乐盒本身牵涉到多组齿轮、蜗杆等的传动（在这个设计中我们将其简化，仅为一组），孩子在组装的过程能直观地感受动力的传动和力的方向的变化。

B. 谱曲是设计的关键点。孩子可以按照他们熟悉的曲谱去拨动移动点，从而摇出他们想要的音乐，也可以自行谱曲，则能带来更多的成就感。

DIY流程说明

1 组装部件
2 连接部件
3

科学性说明

尺寸说明 mm

本设计的定位为小学低年级儿童，尤其是对音乐有兴趣和天赋的孩子。因为定位年龄低，因此仅保留八音盒的音板。随着年龄层次的提高，可以进阶为十六音等。这个设计我们从内新为将传统的手摇音乐盒的原理出发，将音乐盒的每个部件拆开并手子以重新设计，以及最大的创新为将转筒上固定凸点转化为可以由凸点自行创作曲谱的移动点，以及将整个装配设计成可自己DIY组装的模式。整个设计的科学性也主要体现在这两个方面。1）因为音乐盒本身牵涉到多组组齿轮、蜗杆等的传动（在这个设计中我们将其设计简化，仅为一组），孩子在组装的过程能直观地感受动力的传动和力的方向的变化。这样就能用相同的力带来更快的效果。2）谱曲是设计的关键点。孩子可以自行谱曲，也可以按照他们熟悉的著名的曲谱去拨动移动点，从而摇出想要的音乐，则能带来更多的成就感。

锐成机床创新工业设计

设 计 者：房　凯
指导老师：王　展

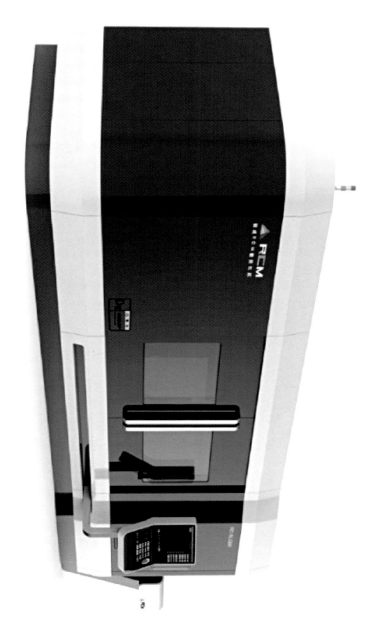

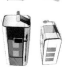
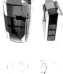

南京理工大学
NANJING UNIVERSITY OF SCIENCE & TECHNOLOGY

造型思路 Design Concept

○ 美学角度：根据机床产品对色彩、形态、材质的要求。对机床进行造型发散。

○ 人机工程：根据机床对人机工程学的要求对形态形态细节进行归纳缩小。调整与人接触的部件色彩、形态、材质。

○ 成本控制：尽量减少不必要的复杂形态，使造型简洁以达到节约成本的目的。

设计定位 Design Orientation

○ 符合人机工程学要求，适合普通用户使用与操作

○ 机床设计力求简洁、协调，突出机床企业形象

○ 凸显机床的科技感、现代感，外观新颖时尚

设计风格 Design Style

○ 色彩搭配：力求整体搭配协调。美观、时尚、简洁。色彩定为黑白搭配、冷峻、强烈科技感。现代感。符合机床定位。

○ 形态语意：在外观造型的时候，尝试不同的造型方法。分别从流线、科技感、现代感、圆润、硬朗三种风格的角度进行造型延伸。金属与器物相结合。

○ 材质选择：通过材质感可以增廉机床产品的档次感，产品的档次感、材质选用。颜色分配、材质选用。以及形态的协调性。

设计草图 Sketch Design

从流线、圆润、硬朗三个角度对各机床进行头脑风暴，并从其中优选出三个方案进行细节完善图的绘制，要综合考虑颜色分配、材质选用，以及形态的协调性。

优选方案 Preferred Project

尺寸图 Masurement Chart

Multi-functional Ruler

设 计 者：鞠 云 李雨欣
指导老师：段齐骏 姜 霖

Geometric construction is definitely not easy for those who are often forgetful. They cannot always bring all drawing instruments with themselves, such as the triangle or the protractor. As a result, it is necessary and significant for us to simplify the drawing tools.

The multi-functional ruler is composed of one ruler, one shaft and one slider. It can be often used in four ways: drawing continuous straight lines, drawing intersecting lines, drawing parallel lines, drawing circles. The ruler is used to draw lines. The shaft can locate points, control the rotation angle, and be a magnifying glass with its convex shape. The slider can maintain the relative position and measure the distance. The multi-functional ruler will simplify each of the four ways into four steps and help you complete geometric construction work easily, instead of former drawing tools.

Draw a continuous straight line:
• Draw a straight line along the outside edge.
•• Pull the slider to the end of groove and hold it.
⁞ Keep the slider stably and move the ruler.
⁞⁞ Continue to draw the former line.

Draw intersecting lines:
• Draw a straight line along the outside edge.
•• Put the center of crosses at the point of intersection, and align the longest line of the cross with the zero-scale line, and keep the ruler in parallel with the former line.
⁞ Keep the shaft stably, and turn the ruler to a certain angle.
⁞⁞ Keep the slider stably and move the ruler, then draw the intersecting line along the middle edge.

Draw parallel lines:
• Draw a straight line along the middle edge.
•• Align the straight line with the zero-scale line in angle scale region.
⁞ Keep the slider stably and move the ruler for the distance needed between parallel lines.
⁞⁞ Keep the shaft stably and turn the ruler for 90 degrees, and draw a parallel line along the middle edge.

Draw circles:
1. Put the center of crosses at the point of the circle center.
2. Pull the slider to where the scale number is just the radius.
3. Put the tip of the pen into the hole of the slider.
⁞⁞ Keep the shaft still, and turn the pen to draw a circle.

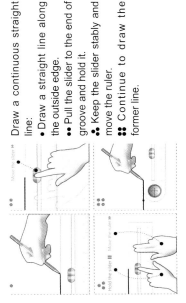

Φ25mm

230mm

20mm

A - A Cross-section

B - B Cross-section

Without shaft

With shaft

Without slider

With slider

...e ruler has one square end and one round ...d, which is concentric with the shaft, and ...s a groove in the middle of the slider. ...erefore, the ruler has three linear scale ...gions and one semi-circular angle scale ...gion. The linear scale region outside is ...0.5 centimeters long, and the inside one is ...3 centimeters long.

...e shaft can be rotated freely, ...d the center of the shaft is ...n the extension line of the ...side scale line. There are ...oss-orientation lines both on ...e upper and lower surfaces ...f the shaft, which have the ...ame center of the shaft. When ...e look down, two crosses ...ll overlap. The shaft is also ...aped as a magnifying glass ...order to magnify the dot and ...e number beneath the shaft.

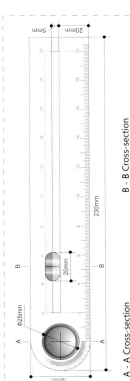

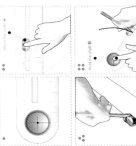

Ruler

Shaft

Slider

The slider can slide along the groove smoothly, and with the position line on the surface for determine the distance from the axis to the slider. Then putting a pen in the hole of slider, a certain radius circle can be drawn.

一、项目概况

1.1 地理位置

该项目位于江苏省苏州市甪直古镇，地处苏州城东南25km，北临吴淞江，南临澄湖，西接苏州工业园区，东衔昆山。全镇面积75平方公里。

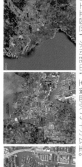

苏州SUZHOU　甪直古镇SUZHI　万盛米行

1.2 项目规模概况

全镇面积约750000平方米，其中方盛米行旧址及其范围区域面积约24000平方米。

二、现状分析

2.1 现状概况——水文条件

甪直古镇依水而建，伴水而生，户户临水。古镇内部河道交织，早期形成了人与自然相融的水乡聚落。然而伴随着地方经济的发展，人口增加和围围居业的开发，古镇内河道受到污染，生活污水、生产废水直接或者间接地排入河道，导致古镇水体污水积。水生动植物的栖息环境遭到破坏，还有上游污水的排放，造成了今日甪直古镇河道淤积严重，逐渐丧失其本身净化能力，人与水的关系日益紧张。

2.2 现状分析——交通条件

甪直古镇建筑格局紧凑，建筑间距狭窄，户户可建筑，围墙围合成院落式空间，从外向内通过街巷连通，形成了狭窄紧张的空间。人们的行方式以步行和非机动车辆为主，古镇缺少相对连贯系统的开放空间，各种铺地样式层出不穷，部分道路雨天积水严重。

2.3 现状分析——植物配置

甪直古镇的自然环境具有高度的人工化干预。户户可建筑，建筑密度高，不临河南一带古镇依山傍水，少丘陵高低起伏状地势，自然植被覆盖率相对较低，用地紧张形成的绿化手段空间，从街巷空间，河道水天系统和层次性，古镇的植物配置却缺乏系统和层次性，加之近十年古镇内的环境破坏，用地紧张等问题和建筑内的院园空间角度分析，对人们的生活产生一定的影响。

2.4 现状分析——建筑

a. 部分古建筑年久失修，房屋形结构单一，无法居住。弃之一边，无人问津，破坏了使用价值。

b. 古镇新旧建筑不协调，古建筑、违建建筑、重要建筑掺杂在一起，破坏了古镇整体的协调，视觉效果较差。

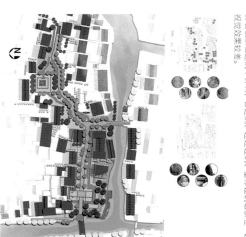

三、设计定位

"利用甪直这一经典历史文化遗产资源，挖掘出保护与景观设计相结合，运用保护、修复、创新等一系列手法，对历史的资源进行重新整合、再生，即充分挖掘地块的历史特性、再生，体现城市支脉的延续性，城市文化生活的需要，满足现代化的古镇的需求，体现新时代的景观设计思路，建设一个生态、现代、极富文化内涵、文明、开放的古镇。"

四、设计构思

4.1 文物保护
4.2 景观整合
4.3 生态恢复
4.4 文化挖掘

苏州甪直古镇
万盛米行旧址
景观改造设计

方案交通流线图

方案景观节点图

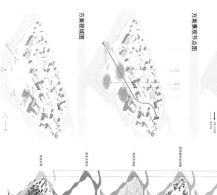

方案绿化图　　主要素分析图

方案总平面图

方案鸟瞰图

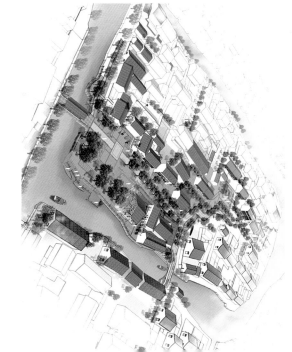

用直古镇万盛米行景观设计

设计者：刘 伟 罗 冉 马凯强

指导教师：徐耀东

案设计构思

用直历史名古镇，河道纵横，作为具有代表性的江南水镇，应充分体现水的特点，万盛米行所在的古镇，作为整个古镇的主要街巷空间，其中万盛米行处作为方案景观设计的核心，运用曲线性的水系和道路景观要素，将古镇的主入口、滨水码头，米行旧址等5处节点串联起来，构筑整体的古水景观空间。

十将古历史名镇人们一些原汁原味的生活形态以雕塑的形式再现，布置在两条线性（水系和道路）景观范围，体现出古镇地域文化特征，增加场地的文化生活和趣味性。

苏州用直古镇
万盛米行02
景观改造设计

米行旧址概念设计——历史建筑的保护

经过现场的调研分析：场地大部分建筑设计，地面杂草丛生，缺乏管理，其中有一米含内部梁架柱式结构相当完整。粮仓建筑分为传统的结构，梁架柱式结构，具有较高的历史价值和艺术形态。分析了该建筑旧址的位置和其他属性，考虑将其作为万盛米行旧址景观改造设计中的重点，设计中借鉴了圆明园旧址景观意向。对米行旧址的墙体进行处理，结构，屋顶进行处理，把危险的墙体和部分房顶进行拆除，保留具有较高审美价值的檐梁，建筑结构，并进行加固处理，然后保留部分分墙体，经过设计展现其残缺之美，调整建筑与周围环境水系，街巷空间的关系，使古镇水系，建筑，街巷，旧址进行空间相互参差。

滨水码头概念设计

古镇水系交织，街巷穿插，建筑临水，滨水驳岸设计应充分利用古镇临水的特性，将居民的生活，外来游客的游憩加入到水的体验中。该设计将乌篷船和水上栈道相结合，利用乌篷船这一水乡文化符合与栈水平台的栈道再现了乌篷功能属性，将二者结合起来，意象上再现了乌篷船这一运载工具为连接古镇人民和水系的重要载体，显示它的历史价值。

驳岸设计，利用周围古镇拆拆下来石材，灰砖和板瓦，一方面减少了古镇改造的费用投入，时间在这些材料上雕刻到班驳的肌理。其次，石材来载了古镇的历史，别把的一部分，充分地利用这些材料补加入古镇的新生改造中。

古代生活器具利用

街巷空间概念设计

局部节点设计

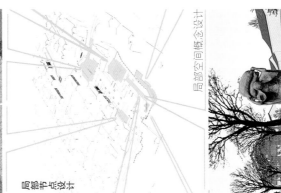

局部空间概念设计

船文化挖掘——"船"设施概念设计

场地东西向剖面图

场地南北向剖面图

万盛米行旧址剖体内

天山矿业有限公司职工阅览室设计

设计者：徐耀东　陈育嘉　刘伟

设计概述

设计方案基地处新疆天山腹地之中，是天山矿业有限公司的职工阅览室。其原有厂区中一座废弃的旧厂房，建筑改建总面积约为720平方米。基于"生态、历史、交融"的设计理念，我们采取了一系列的设计手法。首先，该方案打破了阅览室常规的布局形式，相比于装饰柜的增加着重于空间的塑造。由于原有空间相对单调乏味，为提高空间的使用率和灵动性，该方案增加了二层空间，将空间由小部分分出，形成内置下沉空间的形式，共赋其中间部分为抽空，该方案亦显得更加通透。二层半圆形空间与一层圆形下沉空间相互关系，保存下沉空间的自由地散落在空间中，营造出一种轻松、舒适的氛围。

不仅如此，我们还将绿色自然生态的概念运用在主室内，例如大量绿植、光影写真，并且通过艺术小品体现历史性。设计元素的统一，使整个方案从功能、形式都能够相互融合，为职工提供一个更加优质的阅览环境。

前厅设计说明

我们将原有建筑向南侧墙扩了一处前厅，在建筑外立面上开窗以"框景"。在主入口形成新的设计中，基于"二维图形在三维空间的延绵"与"垂直绿化"的理念，我们设计了一面纵向的下沉空间构件，构件中圆形与圆形的下沉空间相互交叉，呈蔓延值物攀爬于钢架构件，形成一面绿色的景观墙，不仅起到了分割空间的作用，更赋予了老建筑以新的生命力。

中庭设计说明

中庭作为阅览空间的中心部分，我们将墙扩了三层的空间，将废弃的机器在此进行富有历史感的艺术修复，形成了既具有历史感，又有时尚价值的装置艺术品，并以此作为旧时工厂的见证。我们对这艺术品范围围的空间进行了下沉处理，形成具有围合质感的阅读区域。

室外步道鸟瞰图

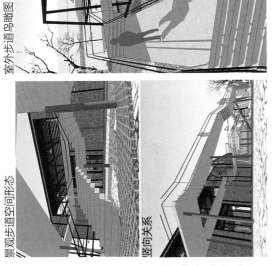

景观步道空间形态

竖向关系

观步道交通流线

室内外空间的整体性与连续性，我们在建筑西侧画面的基型的构想上，我们参考了柔带状水果皮的形态，在步为二维图形在三维空间中的延续，不仅增强了室内空间的参透感，其独特的造型更为人们提供了富有趣味的空间。吸引其所处的特殊地理位置，我们将大壁滩的风光进行再现。由象和概括，用鹅卵石和竹片枝秆其特殊风光再现。

视域分析图

室外空间分析图

层室内视点效果图

厅效果图

书架效果图

书柜和坐椅自由地散落在空间中，营造出一种轻松、舒适的氛围。

厅设计说明

厅部分中，我们从取了新疆戈壁滩的一些本土元素，包括电的土地纹路、戈壁滩的沙丘、大壁滩的基本形态等，将这些白元素进行了高度的概括和提炼，从而形成了这一组现代感与文多井重的装置艺术品。通透的视线、色彩的构成感、上下吻合为了石装置与鹅卵铺垫地，铸就了这后厅空间的隽与神。

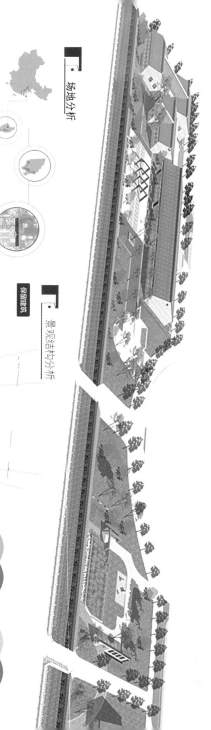

场地分析

该景观改造项目位于南京理工大学友谊河南岸区域，校园中部，具体建设范围西至友谊河（现清真食堂），东至一号路西侧，北靠友谊河，南以现有道路为分界，整体区域足球长体长，占地面积2.3公顷。场地地形北高南低，东高西低，高差不大。

- 大数育超市
- 格林学院周边

景观结构分析

- 保留建筑
- 绿化结构
- 道路结构

① 人民军工发展历程　② 人民军工代表人物　③ 校园文化发展历程
④ 新军事变革与立体兵工　⑤ 新型工业化道路

军工文化　校园文化　红色基因　休闲性

"门"概念的应用

1. 文化意义——场地中的二道门

南京理工大学的地标性建筑物，具有很深的文化意义，将这个概念放大，站在"门"的角度看中国的文化，中国文化是一种语言，门里门外，门内分了阶段，划分了生命，诠释生门关的门又划分了生与死，门里门外的故事就是一部历史文化发展史。

2. 形态特征——门门的形态在平面上呈线性

可以将一个整体区域划分成多个独立的区域，竖向上又是通道，可以将独立的区域统一在同一个画面中，人们在穿越一道道过程中也会有参与与体验的感觉，产生心灵上的共鸣。

为迎接60周年校庆，学校拟将友谊河两岸区域打造成以"军工文化"为主要内涵的具有学校特色及历史文化的景观带，包含五个主题景区。人民军工发展历程、人民军工代表人物、南京理工大学发展历程、新军事变革与立体兵工、新型工业化道路。

军工文化长廊景观设计
NUST Military Cultural Corridor Landscape Design

设计者：徐玥 张 敏 周歆怡 孙宗飘
指导老师：徐 伟

南京理工大学
NANJING UNIVERSITY OF SCIENCE & TECHNOLOGY

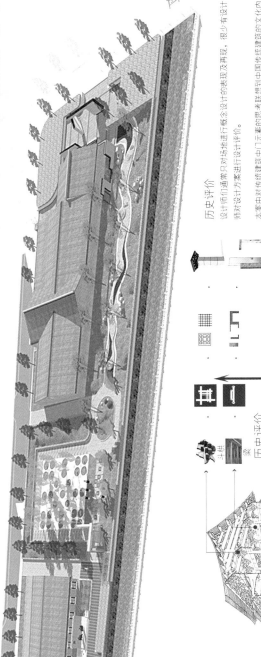

军工人物 ┐
 ├ 内核一致
中国文化 ┘

军工文化 ┐
 ├ 建筑文化
中国文化 ┘

历史评价

设计师的通常只对场地进行概念设计的表现及再现，很少有设计师对设计方案进行设计评价。

本案由对传统建筑中门元素的思考联想到中国传统建筑的文化内涵，传统建筑的材质、�götypes、脊梁、斗拱是建筑中最重要的部分，支撑着整座建筑。中国的军工文化也是中国传统文化的一部分，军工代表人物在军工发展历史中同样起着中流砥柱的作用，两者的核心一致。

"历史评价"概念应用

建筑文化是中国传统文化的重要组成部分。用简化的线条来表现传统建造工艺中繁复的装饰结构，既传达出中式元素的意蕴，又优化了工艺，并适应现代人审美需求。提练柱础、斗拱、脊梁等传统建筑元素，设计成构筑物由低至高错布置在景观带之中，预示军工代表人物是中国军工发展历史中的中流砥柱。

历史评价

斗拱 梁 历史评价

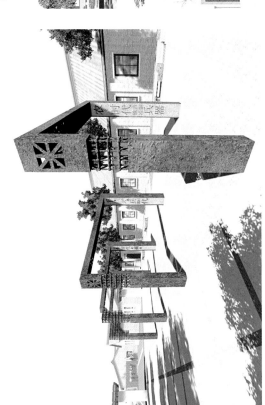

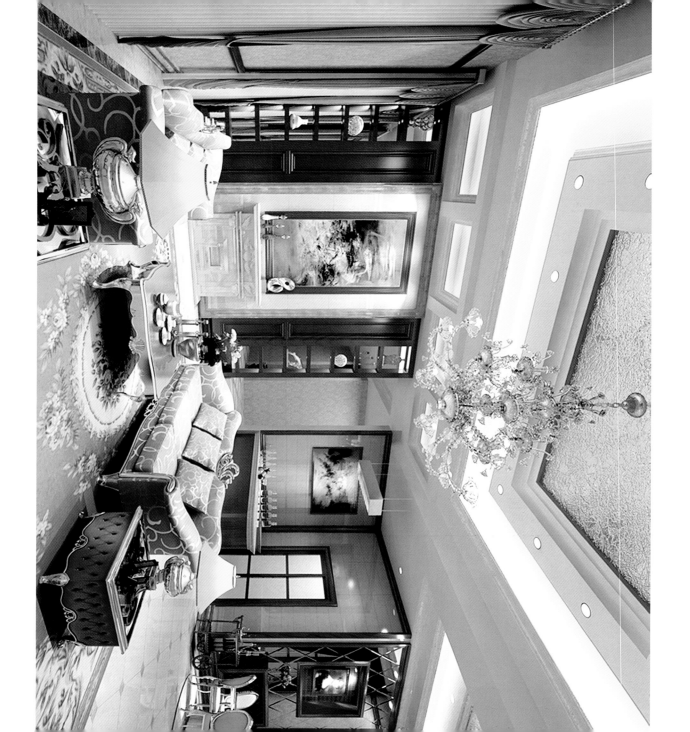

东篁园样板房

设计者:朱 文 夏天龙 潘 明 王 楠

指导老师:徐 伟

本系列的主题是"游列国来泡澡"，其特点如下：

◇以圆筒为包装形式，模拟木质浴桶，表面绘制手绘风格的各国标志性旅游景点，体现主题，尤其适合"驴友"使用。

◇袋泡茶标签设计为手绘风格的各国小人，双臂张开可以悬挂往杯沿。

◇使用时茶包就是一个个泡澡的各国卡通人物，增添趣味性。

个性化袋泡茶包装设计 "个人专属" 系列

设 计 者：凌 云
指导老师：徐瑞华

本系列的主题是"每天一封信"，其特点如下：

◇ 以扁平的信封为包装形式，方便携带，每个信封对应一周七天，尤其适合工作场所或是旅途使用。

◇ 袋泡茶标签设计为小信封，内涵的信笺中有简单的祝福话语，给生活增添温暖。

◇ 包装不同的色彩和花纹与茶的口味相对应，简洁明了又增添个性。

饮茶不仅是一种传统的饮食文化，也具有养身保健功能。但是对于许多年轻人来说，更倾向于市售的瓶装饮品等，长期饮用会给身体增加负担，且包装也会造成污染。本产品是提倡用袋泡茶来替代瓶装饮料以达到养身和环保的目的，是体现当代年轻个体的个性化包装设计。

我和你一样

朵唯女性手机广告系列

设 计 者：罗　丹　刘运良　邬　苑

指导老师：王　辉

以朵唯手机分别作为跳水的跳板、蹦极的山崖、舞蹈的平台，充分展现朵唯女性带来勇于尝试、挑战自我的感受。每个场景都有一个职场散于迈出一步的故事，说出自己的主张，鼓励年轻女性不断尝试新鲜事物、新的娱乐方式，获得惊喜、兴奋、积极的正能量。

我和你一样

我穿十二公分高跟鞋
但我不是不会赴白领
我感受在舒享的未来
但我不愿改变现主张
我种种都是自主的
但我不是个女生那场
我离乐未来
我的伴随的下的
未如用眼 处曾的
我和你一样

DOOV
朵唯女性手机

"养生五谷" 趣味包装设计

设 计 者：吕志伟

指导老师：徐瑞华

养生五谷是食品类，一般都是透明的塑料包装，缺乏设计感和趣味性，所以，我做了一系列的尝试，把其包装做成趣味性的设计，分别是绿豆、红豆、黄豆的包装。因为购买五谷的消费者一般以妇女为主，所以采用了围裙作为主要的图形，把五谷装入塑料袋中密封好再装入设计好的手提袋中，这样看起来就像是穿着围裙的身体，俏皮可爱，从而增强消费者的购买欲。

创意家纺设计

设 计 者：何晓晴

指导老师：王　辉

狗狗对于骨头的爱恋，是没有理由的钟情；红绿灯对小汽车的闪烁，是饱含爱意的警示；粉红色的心跳，藏下多少思念；漫天飞舞的纸飞机，承载儿时的梦想。

女书新语

设　计　者：张晓理
指导老师：王潇娴

首页
进入

"第六感——女书新语"是一个着重于用户的"感"的关于"女书"的文化网站。"第六感——女书新语"从质感、色彩等多角度向用户展现"女书"文化的精彩与美妙，从而使得晦涩难懂的文字能够被感知化。它也是一个符合现代审美，而又不破坏"旧文化"本体的文化网站，也是一种对"旧体新用"的尝试。"女书新语"网站包含首页动画在内的页面共有四级页面，目前而后分别是首页动画页面，主菜单页面，次级菜单页面，内容页面。

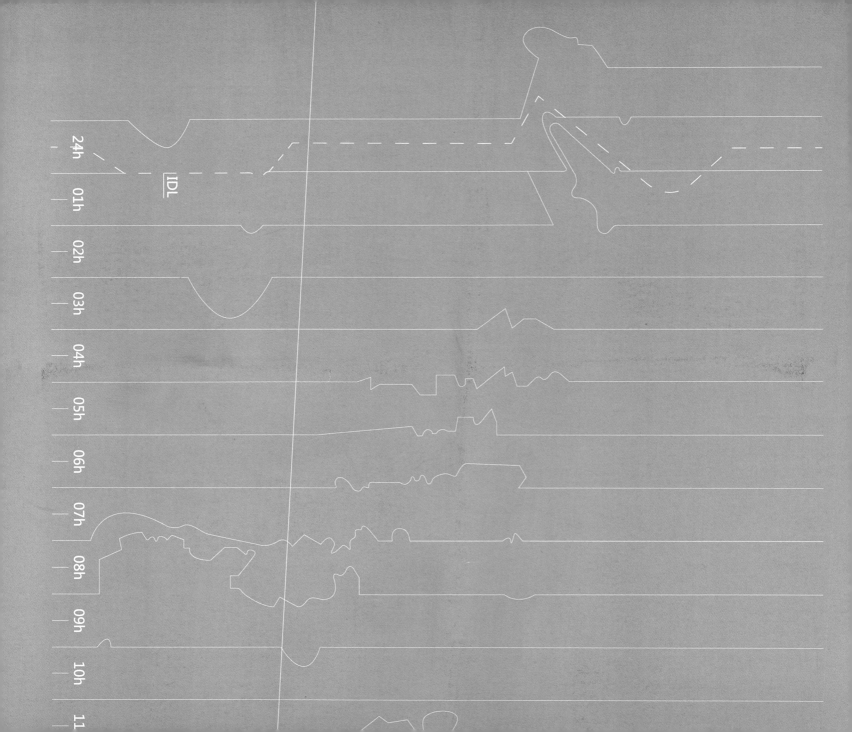

24h

IDL

01h

02h

03h

04h

05h

06h

07h

08h

09h

10h

11

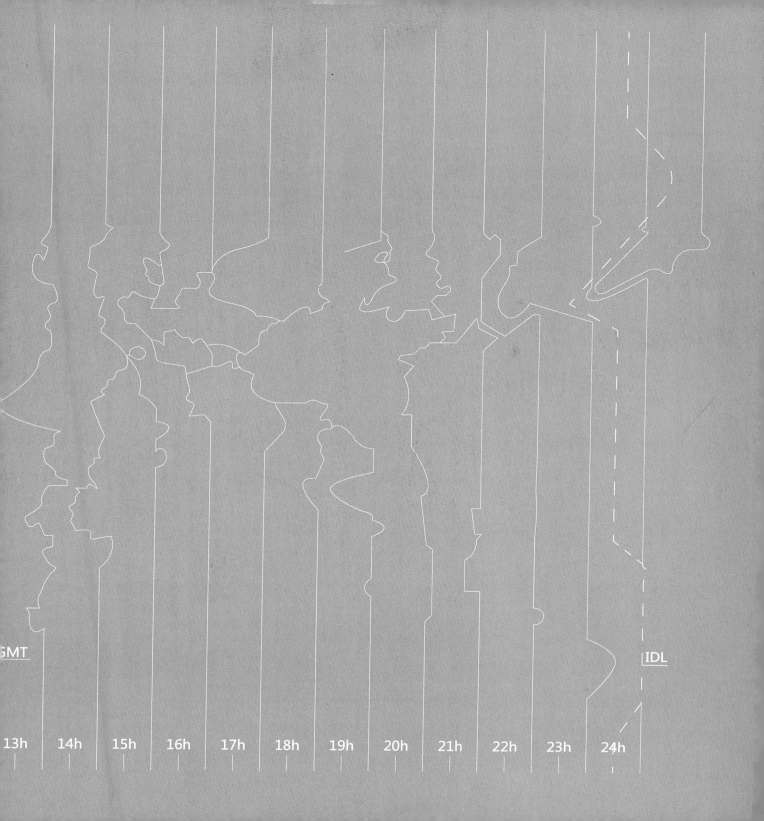

图书在版编目（CIP）数据

跨界与融合　"南京创造"国际校际设计联展作品集 / "南京创造"
国际校际设计联展组委会编. —北京：中国建筑工业出版社，2013.10
　ISBN 978-7-112-15744-0

　Ⅰ.①跨…　Ⅱ.①南…　Ⅲ.①设计—作品集—世界—现代　Ⅳ.①J111

中国版本图书馆CIP数据核字（2013）第197452号

　　责任编辑：吴　绫　李东禧
　　责任校对：肖　剑　刘　钰

跨界与融合
"南京创造"国际校际设计联展作品集
"南京创造"国际校际设计联展组委会　编
*
中国建筑工业出版社出版、发行（北京西郊百万庄）
各地新华书店、建筑书店经销
北 京 嘉 泰 利 德 公 司 制 版
北京顺诚彩色印刷有限公司印刷
*
开本：787×1092 毫米　1/20　印张：13²⁄₃　字数：420 千字
2013 年 9 月第一版　2013 年 9 月第一次印刷
定价：98.00 元
ISBN 978-7-112-15744-0
　　　（24537）